1996

MW00638531

PUBLIC LETTERING

Armando Petrucci

PUBLIC

Translated by Linda Lappin

LETTERING

Script, Power, and Culture

THE UNIVERSITY OF CHICAGO PRESS • CHICAGO & LONDON

ARMANDO PETRUCCI, a former state archivist and librarian, currently teaches paleography at the University of Rome.

LINDA LAPPIN is a language and literature teaching assistant at the University of Rome.

THE UNIVERSITY OF CHICAGO PRESS, CHICAGO 60637
THE UNIVERSITY OF CHICAGO PRESS, LTD., LONDON
© 1993 by The University of Chicago
All rights reserved. Published 1993
Printed in the United States of America
02 01 00 99 98 97 96 95 94 93 5 4 3 2 1
ISBN (cloth): 0-226-66386-8

Originally published as *La Scrittura: Ideologia e rappresentazione,*
© 1980, 1986 Giulio Einaudi editore s.p.a., Torino

Library of Congress Cataloging-in-Publication Data

Petrucci, Armando.
 [Scrittura, English]
 Public lettering : script, power, and culture / Armando Petrucci ; translated by Linda Lappin.
 p. cm.
 Includes bibliographical references and index.
 1. Written communication—Italy—History. I. Title.
P211.3.I8P4813 1993
302.2'244'0945—dc20 93-16342
 CIP

⊗ *The paper used in this publication meets the minimum requirements of the American National Standard for Information Sciences—Permanence of Paper for Printed Library Materials, ANSI Z39.48-1984*

Contents

Illustrations follow page 62.

Chapter One

WRITING AND THE CITY

The attentive and unhurried visitor to any city in the Roman Empire between the first and third centuries B.C. would have been struck not only by the traffic and the colors, by the statues, temples, and public meeting places he or she encountered, but also by the ubiquitous presence of writing—in the squares and in the streets, on the walls and in the courtyards; it appeared on hanging wooden tablets or traced on squares of white and was painted, engraved, carved, or handwritten. These writings were all very different from each other in appearance and also in content, which may have been political, funereal, commemorative, or commercial. Sometimes the messages were public, other times extremely private, including remarks of disapproval, joking reminders, and insults. They were addressed not strictly to the entire urban community but to the rather large portion of it that was literate. Produced by individuals belonging to the most varied levels of society, these writings were visible everywhere, though of course there was a preference for places such as public squares, forums, public buildings, and necropoli. This, however, applies only to the more ceremonial or official examples. The rest were indifferently scattered about wherever space could be found: near the entrance of a shop, at a crossroads, or on any clean patch of wall.

The appearance of the average early medieval European city was quite different, even though it stood on Roman foundations. Here we find almost no trace of public writing in open spaces, with the exception of a few vestiges of ancient Roman inscriptions, which the current inhabitants could no longer read or understand. The conditions necessary for the use of writing out of doors were now lacking; the intentional enclosing of spaces, the narrow, winding streets, the dizzying vertical perspectives of the city walls interrupted here and there by architraves and protuberances were not conducive to such a phenomenon. Moreover, the cultural and social basis was also lacking in that a gradual waning of literacy had reduced what had once been a place where values and information were transmitted through the medium

1

of writing into a place where such communication was no longer possible because of the scarcity of senders and receivers (if we may put it that way), a place where writing was not only absent outdoors but was also hardly present indoors, in either the private or the public realm, since books and other forms of written documents were quite rare.

Furthermore, the equating of the *Ecclesia* with the edifice where religious services were held had concentrated the main display of the church's ideological message—for the most part conveyed through images rather than through writing—within the limited space of the urban churches. Indeed, the functions of writing in society had greatly decreased in number and in value. In imperial Rome those functions had been extremely diverse: commemorative, expressive, transmissive, often combined together, always conveyed through means appropriate to the purpose the text was to serve. Likewise, the range of graphic products was also very vast, differing widely in appearance and technical expression from books to epigraphs, documents, painted signs, graffiti, letters written on tablets, and so on.

We should remember that the functions of writing always correspond to the type of materials used, and therefore those functions correspond to the typologies of products created. These will be rich and varied if the functions are manifold, but they will be limited and simple if those functions are few and unvaried. In early Western medieval society (if we may use such an approximative definition), the simple typology of graphic production corresponded to the decrease in the functions of writing, which had become essentially uniform—it was now commemorative and symbolic rather than transmissive and expressive. Furthermore, the vital "connective tissue"— that is, the daily use of writing by private individuals and its public and official use in open (and not empty) spaces of the city by the lay authorities—had virtually disappeared.

The prevailing civic function of epigraphy and the fact that stone inscriptions were made to be placed outside in open spaces had had a determining influence on the general appearance and overall graphic style of the ceremonial epigraphy of classical Greece and Rome. In this form, the rigid geometric shape, the studied relationship between empty and full spaces, the harmonious layout, the carefully calculated use of different sizes of letters depending on where the inscription was to be placed and on its height from the ground, and the shading of the lettering achieved through V-cut carving all contributed to create a particular effect, which was a harmonious and impressive appearance along with maximum legibility in natural light out of doors.

In the classical world, the function, setting, and expressive means that I have described above were peculiar only to epigraphy. In a certain sense, these factors justified and determined the modes of its formal autonomy, which placed monumental stone inscription at the apex of an ideal hierarchy of rules governing graphic expression in both alphabetic systems then principally in use—the Greek and the Latin.

The epigraphy of the early Middle Ages, both as a genre and as a product, enjoyed neither formal consistency nor normative supremacy in the overall graphic system of which it was part. In general the epigraphy of this period took the form of a vague pastiche of models drawn from widely diverse ancient graphic types (both capital and uncial). The models were often merely a transposition, lacking in autonomous formal canons, of monumental scripts (which in themselves were rather inconsistent and mediocre) used in bookwork. It must be said that the rare and occasional use of epigraphs and their placement in enclosed and poorly lighted places, along with the loss of specific technical traditions (such as V-cut inscriptions) may sufficiently explain why the graphic production of the early Middle Ages depended so heavily on the book as a model for scripts and layouts.

In Italy between the eleventh and thirteenth centuries, however, this situation underwent a change that corresponded to the urban revolution taking place in the cities and to the consequent discovery of the civic and political function of outdoor urban space. This discovery was marked by a conscious return to, if not indeed an imitation of, ancient epigraphic models.

At the beginning of this process, we find in the cities of Salerno and Pisa many striking instances of the new epigraphic revival that are quite varied and even contradictory. For example, the Duomo of Salerno, first begun at the time of the Norman conquest (1076–77) and concluded around 1084–85, is characterized not only by its recourse to the new architectural ideas that had recently been used in the building of the church of the Abbey of Monte Cassino but also by a completely new use of monumental writing for the conveying of a political message that was expressed through innovative aesthetic-formal solutions directly inspired by late-antique models.

This development had two authors: Archbishop Alfano and Robert Guiscard. Alfano, heir and protagonist of a rich cultural tradition blending both the Benedictine/Cassinese and the Greek Byzantine, inspirer of a pathetic revival of Roman myth during the reign of the last Lombard prince, was the creator of a new monumental graphic language that primarily consisted

in the restoration of the capital letters of Roman epigraphy and in a return to the rules that had governed writing in antiquity. Some examples of this new script may be found in the epigraphs Alfano commissioned to commemorate the repositing of holy relics in the duomo.

Robert Guiscard, anxious to proclaim the nature and extent of his new power to the wealthy city of Salerno, was most likely responsible for the decision (though the recent example of S. Angelo in Formis may have provided him with the suggestion) to have his own name, along with his titles and the bold assertion of the legitimacy of his claim to rulership, carved on the outside of the church on the fronton of the open facade of the portico, inscribed in the regular and imposing monumental letters that Alfano had just reelaborated from antique models. (See FIG. 1). Previously the archbishop had employed this script in very traditional ways, carving it on small stone slabs cut to resemble the leaves of a codex that were to be placed inside the church, but the new ruler wanted this script enormously enlarged, carved high above the ground on the entrance to the duomo itself, fully exposed to the light of day. Who could fail to interpret this as a conscious symbol of power, an obvious imitation of the lettering of classical inscriptions, intentionally addressed to the newly conquered city?

The phenomenon that occurred in Salerno, in the outdoor, yet enclosed and controlled space of the large quadriporticus of the duomo, in accordance with the wishes of the ambitious Guiscard and his archbishop, was to find in Pisa quite a different setting and quite different ideological characteristics that were the product of a longer and more complex development. Between 1064 (the year in which the construction of the duomo began) and the third decade of the twelfth century, Pisa, a rich commercial center and flourishing city and now the greatest power in the Mediterranean, became—thanks to its artists and artisans, its clergy and citizens—the center of a major revival of monumental epigraphy in open urban spaces, directly inspired by ancient models.

From the very first, the duomo (which had not been built in the center, but outside the city walls in a vast, open area), with its extensive surface space, was the place chosen for the display of commemorative epigraphs honoring the city, its leaders, and its citizens. The oldest epigraph on its facade, which commemorates Archbishop Guido and the founding of the duomo, is oblong in shape and has a booklike layout. (See FIG. 2.) Soon afterward, before the century had ended, two other slabs were added. One celebrates the military glories of the Pisans, and the other the founding of the duomo, albeit somewhat more solemnly than the earlier inscription. These were rectangular slabs laid horizontally (therefore epigraphic and not

booklike). The writing was in very regular, antique-inspired capitals (Romanesque, if we may use this term) and conformed to strict rules of layout, formal homogeneity, and legibility. Some of the original models from which the duomo's architect, Bousketos, had drawn his inspiration were inserted here along the sides and in the apse. They included fragments of classical Roman inscriptions (sometimes mounted upside down) used as ornamental graphic elements; they were the visual symbol of a tradition. It is significant that in the second decade of the twelfth century, Bousketos was buried in an antique sarcophagus mounted on the facade of his cathedral, outside in the open, honored by an extremely complex epigraph occupying several levels, the text of which mentions Ulysses and Dedalus.

In Pisa during this period, monumental writing broke away from the limits and protection of the sacred areas dominated by the duomo and spread into the open spaces of the city, to urban monuments of a nonreligious nature. In 1115 the Pisan conquest of the Balearic Isles was commemorated by an inscription written in large, square capitals mounted on the very door (the so-called golden door) through which the troops had marched in victory. Perhaps even more significantly, in 1124 a colossal statue of Consul Rodolfo was erected very near by in an open space, accompanied by its own commemorative epigraph, the only example of its kind in Europe at the time. At the beginning of the twelfth century, not only were books and documents being produced in great quantities in Pisa, but within the class of the *mercatores,* new categories of alphabets were being created for writing in the vernacular, along with new written languages, new forms of documentation, and new writers. The wealthiest city of Italy at that time found itself reflected in the new scripts that appeared everywhere out of doors, based on antique forms and models.

Salerno and Pisa did not remain isolated cases in this new civic-conscious Italy, which experienced an era of rapid economic, political, and cultural expansion between the eleventh and twelfth centuries. In Pomposa as early as 1063 in the large inscription "Magister Deusdedit" proudly placed at the foot of the new campanile, the squarish format, the framing, the layout of the text, and the form of the letters themselves testify to a conscious imitation of classical models, to a studied relationship between the inscription and its external location, and to an obvious concern for legibility. In Modena, at the end of the century, an inscription in splendid Romanesque capitals mounted next to the door of the duomo commemorated the beginning of the construction of Lanfranco and Wiligelmo's masterpiece (1099) and was soon followed by another inscription of similar content and style, the work of Aimon, the *magiscola* (master) of the cathedral, who may also have been

responsible for the booklike layout of the two inscriptions mounted outside the building.

Meanwhile, over the span of the century in Norman-ruled southern Italy, yet another phenomenon was taking place: the outdoor display of commemorative epigraphs. Limited to religious buildings, these inscriptions were directly inspired by the Salernitan model. Examples include the portal of Sant'Angelo in Formis, Prince Giordano's inscription on the Duomo of Aversa (1094), the portal of the Duomo of Carinola (1094), the tomb of Bohemond in Canosa (1111) with its large inscription beneath the frame of the octagonal tambour, the portals of the Cathedral of Caserta Vecchia, and finally, the most stylistically accomplished example (see FIG. 3), the inscription carved on the architrave of the portal of SS. Niccolò and Cataldo in Lecce (1180).

The new rulers of the Italian communes, among whose ranks literacy continued to spread and who were growing increasingly convinced of the vast significance and complexity of writing and its many functions, frequently used monumental inscriptions to commemorate the constructing of public buildings, immortalize memorable events, and set down in stone the texts of the new common law. Thus in many towns between the twelfth and thirteenth centuries, statutory laws, obligations imposed on tradesmen and laborers, and the concession of benefits to the community were carved on stone—from the town of Lucca (1111) to the noted *Petra iustitae* of Perugia in 1234. Nearly all these public inscriptions were placed within the architectural structure of a religious building, usually represented by the most important church or cathedral (or in their absence, the collegiate church) of the town. Since they were to be placed out of doors, they had been designed to be (and indeed became) an essential part of the surrounding urban space, whether field, square, or open area, and also an essential part of the civic life that was conducted there. The inscription carved by a certain "Magister Obertus" on a massive stone outdoors near Cemmo in Valcamonica to commemorate the destruction and rebuilding of Milan must be placed in a special category. The ancient, local tradition of rustic rock inscriptions surely played a major role in its creation.

These same moments of Milan's history were also commemorated by the monumental Porta Romana (demolished in 1793), which was decorated with bas reliefs and with rather clumsily carved inscriptions belonging to a different graphic tradition—the Gothic. This large stone, though elegant in intention, has an extremely untidy booklike layout. The capitals of the inscription on the relief in FIGURE 5 are poorly drawn and engraved, and the rather common minuscule used in the inscription in FIGURE 4 (probably the

work of the sculptor Anselmo) is of an entirely different size. Nor does it appear from these specimens that legibility of the text was of great concern to anyone. A completely different effect, however, has been created by four private Roman funerary inscriptions, all clearly legible, that the people of Milan later placed on the arch of the Porta Nuova after salvaging them from a preexisting arch that had been destroyed. This is a striking example of the recycling of Roman inscriptions on a public building that remained without its own epigraph.

Another example worthy of note is the Ferrara statute of 1173 that the local authorities and citizens of this Emilian town had engraved on marble slabs "to lasting memory" and mounted on the side of the cathedral. The text, later covered over in the 1300s (perhaps in conjunction with the death of the free commune), was inscribed in large Romanesque capitals. Aside from the errors, omissions, and calligraphic inconsistencies, the overall effect is impressive, solemn, and intentionally monumental. The lines of the text are arranged *all'antica,* and the underlying concern for legibility is plainly evident (the slabs were placed more or less at eye level), as is the desire to create a direct relationship not only between the text and the mass of citizens but also between the inscription and the physical body of the church itself. Similar aspirations must have guided the clergy of Modena in arranging for the outdoor display of a large inscription (1.55 m × 3.10 m) on sixteen stone blocks elegantly carved in capitals. The style tends toward the Gothic, and the text solemnly commemorates the consecration of the church, which took place on July 12, 1184, thanks to Pope Lucius III.

In this context the developments in Genoa must be considered in a separate category. Here we find a series of relatively late examples, all of which involve the celebration of illustrious families or individuals of the maritime city. This celebration found its own distinctive architectural and graphic expression through the use of an external ornamental element peculiar to the Pisan-Romanesque style—the decoration of the facades of churches and nobles' palaces with broad horizontal stripes of white marble engraved with large Gothic inscriptions. In this category we must include the facade of Santo Stefano with its various inscriptions honoring the Da Passano family up until the time of the Cinquecento (see FIG. 6), and more notably, San Matteo, the church of the Dorias, with its five double bands of stripes bearing inscriptions commemorating the military exploits of this family from the thirteenth to the sixteenth centuries (see FIG. 7). The slabs mounted along the sides of the family's sarcophagi (thirteenth and fourteenth centuries) in San Fruttoso are much smaller in format and very typically Gothic in lettering.

Between the twelfth and thirteenth centuries, the new ruling class of the Italian communes demonstrated that they not only wanted but also knew how to use the symbolic language of monumental writing, which throughout the early Middle Ages had been the exclusive heritage of the church and of the clerical classes. Now this instrument of communication and expression, previously confined to the dark heights inside sacred buildings, was being brought out into the urban space teeming with the activities of citizens, many of whom were now literate, and was put to use in communicating juridical, administrative, and economic matters—in short, secular matters. Moreover, it had begun to appear not only on religious monuments but on all structures that now enriched the city—on doors, palaces, arches, and statues, celebrating the new ruling class and the government of "the people." Frequently, however, the rather unusual techniques of carving and layout and the haphazard mounting of the inscription—often asymmetrical in relation to the main elements of the building itself—reveal the difficulties that the artisans and patrons encountered in their attempt to include writing in Romanesque-Gothic architectural structures, difficulties that would find not one but many solutions, depending on the particular physical characteristics of each monument and its context. The setting of these inscriptions was very different from the setting of monumental writing on urban buildings in ancient times.

Yet another, by no means secondary phenomenon should not be overlooked here. Now the names of the artisans themselves begin to appear on monuments—on church portals, campaniles, and columns; at the bottom of relief sculptures and on leaves of parchment; sometimes together with the name of the patron who had commissioned the work, and sometimes alone. These references to the name of the craftsman are often formulated ambiguously. Although they apparently praise the work itself and thus the person who had commissioned it, in reality they celebrate the now-redeemed role of the artist/artificer. From Wiligelmo, whom we have already mentioned, who is celebrated as *sculptor,* to Nicolaus, the "renowned master" of Ferrara and Verona; from Benedetto Antelami, *sculptor* of Parma, to Rodolfo and Binello of Bevagna; from the Roman marblecutters to Nicodemus "Magistrus" of S. Martino della Marrucina, short rhyming verses in Latin, written by clerical literati and carved by relatively skilled stoneworkers plainly point to the rediscovery of the artist's unique individuality both as a craftsman and as the protagonist of a work of art that was memorable in itself.

This is somewhat in contrast with the humble *operaii,* the stonecutters, who have left scattered graphic traces consisting of a few handwritten lines

or a few carved letters in many monuments. Often in these short poems in praise of the craftsmen the presentation is poor, the letters are misshapen, the layout cramped or untidy, and the choice of location very modest. Moreover, they are usually quite difficult to read and decipher, yet on the whole in both the private and public realm they represent an important graphic phenomenon. Constructed on the work and in it, intentionally addressed to the community at large, they conveyed a message far removed from the traditional liturgical-religious one.

Meanwhile, in the areas and the cities more directly influenced by Byzantine culture, and especially in Norman Sicily and in the doge's Venice from the twelfth to the thirteenth centuries, monumental writing in Greek-style letters and scripts was being used inside the huge new sacred building complexes to provide captions for the vast cycles of figurative mosaics. This was a phenomenon imported from the East, promoted and executed by craftsmen who had originated or had studied there and who displayed great imagination and skill in inserting inscriptions in the empty spaces available, arranging them in lines, circles, and clusters, following patterns used in the sacred architecture of the Eastern Empire.

Another means through which the close-knit threads of the Greek monumental majuscule wove its way into the writing system of the West during this period was the bronze Byzantine doors brought to various cities in Italy between the eleventh and twelfth centuries, which found their way to Amalfi, Montecassino, San Paolo in Rome, Monte Sant'Angelo (1076), Atrani (1087), the Cathedral of Salerno, and San Marco in Venice. The apparently unique presence in these areas of the "Greek style" Latin monumental capital represented a phenomenon that would have important consequences during the Quattrocento, when artisans would look back to the calligraphic styles of the Romanesque era in search of models and inspiration. Monumental Greek letters thus came to appear in the most varied contexts up until the last quarter of the century, when the revival of the ancient Roman epigraphic capital effaced from the panorama of Italian writing the last vestiges of a style deeply rooted in medieval Byzantium.

I n Rome, the awareness of the meaning and function of monumental writing as a tool for the transmission of ideological values had never been completely lost. The presence of the pontiff, the still-evident traces of a secular, imperial power, the intriguing appeal of the ancient inscriptions that were still visible and to a certain extent still legible, the persistence of artistic traditions involving the insertion of writing in architectural monumental structures through the techniques of stone carving

and mosaic, and the continuing production of luxury books for the Curia all contributed to the vast, impressive, and aesthetically complex panorama of graphic production that Rome enjoyed during the twelfth and thirteenth centuries (once it had recovered from the terrible sack at the hands of the Normans in 1084). However, because of the nature of the power reigning there, the characteristics peculiar to its social structure, and the weight of a long cultural tradition that was not to be discarded, the results were quite different from those of the great communes in central and northern Italy. In Rome monumental writing remained inside, where it reached the apex of its expression in association with religious functions, playing only a subordinate role as caption and ornament in large-scale figurative contexts.

In the splendid inscribed mosaics and in the long Roman inscriptions of the period, a phenomenon was emerging that, though contradictory, may be easily explained. It combined the use of the Romanesque capital (though now a somewhat worn-out repetition of very ancient classical models that were still considered contemporary by craftsmen and readers) with the use of techniques of execution, utilization, and presentation of writing that were distinctly early medieval. In short, what was lacking here was the new, or rather a new interpretation of the antique. When it did appear in the bold inscriptions of San Giorgio in Velabro or SS. Giovanni and Paolo (see FIG. 8) written in huge letters carved with the newly rediscovered technique of V-cut carving, or in the dense inscriptions on the House of Crescenzio, or in the proud Roman lettering of the epigraph drafted by Senator Benedetto for the parapet of Ponte Cestio, this new development, limited as it was to external locations, secular functions, or expressions of regained graphic autonomy, was still quite rare and partial and was not enough to modify the situation as a whole, which was indeed heavily dominated by an exclusively ecclesiastical tradition.

In this regard, it is very interesting to compare the monumental writing in the apsidal cycle of Santa Maria in Trastevere (mid-twelfth century) or the great mosaic of San Clemente (twelfth and thirteenth centuries) with the inscriptions by Pietro Cavallini that appear beneath the panels depicting scenes from the life of the Virgin Mary in Santa Maria in Trastevere (see FIG. 9). In the first two, the lettering is thick, heavy, and clumsy, arranged on boldly curving bands and oblique scrolls, in imitation of ancient iconographic models. Cavallini's inscriptions, in contrast, show thin, fine Gothic lettering arranged in parallel lines against a black or white background obviously inspired by bookwork. (In fact, the setting of the panels within the architectural structure of the church gives the impression of illuminated miniatures in a codex.) In reality, both solutions are far removed from

ancient graphic culture. With his book-inspired formal equilibrium and his use of the new Gothic script, Cavallini did indeed make a decisive break with tradition, but in doing so, he rejected the revival of the antique that had been so eloquently expressed in the experiments of Salerno, Pisa, Modena, and Ferrara. At the same time, Cavallini not only denied epigraphic monumental writing its formal autonomy but, more important, deprived it of its public, outdoor function as a component of the urban space, something that had already been successfully tried elsewhere.

What had been attempted by the proud citizens of Pisa and by the illustrious and ambitious Guiscard in Salerno nevertheless found its continuation in the cosmopolitan and cultivated circle of the court of Frederick ("who was German by birth but Italian in language and culture") during the last years of the emperor's reign, through an intentional renaissance of Roman monumental inscription, with its distinctive lettering, spatial arrangement, and layout. During the Norman-Swabian era the practice of mounting epigraphic texts on religious monuments was quite common, but for the most part the expressive, graphic, and textual forms used corresponded more to the modern taste and format than to antique patterns.

The fortified gate of Capua (no longer in existence) built by Frederick II is a noteworthy exception. Here three large classical-style inscriptions surrounded the bas-reliefs incorporated in the structure, which had clearly been built in imitation of ancient Roman architecture. The same could be said of the inscriptions on the gold coins in circulation during Frederick's reign, the so-called Augustals, in which the lettering was borrowed from imperial models, or for the inscription carved in splendid antique capitals below the emperor's fragmentary portrait in Barletta. Also of particular interest is the inscription, Frederickan in inspiration if not manufacture, which was placed in 1238 on the monument created from ancient columns to house the remains of the Milanese Carroccio, which the emperor had taken at Cortenuova. This impressive inscription, with elegant lettering and a spacious layout, may be seen today at the Campidoglio. On the whole, here we are dealing with a short-lived phenomenon, which had very few consequences, since it had not yet begun when an inscription with strong Gothic tendencies was mounted on the Porta of Foggia. It had already ended ten years after the death of Frederick II, when Giovanni of Procida, in the name of Manfred, decided to commemorate the rebuilding of the port of Salerno with an epigraph that looked more like the page of a book than a monument in stone. In the judgment of Giovanni Battista De Rossi, writing some one hundred years ago:

During the thirteenth century, the reading and interpretation of ancient inscriptions was abandoned—they were of no use to anyone. The cause of this attitude, aside from the condition of literary studies, was that people could no longer read the ancient letter forms, for by now their eyes were used to the new form of writing known as Gothic.

Indeed, once the very brief antique-revival experiment of Frederick's era had ended, the range of functions and the uses of writing (in all its aspects) within the context of Italian society in the 1200–1300s came to be dominated by a single model: the scholastic book, whose compact material structure (functional to its use at the reading desk) and crowded Gothic letters made it a suitable tool for learning and for the dissemination of texts. It was a tool destined for supremacy in a world whose hierarchies continued to be organized according to cultural paradigms that were merely textual. Massive, elegant, and ornate, the Gothic majuscule used by Cimabue to write the names of the Christian nations in the cross vault of the upper church of Assisi between 1277 and 1280 in honor of Pope Nicholas III Orsini vividly represents the new fashion in writing. (See FIG. 10.) In comparison, the pale, vague, almost-invisible rounded majuscules *QULT* traced on the fronton of the Pantheon almost in memory of (rather than trying to imitate or repeat) antique capitals clearly symbolized the impossibility of reviving this form of lettering. There clearly was a break with a previous graphic tradition and with the formal meanings of that tradition, which had now become incomprehensible.

While the direct relationship between classic monumentality and letter forms was being lost, in the new inscriptions, public as well as private, indoors and outdoors, the appearance of a series of compressed and involuted letters based on capital, uncial, and minuscule forms, modified in their shapes and proportions and jumbled together in various combinations, grew more and more insistent. This script—known as Gothic—had first emerged in bookwork, where it was used as an alphabet for titles, beginning sections, and capital letters. When placed, or rather carved, on stone, it soon proved unsuitable as a functional graphic language for lapidary use. (See FIG. 11.) Cramped by mediocre or small size, abounding in abbreviations and special signs deriving from the traditions of bookwork, the Gothic majuscule alphabet, often transformed into elegant calligraphic spirals by doubling the letter strokes, came to impose the book-type format and layout on epigraphy and consequently forced epigraphy, previously used outdoors as ornament and language in the urban space, to retreat once more indoors, inside churches and other religious buildings.

The new monumental writing did manage, however, to find its own special context, namely, on the scroll-shaped bands used in the great fresco cycles and on the delicate frames of tumular floor stones. Both of these forms were meant to be placed indoors and read individually at a close distance; at any rate, they were associated with purely ornamental functions that at this very same time were being expressed by the Gothic capital on objects, embroidery, paintings on wood panels, and clothing.

The inscription that Dante imagined carved above the entrance to the Inferno was unreal not only because it was written in the vernacular and in tercet form but also because, like many inscriptions of this period, the length and formal organization of the text were far more suited to the page of a codex than to a slab of marble. This is also true of several civic Florentine inscriptions, two of which were mounted along the sides of the new cathedral in 1298 and 1331 and a third in Santa Margherita a Montici in 1304, in which the overall effect—from the opening words "signum crucis" to the end of its crowded twenty-one lines—reminds the reader rather of a document than a page of a book and that has nothing of the autonomous formal language proper to epigraphy.

In his *Rationale divinorum officiorum,* Guillame Durand extols the value of the physical building of the church in all its aspects but fails to mention display writing, thereby nullifying its meaning. It is significant that he virtually repeats with few modifications Gregory the Great's views concerning the use of sacred images as the written language of the illiterate. In pointing out the differences between the facade and the interior of the church, he mentions the sculpted figures adorning the facade but totally ignores the inscriptions, because in his religious, scholastic vision of written culture, every graphic phenomenon could inevitably be reduced to the text—that is, to the book.

A similar attitude is revealed in two other examples of what we may call the cultural-political program of the Dominican order in the period immediately following the mid-Trecento. In the painting *The Apotheosis of St. Thomas* (on wood panel) by a Sienese artist in S. Caterina in Pisa, and in Andrea Bonaiuto's frescoes in the Spanish Chapel of Santa Maria Novella in Florence, writing is portrayed as an internal and subordinate element, devoid of any autonomous expressive capacity, while the image of the book, open or closed, written or blank, assumes a role of extreme importance in relation to the central characters. Beginning in the second half of the Duecento, Gothic majuscule script played a secondary role in the new sepulchral monuments that began to abound in commemoration of the major figures in the history of the church. Framed in small rectangular tablets in close

written lines, writing became a mere decorative element in the overall architectural-sculptural design, in which its primary function was ignored and denied.

Dante died in 1321, but already before the close of the Duecento, the local exponents of humanism in Padua had rediscovered the ideal value of the classical epigraph and had mounted a Roman slab, inscribed with the name of an obscure freed slave who bore the name of the great Livy, on the wall of Santa Giustina. Meanwhile, Lovato Lovati, Albertino Mussato, and Rolando da Piazzola were attempting (though unsuccessfully) to give new space and a new roundness to the Gothic inscriptions now being carved on arches and tombs, combining the ancient with the new.

In the Veneto, an area steeped in vernacular and antiquarian culture, we should draw attention to the funereal and civic epigraphy of the Scaligeri, which was proudly exhibited outside and inside on sarcophagi and architraves, charged with obvious political significance. Shortly afterward in Rome, Cola di Rienzo became interested in the inscriptions of ancient Rome. "He spent the days contemplating the antique marble carvings lying about Rome. He was the only one who knew how to read their ancient inscriptions and often translated them into the vernacular." Cola's rediscovery of the great inscription of the "lex de imperio Vespasiani" (the law decreed by Emperor Vespasian)—rescued from the oblivion to which it had been condemned, rightly interpreted, and exhibited to the public eye in 1347, "displayed so that all might see and read it"—an excellent example of this new interest in the inscriptions of ancient Rome.

Saxl was thus apparently right when he stated that modern epigraphy has its origins in politics, and therefore it would seem to be correct to draw a parallel between the events that had occurred in the Italian communes during the eleventh and twelfth centuries with what was happening in Rome at the time of Cola di Rienzo and Petrarch. In reality, however, the revival of classical models in the communes had allowed writing, recognized as a vital tool for the assertion and communication of shared public and political values, to reconquer the urban space, whereas in Rome no one managed either to bring the newly rediscovered *littera antiqua*—the classical majuscule—outside again, or to adopt it freely in the creation of new models for monumental writing.

It was thus in another area that the revival of this tool of culture and the values it expressed could take place, a process that was already under way in the mid-Trecento. The area was that of book production and nonmonumental writing, where scripts dating from the Carolingian and post-Carolingian period were first viewed as mere media of transcription and

then gradually came to be considered formal models worthy of admiration and, somewhat later, worthy of imitation.

One of the great promoters of this movement was Petrarch, a man who, in his own words, "stood on the boundary dividing two peoples, looking both ahead and behind," and who highly praised Carolingian script for its clarity and elegance over the Gothic script of his time, though recognizing very great aesthetic value in the dense formal language of Gothic script. Petrarch, however, was unable to break away from the book-dominated graphic conventions of the period. In devising two marble memorial epigraphs for his nephew Francescuolo da Brossano, who died in childhood, Petrarch turned to the Gothic graphic tradition and book-style layout of the day. (See FIG. 12.) Yet, not too far off in the future, the time would come when the imaginative and inventive epigraphers of the Quattrocento, working in close relationship with the new holders of power, would provide monumental writing with new forms, new spatial relationships, and new urban settings.

Chapter Two

IMITATION, EMULATION,

CIPHER

I n the following passage of exceptional clarity E. Casamassima summed up some thirty years ago a graphic and aesthetic up-heaval that led scholars, artists, and practitioners of writing to introduce profound changes in the rules, standards, and forms of writing sanctioned by the past.

> From the majuscules of Poggio's codices and those of his fol-lowers, the *scriptores* of Niccolì's *littera antiqua,* which trans-lated into calligraphic forms a generic ancient epigraphic model, to the restoration of the capital alphabet in Florentine inscriptions during the second decade of the Quattrocento [see FIG. 13], the classical exemplar—more intuitively felt than faithfully reproduced and perhaps mediated through the use of Carolingian and Romanesque models—sprang to life again, with a great freedom of inspiration and in harmo-nious accord with early Florentine Renaissance architecture and sculpture. From the imitation in mid-century manu-scripts of the early Florentine manner used by sculptors and carvers to the faithful restoration of models belonging to the imperial era, through the work of copyists, antiquaries, and artists in Florence, Rome, and Padua . . . the revival of antique lettering—fostered by the exchange and mu-tual influence of epigraphy and bookwork, nourished on archaeology, determined by the prevailing artistic forms—continued with extreme variety for nearly a century and represented, as Burkhardt has already suggested, one of the most significant aspects of Renaissance figurative expres-sion.

This revival altered hierarchies, stylistic traditions, and relationships of pro-duction and of form, creating new rules for scripts and texts, new uses for writing, and new ways of diffusing it through a process that restored to cere-

monial monumental writing its autonomy and dignity, so that once more it occupied the highest rank in the scheme of graphic expression.

The first few decades of the Cinquecento in Italy witnessed a quick succession of events that had a profound impact on this process: the creation of a rigid hierarchy of letter forms; the resurrection of classical epigraphic capitals as a monumental script; the introduction of this script into the realm of literature through the intentional blending of two graphic systems—the epigraphic and the textual—that until then had been separate; the application of this new norm to the field of printing, which at first differed only very negligibly from its use in manuscript work; and the stabilizing of one particular hand (chancery italic minuscule) and its spread throughout ever-widening geographic and cultural areas. These events, which overlapped in a climate of reciprocal influence, formed the accompaniment to another significant development, namely, the creation of a vernacular grammar and the dissemination of this unique and unified language through writing by the learned and by the upper classes.

Just how much the existence and evolution of these events depended on the invention and spreading of printing is difficult to say, but it is certain that the printing press both directly and indirectly created a new type of audience. Readers now were moderately educated, though not scholars by profession, curious, and in search of new, varied experiences. Their relationship with the text was now more detached and distant than in the past, since they could by no means consider themselves as the potential writer of what they were reading. In this new relationship we also find a new vision of graphic elements, which were presented as formally homogeneous in the printed text, each element separate from the next, part of a hierarchy at the apex of which we find the antique-style epigraphic capital, the very same capital that could be seen in the inscriptions carved in public places and on public buildings and was indeed the symbol and the guarantee of solemnity. At the basis of this renewed ideological and aesthetic interest in the ceremonial nature of writing viewed as a system of standardized signs governed by fixed rules, we find a movement based on the imitation of the antique that imposed geometric consistency on the capital alphabet. Among the exponents of this movement were antiquaries such as Felice Feliciano, artists such as Mantegna, calligraphers and typographers such as Damiano da Moille (to whom we owe the first printed treatise on the subject, around 1480), mathematicians and philosophers such as Luca Pacioli (author of *Divina proportione,* published in 1509), and Sigismondo Fanti.

This movement brought about not only the geometrization of individual letters as was done in ancient times but also their rigid confinement in

square geometric patterns according to classical standards regulating the spacing of letters in stone inscriptions. Gradually rectangular or square spacing was imposed, along with fluted frames, text layout patterns, and line spacing, which were calculated according to geometric proportions clearly derived from ancient models. In those places where the need for a complex and rational use of the language of epigraphy was most strongly felt, because of either the presence of a specific cultural tradition or the inclinations of a particular artist, we find entire programs of graphic display decorating the interior and exterior of monumental structures. One example is the Tempio Malatestiano in Rimini, remodeled for Sigismondo Pandolfo Malatesta by Leon Battista Alberti with the collaboration of Matteo de' Pasti, where the interior and exterior are decorated with an organic series of commemorative inscriptions in classical epigraphic capitals. The large inscription running beneath the trabeation of the facade was probably inspired by a local Roman monument, the Arch of Augustus. Similarly, in Florence we find the splendid chapel of the young cardinal of Portugal by Bernardo Rossellino in 1460. Here, though in a completely different graphic style (i.e., the "Romanesque" Florentine capital), commemorative inscriptions appear both in the interior and on the exterior of the chapel, harmoniously arranged so as to create an overall graphic design parallel to the architectural and figurative one.

In the figurative arts of the Veneto, where men such as Giovanni Marcanova and Felice Feliciano were operating, the new (and antique) style in letter forms boldly asserted itself as a figurative element possessing its own aesthetic value. Iacopo Bellini copied classical inscriptions in his sketchbook, now preserved at the Louvre, and Mantegna used them in his Paduan frescoes as imitation intarsia to add antique flavor to the scenes he depicted.

Nor were only letters of the Roman alphabet used, but also (as in the case of the Tempio Malatestiano in Rimini) Greek letters, equally monumental and solemn and squared by means of the *ragione geometrica,* or geometrical method. The use of Greek letters was a clear sign of the bilingual tendencies of humanism in this period and, on an entirely different plane, stressed the absolute figurative value with which the geometric graphic standard was now endowed, as its application modified and ennobled any alphabet. This movement, which had arisen within an antiquarian circle molded by the culture of the book, now returned to the book and covered the pages of luxury manuscripts with antique-style graphic motifs in the form of titles, incipits, and excipits representing inscribed slabs and pillars, reproducing within the small dimensions of the illuminated page the layout, formal balance, framing devices, and cutting style of classical stone inscriptions, often

with surprising illusionistic effect, in which the use of color added a creative (though improbable) touch.

Between the end of the Quattrocento and the beginning of the Cinquecento, the image of the book, along with antique-style capital letters, became a major symbol in Italian pictorial arts, especially in the paintings of the Veneto school. Here we should mention primarily the paintings of Giovanni Bellini (Mantegna and Feliciano were also at work here), in which great care has been taken in depicting the book of this period in all its many forms. We can easily recognize the great liturgical tomes written in double columns of Gothic script, as well as those written in a humanistic hand. The bindings have been carefully reproduced, with close attention given to their dimensions, shape, and the color of the leather. Moreover, as Campana noted in 1962, in Bellini's paintings even the captions and signatures reveal vivid interest in the phenomenon of graphic interpretation as an aesthetic-figurative element, so that the appearance of an antique-style capital or a cursive italic is never fortuitous or insignificant.

A t the beginning of the last forty years of the fifteenth century, Rome, grand capital of the Italian Renaissance, became the center for the experimentation and display of every possible form of monumental writing and for many successive developments in the aesthetics of writing, which were adapted and displayed within the urban context throughout all its diversified structures. Rome would continue to play this role for centuries, although its range of influence gradually began to wane.

The rebirth in Rome (through imitation) of the monumental classical capital had been brought about by the northern, or Tuscan, popes—Nicholas V, Pius II, and Paul II—whose Italian and foreign calligraphers and illuminators trained in the new scripts masterfully combined the figurative language of ornate anthropomorphic, animal and plant forms with the graphic language of initials, title capitals, and the solemn, spacious rounded minuscules of the *antiqua* text. In Rome the production of the luxury humanist codex reached its height thanks to the lavishness of means and materials employed and to the Romans' great preoccupation with ceremony. This flourishing of the handwritten codex concurred rather than contrasted with the introduction of movable type and the printing of books in Italy, which first took place in Subiaco and later in Rome after the year 1465, the work of German craftsmen.

These were decisive decades in Rome for many reasons, aside from those already mentioned. The antique-inspired epigraphic capital began to appear on churches, on tombs, and in open spaces, sporting a new style character-

ized by elongated forms, thin strokes, and a harmonious relationship between different letter widths. One might have defined its style as airy and yet contrived, in which the more or less direct imitation of classic models could be most clearly detected in letters such as the *Y* and the *I,* taller than the other letters and used at the end of Roman numerals. It is difficult to identify the artist responsible for introducing this new style to Rome. If, however, the oldest known example of the new epigraphic lettering is represented by the tomb of Cardinal Ludovico d'Albret (d. 1465), erected in Santa Maria Aracoeli by Andrea Bregno, a Lombard artist who was among the most prolific sculptors active in Rome at the time, then most likely its originator was one of Bregno's collaborators. The inscription of this monument, which presents three different letter formats, displays new harmonies in shading and an innovative relationship between lettering and architectural-sculptural masses.

Within a short span of time these developments, together with the flourishing production of the Roman luxury codex, gave rise to features that were to become characteristic of Roman urban epigraphy, especially in the monuments commissioned by Sixtus IV or erected during his pontificate (1471–84). The two splendid papal bulls proudly mounted on the facade of Santa Maria del Popolo in 1472 seem to inaugurate this new phase, as does the inscription drafted by Bartolomeo Platina (a humanist who was prefect of the Vatican Library) and mounted in 1475 on the new bridge across the Tiber destined to bear the pontiff's name. (See FIG. 14.) In this inscription, the empty and full spaces, the graceful strokes of the letters, the archaic motifs (e.g., the linking of the letters *NT*), and the ornate frame contribute to create a superbly elegant effect.

Sistine epigraphy found wide application in Rome for many decades. Examples include the tomb of Cardinal Niccolò Forteguerri (d. 1473) in the vestibule of Santa Cecilia and the tomb of the captain and commander Antonio de Rio (d. 1475) in Santa Francesca Romana. (See FIG. 15.) When compared with the tombstone of Ottone Del Carretto (the Sforza ambassador who died in Rome in 1465), which is engraved in impure capitals, de Rio's tomb reveals how far the new epigraphic style developed in ten years. Still other examples include the Greek and Latin inscription that Platina designed for his brother and for himself in Santa Maria Maggiore (1479); the tomb of Giovanni della Rovere (d. 1483) in Santa Maria del Popolo, a church dear to the epigraphic excesses of the family's pope; and finally, the great curving inscription mounted on the tower of the Fort of Ostia by Giuliano della Rovere (the future Julius II), carved on ten marble slabs with letter forms modeled on the Trajan style, as Roberto Weiss has noted. Nor

should we overlook the famous fresco by Melozzo da Forli, celebrating the founding of the Vatican Library by Sixtus IV in 1475, which is accompanied by an epigraphic caption whose format, lettering, and framing resemble the inscriptions cut by Bregno's school.

In our discussion of Sistine epigraphy, the paintings of Perugino deserve special attention. In his fresco *The Donation of the Keys to St. Peter* in the Sistine Chapel, the two symmetrical representations of the Arch of Constantine exhibit inscriptions honoring the pope, written in gold letters on a blue background. This use of color in the rendering of epigraphic detail is very characteristic of Perugino and would seem to be inspired by purely pictorial, even miniaturist concerns rather than by antiquarian ones. Similar treatment may be found in his famous cycle in the Collegio del Cambio in Perugia at the close of the century.

At this point we should pause to consider a new phase in the revival of ancient graphic styles then taking place in Rome between the fifteenth and sixteenth centuries. It involved two significant developments: first, the creation of a new and more substantial relationship between the lettering of inscriptions and the architectural structures in which they were included, so that lettering, previously a subordinate element, now became supreme; and second, an ever-growing tendency toward Greek and Latin bilingualism, already visible as a decorative element in Mantegna's frescoes.

A new type of dislocation between figurative mass and sections of writing had already been attempted by the Bregno school in two splendid funerary monuments erected in Santa Maria sopra Minerva: the tomb of Cardinal de Coca (1477; see FIG. 16) and the tomb of the Florentine Diotisalvi Nerone (1482). In the former, part of the inscription, which is divided in two sections, has been carved on a long undulating cartouche, which disturbs the harmony of the line. In the latter, a cartouche with a Latin inscription is inserted in the lower part of the complex, flanked by two relatively empty slabs inscribed with mottoes in Greek.

Shortly afterward, Rome witnessed the development of a new design in funerary monuments that would meet with great success, consisting of an inscription and a bust of the deceased, done in relief and either placed in a niche or free-standing. Famous examples of this new fashion include the Sarti tomb in S. Omobono (the ancient model from which the sculptor probably drew inspiration has been identified by Williams), the two tombs in antique style of the Bonsi brothers in San Gregorio al Celio (see FIG. 18), and the two Pollaiolo tombs in San Pietro in Vincoli, which have been attributed to the Lombard sculptor Luigi Capponi.

Thus between the fifteenth and sixteenth centuries, Italian Renaissance epigraphy, clothed in the rediscovered and reelaborated antique style, was busily conquering outdoor urban space, boldly appearing on the facades of buildings and churches, weaving itself about the city, dividing and accenting its surfaces. In Urbino, Guidobaldo I had a majestic inscription in monumental capitals, full of ornamental flourishes and fanciful and highly stylized signs separating the words, carved on the four walls of the courtyard of the palace built by his father. (See FIG. 17.) Meanwhile in Naples, Pontano had decorated the facade and flanks of the tomb erected in memory of his wife, Adriana, with dense inscriptions in which great pains have been taken to imitate classical lettering, thus creating an exemplary and famous model of this new fashion. In Rome, the house of Lorenzo Manilio at the Portico D'Ottavia was adorned with a long, external, and significantly bilingual inscription in two different sizes of letters, which were carved directly on the wall itself. (See FIG. 19.) This inscription shows great precision in its proportioning and in its cutting technique and generally creates a much cleaner and starker effect than the more delicate Sistine style. To conclude, we must mention the large and impressive inscription along the cornice of the *piano nobile* (upper floor) of the Palazzo della Cancelleria (1495), where the interplay of the letter forms seems to set the first floor apart from the long facade, as well as the inscription in pure classical design by Bramante in the cloister of Santa Maria della Pace, dating from 1504.

Sistine epigraphy arose and developed in antiquarian Rome between the fifteenth and sixteenth centuries under the ambiguous banner of imitation. Indeed, the entire search then being conducted for a new standard and a new formal code for monumental writing took the form of a complex and more or less calculated operation of restoration, reelaboration, and renewal of ancient graphic models. The motives, means, and results of this process must be sought beyond the narrow limits of the inscribed stone surface. They may be sought, for example, in the *Hypnerotomachia Poliphili* by Francesco Colonna, printed in 1499, and the *Epigrammata antiquae Urbis* by Mazzocchi, printed in 1521, two books that were both very Roman indeed, even though the former was printed in Venice and its author was long thought to be of Venetian origin if not inspiration. In the *Hypnerotomachia,* "imaginary inscriptions imitating the antique are found on nearly every page." (See FIG. 20.) There are over seventy inscriptions in Latin, Greek, and even in rather fanciful hieroglyphics, which are printed in majuscule characters and inserted in woodcut illustrations depicting daring or conventional architectural settings. In the text great care has been given to the appearance of the letters, which have been very handsomely rendered—al-

most excessively so. According to the commentary in the text, the letters are *eximie* (noble), *egregie* (excellent), *perfecte, elegante, exquisite, veterrime* (illustrious), *excavate exquisitamente* (exquisitely carved), and *mensuratissime* (well proportioned). In Colonna's cultural message, the contrived and indirect vision of the classical world could not be severed from a formidable epigraphic presence that was as polyvalent in meaning as it was plurilingual and that also represented an absolute standard of graphic elegance. This was to be achieved through the imitation of the antique (at least that was the intention), but the result was quite the opposite. The long series of *exempla ficta* furnished by the text ends up being a rather anomalous creation, extremely imaginative in text, layout, and lettering.

The relationship between book and epigraph evidenced in the Mazzochi collection, which is rich in meanings at many levels, is much more immediate and direct. This collection, which imitates the squarish woodcut illustrations of the Poliphilus inscriptions, testifies to the coming of age of the science of epigraphy and also represents the conscious attempt of Renaissance culture to master the complex network of relationships existing among display writing and monument, architecture and inscription, lettering, sculpted mass, and empty space. This was the relationship manifest in antique epigraphy that Mazzocchi attempts rather awkwardly to re-create, sometimes inserting inscriptions on the woodcut illustrations of arches, aqueducts, and columns where they really appeared, but at other times arbitrarily framing the text in purely imaginary settings, in the fanciful fashion of Colonna. This is yet another indication of the underlying ambiguity that pervaded the Roman (and Italian) theory and practice of using archaeological sources as models for graphic styles.

Another important book that made its appearance in antiquarian Rome was the *Antiquitates,* published on the eve of the sack in 1527 by Andrea Fulvio, with whom Raphael had collaborated a few days before the artist's death, as the author tells us. Indeed, we must locate Raphael at the center of a lively and influential movement that brought the classical graphic standard into the composition schemes of painting at that time in obedience to intentions that in Raphael were firmly rooted in a deep appreciation of the antique and in a vast experience of antiquarian matters.

In the paintings of Raphael (who, after all, was heir to Perugino), the feeling for writing and for the book as figurative elements is quite strong, and his painstaking, almost philological treatment of varied kinds of graphic products is particularly striking. Thus we find Pythagoras in the Stanza della Segnatura writing in an oblong book that resembles an arithmetic primer, while cursive script appears on single sheets of paper, and scientific texts are

portrayed as massive objects of large format. In Raphael, however, the capital is always purely classical and is rendered in the antique fashion, in epigraphic captions. Or, as we find in the Stanza della Segnatura, with one exception it appears on *tabellae ansate* (tablets with handles on the side), in pure classic style arranged horizontally. The graphic display in the fresco *Sybils* (1514) in Santa Maria della Pace is even more complex, based on an interweaving of antiquarian motifs and Latin and Greek texts inscribed on oblong, rectangular slabs. Likewise the large engraving by Marcantonio Raimondi, the *Quos ego,* which shows five inscribed cartouches, has a very Raphael-like flavor. Nor must we forget that Raphael wrote a very elegant italic cursive characterized by very thin and mannered letter forms.

In Venice between the Quattrocento and Cinquecento, monumental epigraphy developed in connection with the decoration of the large tombstones that paved the floors of the city's churches, following a medieval tradition that resisted the assimilation of imitation classical motifs and was unable to adapt to the new fashion. Yet, in the early Cinquecento new graphic and aesthetic elements began to appear in these inscriptions and reveal a relatively direct relationship with the then-flourishing industry of book printing. While maintaining the traditional format, which naturally enough resembled the page of a book, these tombstones gradually acquired ornately decorated frames accented by squared corners that began to resemble the framing devices of the woodcuts used at that time in Venetian typography. (See FIGS. 21–23.) The space within the frame was divided by four metallic or marble medallions that resembled the bosses used in fifteenth-century bookbinding. The lines of the text of the inscription were often arranged so as to create geometric patterns (triangles, amphoras, lozenges), which at that time were common in book printing at first for colophons and later for titles.

In contemplating these epigraphs, the viewer is inevitably reminded of the cover or title page of a book, and it is reasonable to suppose that if late fifteenth-century Venetian book design, in all its elegant simplicity and imaginativeness of form, furnished Venetian epigraphy with a model for the following two decades, then it is also quite reasonable to suppose that the splendid Venetian epigraphs of the early sixteenth century likewise offered book design a variety of new ideas that the printed book, in search of a definite identity, adopted for its title pages and covers during the High Renaissance.

In Venice the relationship between the new printed book and monumental epigraphic writing expressed itself in much more contradictory ways than it did in Rome, even if, through a process of reciprocal influence, it

provided ideas that were entirely new to both typography and epigraphy in an almost total autonomy of imitation and archaeological borrowing. Meanwhile, in the years 1528–30 Falconetto constructed the huge Roman arches of the Porta S. Giovanni and the Porta Savonarola in Padua and decorated them with superb, classically inspired inscriptions.

Thus the book form guided by epigraphy now became monumental, and it became so through imitating the layouts of Venetian funerary inscriptions, thereby transforming imitation classical monumental writing that had been revived by the epigraphy and the antiquarian tendencies of the late Quattrocento. In contrast, in areas such as Venice, where the classical model and the method of pure archaeological imitation had been rejected, epigraphy began to recognize the growing supremacy of the book as an absolute standard that was gradually conquering the whole of written culture. An example and manifesto of this new trend is *Le imagini delle donne Auguste intagliate in stampa di rame,* one of the most successful works of the engraver Enea Vico, published in Venice by Valgrisio in 1557. In this collection a splendid epigraphic title page is followed by a series of engraved plates in which writing has been skillfully inserted in antiquarian-inspired figurative designs (appearing on coins, tablets, and elsewhere), forming a handsome accompaniment to a complex manneristic decor of drapery, sphinxes, festoons of fruit, and masks.

In general it should be said that in the early Cinquecento, Colonna's subtle and ambiguous references and his free use of epigraphy as an element charged with ornamental and allusive meaning seem to open the way for more complex functions of monumental writing, just at a time when the growing role of writing on monuments began to demand even greater space indoors for its expression. It now appeared on or near the great fresco cycles, on ceilings, along staircases—in every environment that had been ennobled by figurative or symbolic decoration. At the very moment when the adoption of the classical standard was threatening to crystallize the function of monumental writing in fixed forms in every graphic and artistic manifestation, the extensive and unconventional use of display and monumental writing adapted itself to the needs of the moment and to the requirements of different techniques, bending to the whims, stylistic inclinations, and ideological-cultural tendencies of artists, literati, and patrons. As a result, monumental writing now achieved a new relationship with space and enjoyed a totally new autonomy of expression while exploring new forms and new layouts and launching new dialogues with the public.

It is most significant that in the Stanza della Segnatura, Raphael resorts to a device charged with symbolic meaning that would later become charac-

teristic of baroque monumental epigraphy—that is, the partial concealment of the text, which in this case has been covered over by figurative elements, thereby challenging the reader to an erudite game of interpretation. The explosion of emblematic literature based on the combined impact of image, text, and script was at the door, but Poussin's *Et in Arcadia ego* was still a century away.

One of the episodes (perhaps we should say intermediaries) that were at the basis of these new and fertile experiments in monumental writing was the current literary vogue for emblems, born of the interweaving of scholarly traditions of varied origin (which, at the root, were all humanistic), inaugurated in 1531 by the publication of a book by Andrea Alciato that presented a series of Latin mottoes accompanied by a picture and an explicatory epigram. Quickly spread by the printing press to a relatively vast homogeneous public united by a common culture of classicist formation, emblematic literature fulfilled an important social function in that it allowed a large portion of the urban aristocracy and middle class to acquire a knowledge of heraldry and a common ideological language through the aid of simple and effective expressive tools. Furthermore, it induced the intellectual and cultural leaders to increase their ideological and practical dependency on the enhanced social dominance of the aristocracy and also furnished the theoreticians of the Counter Reformation—in particular, the Jesuits—with a very immediate means for propagating a compact code of values within the ruling class and for transforming single members of that class, whether individuals or collective, into spreaders of the word.

The emblem, which appeared not only in printed anthologies but also on public and commemorative buildings and structures, initiated a much more complex relationship between writing and image. Writing was dismantled into various parts (e.g., motto, epigram, note) and began to appear within the image itself. Letters maintained their graphic legibility, but the meaning of the message was obscured and its deciphering rendered arduous. In this way the Renaissance graphic tradition (which had been founded on the rediscovery of letter forms distinguished for their exceptional clarity) was respected, although only formally speaking. At the same time a contorted process was set in motion in which the reader's critical intelligence, challenged by the game of allusion, was continually given opportunities for self-gratification as it cleverly decoded the message transmitted through an obscure language that a host of obliging functionaries hastened to explain to the masses, as Ripa did with his detailed encyclopedia of emblems, first published in 1593. In the end, the development of the emblem would bring about the discarding of the fixed geometric graphic scheme based on the

classical model and would encourage a general tendency to experiment with different letter sizes and different modes of expression, even at a purely formal level.

A couple of years before the publication of Alciato's collection, Giulio Romano had decorated the Sala delle Imprese in the Palazzo del Tè (1527–29) in Mantua with a profusion of ribbons inscribed with mottoes in praise of his noble patrons. Likewise, in the other rooms (e.g., the Sala di Psiche) painting and writing were nobly combined in the aristocratic rite of heraldic decoration.

An analogous but more complex episode took place around 1560 near Rome at the Villa Farnese of Caprarola, where the Zuccari brothers, working under the direction of the renowned scholar Annibale Caro, provided captions for the great commemorative cycles celebrating the glory of the house of Farnese with intricate cartouches (which in the scholar's instructions were defined as tablets, or signs) of an epigraphic nature, covered with mottoes and heraldic symbols. Meanwhile in Bologna, the aristocracy of the city had begun to decorate the Palazzo dell'Archiginnasio (completed in 1564) with signs and family mottoes, gradually invading the interior of the building in a process of appropriation that was officially regulated in 1574 and that would continue for centuries, creating a vast and varied display of epigraphs in wood, stucco, and marble, variously painted, gilded, and carved.

A handsome combination of graphic and figurative elements may be found in the large cycle of emblematic frescoes painted in 1589 by Pomarancio and Antonio Tempesta in Santo Stefano Rotondo in Rome. These works follow an ideological-didactic scheme provided by the Jesuit Michele Laurentano and were published soon afterward in book form, illustrated with engravings by Tempesta and printed by Giulio Rossi as *Emblemata Sacra S. Stephani Caeli montis* . . . (Rome, 1589).

In contrast, almost in opposition to this allusive, book-oriented display writing, in the major Italian cities during the second half of the Cinquecento, there appeared on many civic buildings (on doors, forts, and public palaces generally) conspicuous monumental plaques in large format, with brief inscriptions containing specific references to the building's particular civic function. This practice, rich in expressive and evocative power, continued into the Seicento. Examples include the Porta Palio in Verona by Michele Sammicheli, decorated with two symmetrical plaques in 1557; the Porta del Popolo in Rome, with its plaque by Palatino, which we will discuss later; the Porta del Molo in Genoa, surmounted by a large plaque that resembles a proud seal stamped on the door itself; and finally the large

plaque placed by constable Filippo Colonna on the Roman palace of Pius IV in via Flaminia, which enchanted the poet Leonardo Sinisgalli with its absolute "harmony of the whole" (see FIG. 24). In this inscription the large format of the writing space, the smooth whiteness of the surface, the delicate framing, the layout of the text, and its central position on the monument are all characteristic of the new trend and have been designed to create complete, global legibility of the graphic artefact.

By the end of the sixteenth century, monumental writing now reigned supreme, allusive and explicative, slave to the image and yet prevailing over it, enclosed once more inside buildings and churches, essential to the delineation of architectural space. Through its influence, the entire code of rules governing the rhythms and functions of epigraphy had come to be modified through a series of episodes and developments that had occurred on quite different territory.

Chapter Three

SEARCH FOR A STANDARD AND

THE NEGATION OF WRITING

Telltale evidence of this complex process of tension and modification may be found in the life and work of Michelangelo Buonarroti, whose contradictory relationship with writing first began in 1488, when at age thirteen he went to study at the workshop of Ghirlandaio, and ended with his death in Rome in 1564. This entire arc of time represents a period of transition between two very distinct stylistic phases in the history of monumental writing: the phase of humanistic imitation, and that of mannerist invention.

Born of merchant stock into a family for whom writing served the purposes of business and trade, Michelangelo as a child learned the commercial hand, *mercantesca,* which he later abandoned for the chancery italic hand of unified humanistic culture. Thus he personally experienced the conflict that had cleaved the entire literate minority in two at the turn of the century—a conflict that was not only graphic but also cultural, linguistic, and social. Deeply rooted in the Florentine tradition, Michelangelo never acquired the habit of using the *antiqua*-style capital nor the taste for it. On one of his youthful sculptures in wood, a *Christ,* we find a trilingual inscription in which the elongated forms, the fine and delicate strokes, and the uneven layout echo the Romanesque models common in Tuscany at that time.

In old age he stated that writing was not one of his arts and that it had caused him much worry, and yet he used it profusely and understood its great social importance. It is significant that he insisted that his nephew Leonardo learn to write a legible and elegant hand. Michelangelo's letters and his transcriptions of his own poems reveal extreme care in the execution of an italic hand that was one of the most regular and characteristic of his time. Aside from this very acute understanding of writing as a tool of expression, Michelangelo also had a profound awareness of the aesthetic value of signs and of all graphic products, an awareness that stemmed from his deep appreciation of antique art, as we know from the *Dialogues* of Francisco de Hollanda.

And yet for all his humanism, Michelangelo never contributed to the re-vival of *antiqua*-style monumental script. If we examine his inscriptions on the ceiling of the Sistine Chapel (1508–10), we will see that they depict molded wooden plaques that seem to hang suspended from the overhead structure and are most definitely not epigraphic. (See FIG. 25.) Though the plaques inscribed with the names of Christ's forebears are meant to represent marble inscriptions, this effect has been created in a rather indirect and am-biguous way, achieved through a pictorial contrast of tone.

It is especially in the great architectural works undertaken by Michelan-gelo between his full maturity and extreme old age that his concern with the norms of monumental writing reached its high point and was resolved through a series of unique and innovative solutions. On the tomb of Julius II, which may be seen today in its reduced form in San Pietro in Vincoli, there are no inscriptions. The blank surface space was probably meant to be left empty, as it was left in the Medici tombs in San Lorenzo in Florence, where the sarcophagi and the sectioned wall structure display vast surface space that for centuries has remained unmarked by graphic signs, despite whatever the patrons may have originally intended. This process reached its most perfect equilibrium in the alternating of empty and full spaces in the Laurenziana Library, where not a single inscription appears.

Thus in an era when monumental writing was invading monuments and architectural spaces, Michelangelo refused to recognize its function or to adopt it, even in those contexts where it would not only have been legiti-mate to use it, but also opportune or even necessary. This is most likely due to his disinterest in the Roman stylistic tradition of imitating classical letters, a disinterest that enabled him to sense the growing contradiction between the schematic rigidity of the imitation classical epigraph, with its hard frames and immobile flatness, and the turbulent pathos to which he gave life in his sculpted forms and architecture. Rather, the use of another innovative architectural element must have seemed to him far more expressive: blank epigraphy, emptied of its writing and reduced to a pure and simple plaque, surrounded and outlined by a frame in stark relief, which enhanced the effects of shading in a way that no monumental writing of the period (Pir-anesi was still to come) could have done. Here the observations of Michel Butor, though uttered in an entirely different context, may be relevant: "The absence of writing from a place which has been prepared for it be-comes a nostalgia for a vanished state of things, and yet is also the expression of a void, of an incapacity of our language, and thus an invitation to a new decoding, and to a new text."

In 1539 Michelangelo selected the definitive location for the statue of Marcus Aurelius in the Campidoglio (see FIG. 26), and later in 1546 arranged the display of the fragments of the recently discovered marble tablets inscribed with the names of the Roman consuls. For both projects he found new and daring solutions. Michelangelo's inscription for the antique equestrian monument was carved on the curved surface of the pedestal, which modified the aesthetic balance of the letter forms, detracted from legibility, and, most important, broke with the rigidity and flatness of the imitation classical epigraph. The fragments were mounted with pictorial flourish and caprice in the framework of a totally extraneous architectural structure.

Rome in the meantime was experiencing a burgeoning of studies on the subjects of monumental lettering and handwriting. In 1540 Giovanni Battista Palatino, a Calabrian who had found his niche in the cultural circle of the Farnese family, member of the Accademia degli Sdegnati and dilettante antiquarian, published a book entitled *Libro nuovo d'imparare a scrivere tutte sorte lettere antiche et moderne,* an unusual book, very different in spirit from those of the true professional calligraphers Arrighi and Tagliente but destined for great success. Its popularity gives us proof of the keen and widespread interest in graphic phenomena during that time. Among the styles illustrated in Palatino's *Libro* (which was reedited and reprinted many times), we also find a monumental capital based on one of Arrighi's models. However, it is most especially with the work of Ferdinando Ruano, the Spanish *scriptor* of the Vatican Library after 1541 and associated with Cardinal Cervini, that we witness a return to the systematic study of epigraphic capitals based on antique models. In his treatise *Sette alphabeti* published in Rome in 1554, Ruano informs us that he has "measured and studied the antique letters that may be seen in many places in Rome" and, in connection with this, even mentions having consulted an "enchained" codex of Virgil at the Vatican, the Vat. lat. 3867, dating from the early sixth century, thus admitting that he had consciously merged two graphic styles of an entirely different nature (the so-called rustic capital of calligraphy and the carved capital of epigraphy), clearly signaling that he had begun to move toward a relatively profound modification of traditional models.

Between 1544 and 1548 the Sala Paolina in the Castel Sant'Angelo was decorated with frescoes celebrating Pope Paul II painted by the workshop of Perin del Vaga. Above the complex scene a splendid inscription was carved and gilded in large capital letters in which the slightly curved *X* and the twisted tail of the Q echo models found in bookwork and are reminiscent of the letters in Ruano's manual. Furthermore, they would seem to be

an expression of the close ties existing between curial Rome and the rebirth of artistic epigraphy and of learned antiquarian epigraphy during this period. (See FIG. 27.) In Rome in the years 1562–63, a large inscription was mounted on the facade of the Porta del Popolo in celebration of Pius IV. This inscription had great ideological and urbanistic significance, both because of its message, which was addressed to everyone entering the city, and because of the solemn place it occupied, for it rather resembled an official seal stamped on the city walls. It was was designed in 1564 by Palatino, "writer of antique Roman letters" of the commune of Rome, and although it follows in the classical tradition, it represents a conspicuous striving toward the monumentalization of graphic signs in as yet untried dimensions with stark shading effects, varied V-cut depth, and diversified letter size.

In these same years the need to modify the formal canons governing the use of antique letter forms found even greater expression in two series of monumental inscriptions mounted on the newly constructed Palazzo Spada and the Casino of Pius IV in the Vatican. The facade of the Palazzo Spada is lavishly decorated in the antiquarian style, crowned by a series of eight plaques interspersed between the windows on the top floor, where the inscriptions are lettered in relief. (See FIG. 28.) The facade of the Casino of Pius IV, designed with great charm and imagination by the archaeologist Pirro Ligorio, bears two inscriptions. The main inscription is in stucco letters in relief; the secondary one is engraved, consisting of a single line. In both the Palazzo Spada and Casino specimens, writing, projected outward by the bold use of relief, acquires a far greater expressive potential in comparison with the typical inscriptions of the period, which were rendered through the opposite technique of V-cut incising. The writing participates dynamically in the general movement of mass and shading created on the surface of the facade by rich ornamental and sculpted detail.

We do not know if Michelangelo ever saw the work of Palatino, whose rigid chancery cursive his own hand closely resembles, or if he was familiar with Ruano's work. Most certainly, however, he was familiar with the innovative stylistic solution offered by relief epigraphy, which he boldly used in the inscribed stones on the internal facade of Porta Pia, creating an entirely new and innovative effect. (See FIG. 29.) This was his last architectural work, undertaken when he was well over eighty years of age. The fine-line inscription on this structure, which has been described as "the most baroque" and as "the most deliberately anticlassical in the architecture of Michelangelo," is cut deeply on a block of thick travertine, has no frame, and appears to be suspended in the void above an ornamental festoon fastened to two protruding volutes. In the overall effect, the inscription enjoys a po-

sition of supreme dominance, quite a novelty for Michelangelo, and is particularly impressive when viewed from below. At the same time, the graphic insert with its decidedly accentuated formal rhythms is part of a general harmony of empty space and mass dramatically enhanced by the stark contrast created by the two blank and heavily framed plates below.

Chapter Four

URBAN EPIGRAPHY IN THE

MONUMENTAL CITY

I n 1560 another scribe of the Vatican Library, Giovan Francesco Cresci, published a new manual on the art of writing that represents a turning point in the graphic tastes of the time, for the new models presented in this treatise would soon replace all previous ones. Cresci, whom some have described as the first baroque calligrapher, created a new canon for chancery script on the basis of a heightened and more functional awareness of cursive script, on a greater fluidity of stroke, and on the prevailing of the decorative aspects of graphic signs over their structural ones. This change was justified on the theoretical plane by the rejection of fixed rules and by the exalting of the role of the writer's eye and imagination, the very same trends and ideas expressed in the art of the period, for which Vasari was both spokesman and supporter.

It is difficult, however, to recognize these principles in the antique Roman majuscule included in Cresci's manual, which the author claims to have drawn from ancient models. ("My master was the tribunal of these Roman antiquities, where we may see the true art and form of these majuscules.") Instead, his capital alphabet shows "a complete freedom from earlier calligraphic models," and even from the classical models that have filtered through here deeply modified by the refined and watchful influence of mannerism. As Casamassima has stated: "In the proportioning of certain letters—most especially the M, N, and Q—which is different from the proportioning of classical or traditional Renaissance models, in the tilting of the forms, in the tapering of the curves, in the use of thin, slightly concave serifs rounded at the ends, we may recognize the late mannerism of architecture and sculpture."

With Cresci a new standard was born not only for cursive script but also for monumental capitals, a new standard that corresponded to the change in artistic taste and that modified the structure, proportions, and shape of letter forms. However, this new standard also rejected the use of revolution-

ary techniques that might have been adopted by a Pirro Ligorio or a Michel-angelo.

Cresci's innovations came to be welcomed by Roman epigraphers only very gradually. The enormous stone mounted by Alessandro Farnese on the internal facade of the Church of Gesù in 1575 virtually ignored this new development, instead displaying a formal equilibrium already attempted in the inscription on the Porta del Popolo. (See FIG. 30.) The large plaque with the grayish frame on the tomb of Pius IV erected in 1582 by Alessandro Cioli in Santa Maria degli Angeli represents the only concession to the new fashion. (See FIG. 31.) At this time, the search for new techniques and new materials grew more intense. Tomb inscriptions were engraved on red and black stones, and texts began to appear on curving cartouches and sculpted drapery, thereby breaking with the convention of the straight, horizontal line. Carved letters were gilded, while others were cast in bronze or copper and attached to marble backgrounds. These were all rather new develop-ments that had not yet come to be part of the prevailing taste for either public or private patrons. They nevertheless anticipate the basic features of baroque monumental writing and were already present in the unique sepul-chral stone commemorating Francesco Maria I Della Rovere (d. 1538) erected by the young Bartolomeo Ammannati (as Vasari tells us) in Santa Chiara in Urbino. (See FIG. 32.) On this monument we find a large, pol-ished slab of red porphyry inscribed in gilded bronze letters (the text of the inscription is by Bembo) arranged in page fashion, obviously patterned on the illuminated book. This daring and novel experiment had no immedi-ate successors.

Cresci did not remain isolated, however, and his stylistic suggestions were not launched into a void. In a later treatise that was both theoretical and practical, entitled L'idea per voler legittimamente possedere l'arte maggiore e minore dello scrivere, published posthumously in Milan in 1622, he listed a large number of his own disciples, many of whom were working in Rome for the Vatican Library, the Sistine Chapel, and the Vatican Chancellery, places that in the last quarter of the century had become the center for the new experiments in graphic style, which were characterized by a growing free-dom from antiquarian influences and by a search for a new formal equilib-rium. It was in this very period that the science of classical epigraphy came to be recognized as a historical discipline in its own right, no longer merely part of the study of antiquity, through the efforts of scholars, bibliographers, and philologists such as Guglielmo Sirleto, Onofrio Panvinio, and Fulvio Orsini. This new development consequently posed a more rigorous, chro-

nological, and detached perspective on antique graphic models, which automatically lost some of their appeal as absolute formal standards, which they had directly or indirectly exercised before that time. Meanwhile, the founding of a printing establishment at the Vatican (1587) by Sixtus V and the subsequent production of official monumental works printed in specially created characters made the book once again the central focus of graphic experimentation and gave rise to a search for new standards for movable type.

Among Cresci's disciples was Luca Horfei of Fano, scribe of the Vatican Library and the Sistine Chapel, whose name is associated with an important development in Rome in the use of monumental inscriptions as a commemorative and ideological tool, a development that had had many illustrious precedents. This was the widespread use of Sistine epigraphy in Sixtus V's vast urban reconstruction program. The ideal Renaissance city (and especially the capital of the state) was characterized by long, straight streets, wide regular spaces, uniformity and repetitiveness of structures, lavish use of commemorative and ornamental elements, and maximum visibility from both a linear and a circular perspective.

Inspired by this ideal, Pope Sixtus V undertook a colossal urban reform project in Rome that brought about the creation of several major routes of communication and of some focal points of convergence, which were marked by obelisks and columns. This whole enterprise was perhaps partly motivated by the pope's hankering for self-glorification, since quite a good deal of it revolved around Villa Montalto, his personal residence, but it was also the proud affirmation of the universal supremacy, not only of the pontiff, but also of the Roman Catholic Church and the holy city of Rome. This was the intent to be expressed publicly in the new urban disposition, in each of the individual architectural works, and above all in the epigraphs that were to be exhibited in the very places and on the very buildings that represented the artistic culmination and the magnetic center of the new order. Indeed, those places that had been selected according to a most "ecclesiastical" logic, which was also distinctly Roman, were destined to welcome hoards of the faithful flocking from all over Europe and to convey to them very specific messages clothed in signs and symbols. The task of creating and producing in a brief span of time such a great number of ceremonial inscriptions suitable for diverse architectural and spatial situations and yet conforming to a common logic with few stylistic discrepancies was indeed no small task, and it is most remarkable that the engravers and artists of Rome and especially those of the Curia school were able to tackle it with admirable consistency, producing at times inscriptions of great power.

The architectural aspect of this immense epigraphic program was handled by Domenico Fontana. Credit for its success, however, must go to Luca Horfei, direct disciple of Cresci, whom we have already mentioned. A man of vast and varied graphic experience, skillful scribe of the huge Sistine musical codices, in which he masterfully alternated various formats of Gothic, *antica tonda,* and chancery cursive, Horfei elaborated a style of epigraphic capital that he claimed was based on classical models but that in reality was derived from more modern ones.

Compared with the work of his master, Cresci, Horfei's work is slightly lacking in uniformity and consistency, but it is striking for its eclectic variety of materials and techniques, which include white marble plaques, carved and gilded black marble slabs, the use of framed or unframed layouts, and plain gray stone blocks. Horfei informs us that he was personally responsible for fifty or so inscriptions designed and mounted throughout Rome (plus two in Civitavecchia) between 1585 and 1589, and certainly he was responsible for quite a few more after this date. Some of the more impressive ones notable for their expressive and ideological value may be seen on the obelisks erected throughout the city by Sixtus V, including the inscription on the obelisk in Piazza San Pietro dated September 1586, the one on the obelisk in front of the apse of Santa Maria Maggiore carved in the summer of 1587 (see FIG. 34), the one in San Giovanni Laterano dated 1588, and the one in Piazza del Popolo dated 1589, all of which contain rather complex texts that posed the technical problem of carving directly on antique granite without having to resort to the use of some other background material or ornamental framing. (The texts of the last three were drafted by Cardinal Silvio Antoniano, theoretician of the Counter-Reformation.) Horfei solved this problem at times by exploiting the effect created by the use of very long lines and at other times by relying on a single and extremely brief inscription. He abandoned the idea of gilded lettering after his first unsuccessful attempt (the Vatican obelisk), during which he discovered that the use of gold lettering on the gray surface of the Egyptian stone detracted from rather than enhanced the text's visibility and legibility.

Extremely aware of the aesthetic and expressive function of epigraphy in a monumental context and thus conscious of the need for constant flexibility in its formal and structural aspects, Horfei also designed and engraved inscriptions that were quite different from the ones he had done for the Sistine obelisks—for example, the traditional and rigidly framed inscription on the Porta Furba or the one on the Porta Tiburtina (both dating from 1585), or the enormous inscription that dominates the Fontanone dell'Acqua Felice in Piazza San Bernardo (1587). (See FIG. 35.) Likewise, the large

inscriptions along the cornices of the Lateran Palace or the Scala Santa display quite different characteristics. Of particular interest is Horfei's contribution to one of the most significant artistic and religious (as well as political) initiatives of Sixtus V, namely, the erecting of a monument to Pope Pius V in the Sistine Chapel of Santa Maria Maggiore. Here we find three inscriptions in different letter bodies carved in gold on a slab of black marble. What is most interesting here is the graphic style, which reveals a novel and surprising feature. Horfei used pronounced ornamental serifs at the end of the strokes, following an obsolete late-antique fashion, along with the use of punctuation marks normally used in books, scattered throughout the text, adding commas and semicolons to the usual triangular dots. This was most likely done to solve a technical problem presented by the use of gold carving on a black background. Horfei probably felt that this additional punctuation was needed in order to make sure the letters would be clearly visible and the text easily legible at a glance.

Among Horfei's inscriptions we must include the two large marble tablets bearing the new constitutive regulations of the Vatican Library mounted on either side of the entrance to the Salone Sistino, dated 1588, admirable for their classical simplicity, elegant layout, balanced treatment of empty and full space, and graceful and delicate letter forms. Indeed, in the figurative and graphic design covering the walls and ceiling of the great hall that lies beyond the door, the celebration of graphic culture in all its manifestations and potential—from the invention of the alphabet to the making of books, from the founding of libraries to the carving of memorial inscriptions and even to the burning of heretical books—represents the dominant motif that transcends the specific message and uses of monumental writing to become a conscious and explicit symbol of the far vaster politics of script that we may consider characteristic of Sistine Rome. For this reason, aside from different forms of layout or different techniques used, all the inscriptions designed by Horfei for this hall share an immediately recognizable graphic style characterized by a proportional elongation in both the height and width of individual units, by a subtle and sometimes very faint use of shading, and by the moderate but visible use of serifs accentuated by the lengthening of certain strokes or signs (the tail of the Q, Y, I, etc.; see FIG. 35). These are elements that we do not find in the prestigious models of the imperial era or in Cresci's theoretical examples. We do find them, however, in the Roman epigraphy of the previous century, introduced by Bregno and Sanvito and common in the period between the pontificate of Sixtus IV and the early Cinquecento.

If there is anything baroque in Horfei's work, it is his use of pseudo antique elements and models that have been passed off as antique. The restoration of capital majuscules that Horfei proposed was something he preached rather than practiced, since the graphic norm used to replace the Trajan model in his work for Sixtus's urban inscriptions was something much closer in time and more modern in taste, dating only from late Quattrocento. This was most certainly not due to the lack of technical skill on the part of the craftsmen but was rather the product of a relatively intentional process of dissimulation and mystification that we find expressed in Horfei's work on a very elementary level—for example, in the otherwise inexplicable discrepancies in appearance, proportion, and style between the lettering of his epigraphs and the reproduction of those very same epigraphs in a printed collection, both of which were personally supervised, if not actually engraved, by the artist himself. (The reproduction, entitled *Varie inscrittioni del santiss. S. N. Sisto V pont. max* [Rome (1589)], was a collection of copperplate etchings in the form of an album with a dedication signed by Horfei.)

Precisely this dissimulation of the sign and mystification of the message (which can already be sensed in Horfei, if only indirectly, in his ambiguous relationship to the models he drew on) would greatly influence the general tendencies and trends of epigraphy in the century to come, when monumental writing, expressed indifferently on "paper, copper, bronze, and marble" as Elicona wrote in 1598, would become one of the most widespread instruments of social expression and self-celebration.

Chapter Five

PAPER, COPPER, BRONZE, AND MARBLE

At the beginning of the 1600s the use and classification of display writing was divided into two opposite categories: the rigorous late-Renaissance tradition deriving from Luca Horfei's *litterae sistinae,* which imposed rigid geometric rules on letter forms, layouts, and writing surfaces, versus the new trend, which was open to innovative techniques and experimentation with letter forms and with the relationship between letters and monumental space. The late-Renaissance tradition was used most primarily for outdoor inscriptions designed to be incorporated in open architectural contexts of large-scale dimensions. In contrast, the new trend was mainly used indoors, generally for funerary inscriptions of limited size. The former was for public use; the latter was for (and was determined by) private patrons. Indeed, it is significant that in 1589 the writing master Giacomo Romano in his writing manual *Il primo libro di scrivere* (Rome, Pietro Spada) praised the new freedom from classical epigraphic models: "because very few ancient epigraphs are to be found which have good letters, and those few that do exist also have many bad letters, which may not be used nowadays. . . . However, you will see that my majuscule is different in many ways from the ancient one."

The public inscriptions produced in Rome during the pontificates of Clement VIII and Paul V, the heirs and continuators of Sixtus V, belonged to the first category and could almost be said to represent its stylistic and expressive culmination. These inscriptions, however, also overexaggerate the formal characteristics of the Sistine style in the type of format used, which is often gigantic; in the use of cast metal and of brass applications; in the use of ornamental detail; and in the frequent practice of coloring or gilding the carved letters. Both Paul V and Clement VIII employed this spectacular type of monumental epigraphy on the monuments they commissioned in order to emphasize their architectural contributions to the city of Rome even more dramatically than their predecessor had done.

But Sixtus V had had a master epigrapher-calligrapher at his service: Luca Horfei. Clement VIII and Paul V had others of great professional skill, but we know almost nothing about them except their names. Among these was Marcantonio Rossi, scribe and illuminator of liturgical works, carver of the inscriptions in San Giovanni in Laterano in 1598, and author of a manual of scripts published that same year entitled *Giardino de scrittori,* in which along with the chancery cursive, the *mercantesca* (at such late date!), the *antica tonda,* and other scripts, we also find the geometrically proportioned *antiqua* capital. In this collection images and metaphors of writing play a central role in the poems praising, as was the custom, the book itself, its author, and the man to whom it was dedicated, Cardinal Pietro Aldobrandini. In these verses G. B. Elicona celebrates "the paper, copper, bronze, and marble" inscribed by calligraphers, while Scipione Caetani flatters Aldobrandini when he writes, "Fame is your pen, and the world your paper." Another poet, Antonio Caetani, praises the permanence of monumental writing, whether it is written in ink or cut in marble or bronze, while Bartolomeo Rossi extols the excellence of handwriting, proclaiming its superiority to the marble epigraphs of antiquity. "Your glorious writings will live on as though carved, outlasting bronze."

Another calligrapher active in Rome during the turn of the century was Cesare Domenichi, who cut some very clean inscriptions in pure Horfeic style for Cardinal Cesare Baronius in the Roman churches of SS. Nereo and Achilleo and San Gregorio al Celio. In 1602 and 1603 he published two very important treatises in Rome, both entitled *Delle lettere nominate maiuscole antiche romane.* In the later treatise Domenichi stressed the important function of display writing in monumental structures, defining it as "the spirit and soul of the entire decoration," and claimed that "writing without decoration gives greater satisfaction than decoration without writing, especially in those works dedicated to the memory of persons who are remembered through the inscriptions" (p. 7).

Domenichi saw that display writing focused the expressive functions of inscribed monuments, a role that required that letter size and proportion be enlarged, led to the appearance of gigantic letters, and brought about the spatial domination of written plaques on architectural structures. This is indeed what occurred during Paul V's pontificate, beginning with the large and splendid inscriptions in varied letter size on the huge Fontanone dell'Acqua Paola on the Janiculum, dating from 1612, which dominates the cascade of water and looms majestically over the urban panorama stretching below. (See FIG. 36.) This may be legitimately compared to another truly

enormous inscription engraved two years later on the fronton of San Pietro, which in its own day was described as having excessively large letters (Bibl. Apos. Vaticana, ms Barb. lat. 2353, fol. 13v).

Also operating in Rome in this very intense period of activity was Fabrizio Badessi, to whom we owe the inscription on the huge column erected in honor of the Virgin by Paul V in front of Santa Maria Maggiore in 1614 and also several of the inscriptions in the Quirinal Palace. But among all these artists the one who best illustrated Domenichi's lesson regarding the autonomy and spatial preeminence of epigraphic writing was Ventura Sarafellini, master of calligraphy at the Scuole Pie of Rome from 1618 until his death in 1664. This is the artist who created the two most gigantic inscriptions of the period: the enormously proportioned and admirably classical mosaic inscription in capital letters in gold, blue, and enamel on the tambour of the cupola of Saint Peter's dating from 1605–6, and the inscription on the nymphaeum of Villa Aldobrandini in Frascati, which is 118 meters long and, according to Cesare D'Onofrio, is perhaps the largest inscription of the period, not only because of its length, but primarily because of the huge proportions of the letters. (See FIG. 37.) This inscription is characterized by perfect design of letter forms, deep carving, stark shading, and the elegant use of serifs and of triangular word-separation markers typical of Horfei. Drafted by Gian Battista Agucchi and mounted on the villa in 1619, it is textually and rhetorically quite simple, but its impressive appearance and extensive visibility are rich in meaning. In creating it, Sarafellini brilliantly exploited the long, continual serpentine line offered by the architectural structure of the complex.

Commenting on the construction of the villa, Agucchi wrote, "What we have built are not houses or habitations but chapels, hemicycles, hippodromes, columns, lakes, staircases, and pools"—in other words, as he put it, "strange novelties and unique constructions." The distinctive feature of the architecture of this period was precisely this strangeness expressed in the massive, grandiose, and awesome quality of these buildings, which were decorated with gigantic, antique-style inscriptions designed by the last and obscure followers of the Horfei tradition.

Chapter Six

MOURNING, DISSIMULATION,

CELEBRATION

N ot only the forms of monumental writing but also its setting and function were undergoing rapid transformations in Italy. Tastes had changed, and this change ran parallel to the widespread adoption of a series of innovations that had emerged during the last quarter of the Cinquecento. Considered together, these innovations form a new aesthetic that characterized the baroque funerary inscriptions of the Seicento. They may be summed up as follows:

1. The use of writing surfaces fashioned to resemble objects that were quite unsuitable for this purpose. Inscriptions were engraved on hard surfaces shaped like drapery, cushions, cartouches made of wood, scrolls, sheets, ribbons, shields, and even shells and animal skins.
2. The dislocation of writing on curved or wavy lines characteristic of the figurative style of the period (the so-called serpentine line, or the spiral), which led to the deformation of signs and diminished legibility.
3. The use of color in sections containing writing.
4. The discarding of the traditional square-shaped plaque and the success of diverse formats of varied shape.
5. The dismantling of the text into sections according to the various partitions or sections of the monument and its structure.

Thus in the funerary epigraphy of the baroque period we find the expression of a series of tendencies that were common to the art and poetry of the time. Foremost among these was the search for movement as a stimulus to emotion. Adopting one of Aby Warburg's critical categories, we might say that "plastic" writing represented a true "symbol of the pathetic" that did not derive, as in other cases, from the classical repertory but rather from the medieval one, that is, from the inscriptions on curvilinear cartouches that frequently appear in late-medieval painting. The rejection of the geometric regularity of Renaissance calligraphy brought about the further rejection of the enclosed, flat surface of the classical plaque, which in turn gave rise to the new fashion for technical innovation and new materials, even if these

were only suggested to the imagination by the use of marble draperies or stone ribbons. All these developments finally led to the break with the classical epigraphic tradition, whose influence and prestige had reached an all-time low.

It is quite fitting that the new century should open with the bold graphic-figurative experiment attempted in Mantua by Antonio Maria Viani in the Room of the Labyrinth of the Ducal Palace, where the inscription obsessively repeats over and over the same motto, which in itself was quite ambiguous—*Forse che sí Forse che no* (Maybe yes maybe no)—inserted in the twisting and turning corridors of a labyrinth, a presentation that greatly interferes with visibility, legibility, and intelligible verbal meaning.

In 1630 Nicolas Poussin took up a theme that had been treated by Guercino a few years earlier (see FIG. 38), consisting of a pastoral scene showing a group of shepherds contemplating a ruin bearing the inscription "Et in Arcadia ego." In his elaboration of this theme (see FIG. 40), Poussin added, or rather revealed, a new element that was quite typical of the epigraphy of the period: the tendency to obscure the meaning of the graphic sign, to treat it as elusive, ambiguous, and difficult to decipher, thereby portraying monumental writing as something remote, fascinating, and pompous, decipherable only through conscious and strenuous effort. In Guercino's painting the inscription appears along the upper edge of a wall, a very visible and legible caption, unseen by the shepherds, whose attention is entirely concentrated on a skull on top of the wall. Poussin painted two versions of this scene. In the first, the shepherds, who do not seem to notice the skull, have been assigned the role of public reader and with obvious difficulty are trying to decipher the epigraph carved asymmetrically on the side of a sarcophagus. The shepherd most absorbed in this task is tracing the letters with his finger while he reads and in the process covers up some of the letters with his hand so that the text is partially hidden from the real public reader—the beholder of the painting. In Poussin's second version (see FIG. 39), the act of deciphering has become the central focus of the scene. The figures gathered round are pointing out the inscription to each other and seem to be engaged in an antiquarian discussion about its meaning, but as far as the viewer of the painting is concerned, the inscription is quite illegible.

The engraving of inscriptions on surfaces fashioned to suggest unsuitable materials, the use of color, the dislocation of the inscription on various levels, and the rejection of the flat geometric scheme all hindered legibility. This reduction of legibility, which is strongly suggested in Poussin's paintings, was an intentionally created effect, as we may see in a vast number of inscriptions in monumental structures where the visibility of part of the text

has been purposefully obstructed. Bernini's tomb of Urban VIII illustrates this point. On this tomb the figure of Death is writing the pontiff's name on a cartouche of black bronze, but the position in which he is sitting blocks our view of several letters of the inscription.

In this progressive obliteration of the sign the extreme phase of the blank plaque deserves mention (a tendency already present in Michelangelo, as we have noted). Borromini followed in this direction and frequently used empty plaques in churches, for example in Sant'Ivo alla Sapienza, in Sant'Agnese in Piazza Navona, in San Carlo alle Quattro Fontane, and in the Cappella Spada of San Girolamo alla Carità, where either no trace of writing appears at all, or else only the most essential and concise inscriptions have been allowed. Borromini was not the only one to do this, even though he was the staunchest supporter of the negation of writing in his day. Bernini left the interior of Sant'Andrea al Quirinale quite blank except for one large plaque that is nearly impossible to read from ground level. The Chapel of S. Pietro in Montorio and later the Maddalena were also quite devoid of inscriptions, and in Venice during the latter half of the century both the interior and exterior of Santa Maria della Salute were left bare.

The general impression is that in the new and vaster spaces that urban architecture now offered to the Italian cities of the Seicento, monumental display writing no longer had its own role and function. Thus no monumental lettering appeared in St. Peter's Square or in Piazza Navona in Rome or in Piazza San Carlo in Turin. We find a similar indifference to the public graphic message in the suburban villa, an architectural structure very dear indeed to the aristocratic ruling classes. Surrounded by parks and decorated by statues, it was generally unadorned by display writing, almost as though the private show of power and the explicit message of the engraved written sign were considered not only useless but rather indiscreet and superfluous.

Thus we have first the dislocation, then the dissimulation, and finally the negation of writing. As we have underlined, this development represented not merely a "phase of sophistication by artists" but a very complex linguistic and rhetorical process that enticed viewers into the game of interpretation and placed them in the role of protagonist and even inventor of the verbal meaning. This process followed a trend that had been widely experimented with by the Jesuit-influenced schools of the Counter-Reformation and publicly manifest in the urban society of the time through varied rituals and behavior, most especially through the widespread diffusion of mottoes and emblems in manuscripts, printed books, monuments, inscriptions, and ceremonial and funeral display.

Monumental writing enjoyed a vast public that had willingly become protagonist of the interpretive process, a public composed of aristocrats from the city and the court, varied ranks of the clergy, magistrates, professional men, property owners, and *rentiers* who aspired to nobility. If these men and women had become the protagonists of monumental writing, it is indeed because they were the patrons of the inscriptions and monuments that contained it and the lords and masters of the places where it was displayed. In the chapels and the churches space was set aside for their private use through a process of feudal appropriation that was characteristic of the religious and civic practices of the time. This phenomenon, which was widespread throughout Italy and a good part of Europe, was aided by the fierce iconoclasm of the Counter-Reformation, which picked the church clean of its existing figurative decoration (now condemned for ideological reasons) and handed the bare bones over to the self-celebration rituals of the ruling classes.

The monuments to these rituals may be seen in every city in Italy, but undoubtedly Rome and Venice have preserved the richest, most continual, and most significant testimony of this phenomenon. Upon entering a seventeenth-century church in Rome or Venice that has been chosen as the privileged site for these lugubrious celebrations, the visitor cannot help being overwhelmed by the aesthetic effect created by such indiscriminate use of monumental writing. Within the enclosed space of the baroque church we find an enormous concentration of verbal signs scattered about everywhere, crammed into every available space—letters, mottoes, texts painted or carved, in varied colors or in black, on plaques or cartouches molded to look like wood, ribbons, shields, frames, ovals, and scrolls and literally covering the floors, the walls, the ceilings, the columns, and the altars.

Though dating from different periods and fashioned by different artists for different patrons, the huge number of these inscriptions, their physical proximity to each other, and the distinctive characteristics they share all blend together to form a unique graphic phenomenon of great figurative meaning and represent what we might call a self-contained "graphosphere" and an integral part of the ornamentation of the building by no means inferior to its friezes, paintings, and sculptures.

Employed and displayed in such a way, monumental epigraphy, a symbol of power and social prestige, lost the three-dimensional visibility of the classical or Renaissance inscribed plaque and instead established a two-dimensional and coloristic relationship with the interior surface of the church. At the same time, ceremonial writing, no longer confined to the flat surface within the boundary of a frame, became an omnipresent motif

in the architectural context. Through this process of spatial expansion epigraphic writing came to lose its expressive autonomy, not only in relationship to the language of the figurative arts, but also in relationship to the other graphic language—that of the book, or rather the product of printing at that time—which was naturally two-dimensional and which increasingly tended to present its figurative graphic elements (woodcuts and copperplate etching) in combination with typographic elements.

In Rome during the baroque period the examples of this epiphany of ceremonial epigraphy are many, and taken together or individually, they indicate a very deep sensitivity toward the pathos and the more dramatic aspects of mourning, often bordering on the celebration of opulence. These same tendencies were reflected in the new calligraphy styles that had been liberated from the constriction of geometric models and had become more sinuous and ornate, embellished with ornament and color. The innovations of baroque epigraphy did indeed have their precursors in the previous century, as for example the funerary monument to Elena Savelli (d. 1570) in San Giovanni Laterano, the work of Jacopo del Duca (see FIG. 41), in which we find polychrome lettering, the dislocation of writing into several sections (one of which represents a slightly ruffled banner), and a relief portrait of the deceased placed between the inscribed sections. At the beginning of the Seicento the memorial monument to Cardinal Paolo Sfrondato (1618) in Santa Cecilia illustrated a new development in the typology of funerary monuments that became common outside Rome, namely, an upright monument with tumular floor stone created from different materials and rendered through different techniques but reflecting the same aesthetic taste. (See FIG. 42.) In this heavy, sumptuous, and polychrome monument, the central black marble plaque bearing the inscription offers a stunning contrast to the red marble floor stone inlaid in white, where Arabic numerals stand out starkly amid the Roman letters.

Further evidence of the late Renaissance fashion are the six inscribed plaques in San Marcello designed by Alessandro Algardi for the Frangipane family. These show a most austere rapport between written and sculpted elements, whereas the large inscription commissioned by Urban VIII for the facade of SS. Luca and Martina in the Forum is clearly in line with the Sistine tradition of Horfei.

Many other examples testify to this attempt to create an effect of opulence and splendor never before achieved through the use of new styles and techniques. For example, in the dramatic monument to Lucrezia Tomacelli in San Giovanni in Laterano (1625), the use of relief lettering in cast metal creates a polychrome effect and a sense of durability in time (see FIG. 43).

In the funerary monument to Francesca Caldarini Pecori Riccardi (d. 1655) by Antonio Raggi, the epigraph has been inscribed on a molded cartouche mounted on a draped banner (see FIG. 44) And the splendid complex commissioned by Cardinal Francesco Barberini in Santa Maria dell'Anima to honor the learned librarian and scientist Luca Holstenio (d. 1661) is decorated with a long inscription carved on a banner (see FIG. 45).

In this obstinate striving toward the ornate and the spectacular, often accompanied by a touch of the macabre, which was indeed characteristic of baroque epigraphy, we must mention the experiments of Gian Lorenzo Bernini in this vein, including the tomb of Urban VIII already discussed (see FIG. 46); the monument to Valtrino (if it is Bernini's work) in San Lorenzo in Damaso, decorated with a black banner emblazoned with a skeleton and inscribed with a gilded epigraph mounted below a portrait in a medallion; the funerary monument of the De Silva family in Sant'Isidoro (1663; see FIG. 47); the simple masterpiece of the Fontana delle Api commissioned by Barberini, where the inscription is cut across the pleated surface of a marble scallop shell (see FIG. 48); and lastly, the decorative unfurled ribbons bearing inscriptions in praise of the Chigis mounted on the two altars that stand opposite to each other in the transept of Santa Maria del Popolo.

Other even more ponderous and elaborate examples dating from the second half of the century in Rome include the Church of Gesù and Maria on Via del Corso, the private temple of the Bolognetti family, where on either side of the central portal stand two splendid funeral monuments, dedicated to G. and C. del Corno (1662 and 1608) and carved in a similar style by Ercole Ferrata and Domenico Guidi. These two monuments display striking inscriptions in gilded lettering set deep in the folds of polished jet-black drapery. Also dating from this period are the two handsome monuments in similar style in the church of SS. Luca and Martina, erected in 1681 to the memory of the painter Lazzaro Baldi and his sister. The inscriptions are divided into three sections, written in yellow on a black background. Toward the end of the century we find the superbly ceremonial tomb of Clement X in Saint Peter's adorned by a long inscription engraved on a cartouche borne by two putti, patterned on a heraldic design common in bookbinding in the seventeenth and eighteenth centuries. The tomb of Cardinal G. Gualterio in Santa Maria dell'Anima shows similar stylistic tendencies. Finally, in the Cappella Ludovisi of St. Ignazio we find the sumptuous funerary monument to Gregory XV with a double inscription in polychrome letter forms. A similarly refined engraving technique may also be seen in another monument in this same church, dating approximately from the same period

(1698), namely, the tomb of Cardinal Scipione Lancellotti, decorated with harmonious metallic ornamental detail.

The baroque tendencies in funerary epigraphy did not subside at the turn of the century. At the beginning of the eighteenth century we may find lavish evidence of the prevailing fashion—for example, the monument to Francesco Erizzo (d. 1700) in San Marco by Francesco Moratti, and especially the dramatic and eloquent monument dedicated to Queen Christina of Sweden erected in 1702 in San Pietro by Carlo Fontana after many years of planning and elaboration. (See FIG. 49.)

Fontana, an artist whose influence was felt in Rome for several decades, was deeply interested in the function and display of writing in funerary and civic architecture. His sketches reveal that he took great pains to work out the spacing and layout schemes of the texts he intended to carve, carefully studying the length in relationship to the available space. He also gave indications as to what type and thickness of letters should be used. Called upon to satisfy the tastes and whims of the most august patrons, Fontana frequently offered them alternative solutions—for example, the choice between a cartouche fashioned to resemble a rolled sheet of paper or an elaborately molded curving cartouche—thereby demonstrating both the infinite possibilities available to the baroque artist for the display of writing and the substantial equivalence of these possibilities.

In contrast with the opulence and ostentation of these monuments, we should also mention here the large slab on the tomb of Cardinal Andrea Barberini that was laid in the floor of the Church of the Capuchins in 1646. (See FIG. 50.) The extremely pure letter forms carved in this stone and the absence of color or figurative ornament are indeed an appeal to rigor and austerity; the sternness of its form is echoed in the ascetic brevity of its inscription.

We continue to find an abundance of baroque inscriptions on Venetian memorial monuments during the seventeenth century. (See FIGS. 51–52.) Compared to the epigraphy of Rome, however, the grand capital of baroque monumental writing, Venetian epigraphy differs significantly, primarily because in Venice there was little space available for the display of writing, given the scarcity of open spaces and large piazzas and given the low legibility of inscriptions mounted on facades facing the water. These conditions explain the vivid use of color in the gilding of the entire background of inscribed slabs following a centuries-old local tradition. Another difference consists in the practice of decorating the facades of churches with portraits and funerary monuments commemorating important personages

buried inside, accompanied naturally by inscribed plaques such as the one on the baroque facade of San Moisè, decorated with a trapezoidal inscribed plaque borne by two camels commemorating Vincenzo Fini (d. 1660), the founder of the church. (See FIG. 53.)

In other respects Venetian baroque epigraphy imitated the general style, function, and characteristics of monumental writing of the period, with a certain accentuation of coloristic or monumental qualities, as we may see in the colossal mausoleum of Doge Giovanni Pesaro (d. 1659) in S. Maria Gloriosa dei Frari by Baldassarre Longhena. This structure was decorated with five epigraphs drafted by Emanuele Tesauro mounted on various sections of the monument and accompanied by figurative and sculptured motifs that blend superbly with the florid style of the relief inscription. (See FIG. 54.) The ornate letter forms of this inscription are patterned on a graphic model common in Venetian printing during this era. In this same church we may also find an inscription carved on a shell-shaped cartouche of polychrome marble mounted on the monument to Girolamo Garzoni (1668), which among the major examples of Venetian epigraphy is closest to the experiments in Rome.

The rather fantastic models so highly esteemed in Venice surprisingly found a distant echo in the complex baroque adventure of the city of Lecce. The architectural style of this city was far too obsessed with the triumph of the ornate and of the figurative to grant much space to the display of writing, which found expression in new flat, close-written formulations deriving from the Neapolitan tradition. However, Zingarello, one of the more brilliant local artists, found an original solution for display writing in 1663, when he decorated the facade of the church of Sant'Angelo with a long impressive inscription in huge, rounded, embellished letters linked with bizarre ligature devices and borne by lively cherubs. (See FIG. 55.)

Rome and Venice were thus the two major centers of baroque monumental epigraphy. This was not merely because in both cities the urban layout and the religious architecture—renewed by the Counter-Reformation—lent themselves uniquely to the celebrative display of writing, or simply because the noble and clerical classes of both cities were preoccupied with the celebration of their own names, but because both states attached enormous value to the symbolic meaning of monumental writing, to the extent that they allowed themselves to become involved in a *bellum epigraphicum,* with major diplomatic and political consequences. In 1635 Urban VIII had the inscription on a fresco depicting a moment of Venetian history in the Sala Regia altered so that it conveyed anti-Venetian sentiment, whereupon Venice protested by withdrawing its ambassador from

Rome. The offensive inscription was later covered over, but the incident was not considered closed nor the wrath of the Venetians placated until Innocent X restored the original text in 1645.

Somewhat later in the same century we encounter an epigrapher pope, Alexander VII Chigi, who was deeply aware of the symbolic and evocative value of public inscriptions. This pope enjoyed supervising the wording, layout, and placement of all the epigraphs mounted throughout the Vatican and Rome that were to bear his name. In a manuscript at the Vatican Library (Biblioteca Ap. Vaticana, ms. Chigi, I VI 205) we may see his sketches for several layout designs (fols. 309r, 448r) and read his sharp comments scribbled in pencil concerning the inscriptions submitted for his approval: "This is not worthy of the pope's name" (fol. 377r), or "This is going into a public street, and there's no room for all these lines" (fol. 353r). Of this pope we know that he also carefully studied Poliphilus (there exists a copy annotated in his own hand [Stamp. Chigi, II 610]) and that he loved to receive visitors surrounded by skulls and with an open coffin at his side.

Chapter Seven

EPHEMERAL MONUMENTAL AND

PAPER MONUMENTAL

I n 1655, at the very beginning of Pope Alexander VII Chigi's pontificate, Emanuele Tesauro's *Il cannocchiale aristotelico* was published in Venice. This book, which was to meet with great popularity in its own times and also generations later, was not merely a treatise on the subject of aesthetics or rhetoric, but rather dealt with epigraphic style. The author, a former Jesuit priest who was to become one of the most successful masters of public ceremonies in the great capitals of the North (Turin, Milan, and Venice), took a very literary view of epigraphy.

For Tesauro, epigraphy was an art "midway between poetry and oratory," something quite the opposite of the classical and Renaissance tradition, which he accused of being "devoid of liveliness and wit." Glancing through Tesauro's treatise, especially chapter 13, the reader has the impression that this work is in reality a sort of theoretical and practical manifesto of baroque epigraphy, a form of writing that was characterized by its "liveliness," "wit," and "cleverness," by its intentional obscurity ("which in a thousand subtle ways conveys ideas by disguising them"), by its typological variety, and lastly by its great concern for legibility (of a very particular kind). According to Tesauro, the legibility of an epigraph did not depend solely on the clarity and comprehensibility of the text and its constituent signs, but also on its compliance with the new rules of rhetoric, which required that epigraphs be structured differently from oratorical compositions. Tesauro illustrates this point by providing a few passages from Cicero and Tacitus that have been slightly modified. He then remarks: "Can you not see how through this slight alteration a eulogy intended for the ear has become quite legible?"

Tesauro was very much concerned with the function of epigraphic writing in relation to a specific audience of readers for whom the message was to be comprehensible, even though it had been cleverly disguised. This audience consisted primarily of readers of books, however, not only readers of carved display epigraphs. The inscriptions that Tesauro discusses, which

were so avidly consumed by the public and to a certain extent commissioned by them, were essentially a literary genre that found only partial expression in stone or marble. For Tesauro the new epigraphy, or "lapidary wit," included "eulogies, epitaphs, dedications, epigrams, mottoes, and every kind of inscription," all complex texts that , though they could be carved in "eternal letters," were primarily intended to be written, for indeed writing is, as Tesauro confirms, "the sowing of words on paper."

Before Tesauro died, one of his admirers, E. F. Panebianco, collected and published the inscriptions he had created for various occasions, grouping them by genre categories—those composed for "extremi honores" or birthday festivities ("natalitiae pompae"); for "publicae receptiones" of illustrious or royal personages; for special religious ceremonies ("sacrae celibritates"); for erudite circumstances ("literarii apparatus"); for "historicae inscriptiones," the celebration of illustrious men ("illustrium virorum elogia"), the decoration of royal habitations ("regiarum aedium ornamenta"), and the inscriptions for places and monuments ("rerum locorumque inscriptiones et monimenta"). Here it must be emphasized that only a few specimens in these latter categories include inscriptions written to be cut on durable materials or displayed on or in permanent structures such as monuments or buildings. The rest of these texts "in epigraphic style" had been printed on paper, on single sheets, or in books—that is, in temporary and ephemeral contexts, on impermanent structures, arches, and mobile machinery used in public fetes and funeral ceremonies that were destroyed once the occasion was over. Tesauro was an expert in creating texts and display scripts for these situations.

It is difficult for us to realize just how common this type of graphic-scenic-visual spectacle was in the cities of Italy and of Europe during the 1600s and 1700s. However, the ubiquitous, constantly renewed, and ever-changing display of writing made a significant contribution to the urban environment and played a major role in the cultural formation and the artistic and literary education of its citizens. One source dating from this period, a diary kept from 1662 to 1669 by Anton Stefano Cartari, a young provincial aristocrat from Orvieto, gives us an indication of how important official and ceremonial events (inevitably accompanied by a rich display of writing) were in Roman society and in the education of a youth of his social standing. Cartari, whose untimely death brought an abrupt close to a budding literary and scholarly career, spent most of his time in Rome studying rhetoric and attending various official public and academic functions, funeral ceremonies, and holiday celebrations; he took part in processions and visited churches, museums, and illuminated manger scenes. In each of these con-

texts, display writing—more or less visible, extensive and permanent—was very much present, serving as legend, explanation, title, and verbal emphasis of the particular event and its recondite meaning. It captured the attention of this young scholar and of other official and unofficial transcribers who made careful records of these ornate and conspicuous epigraphic texts.

We are to construe "epigraphic" as Tesauro intended it—that is, any text written in a ceremonial manner and publicly displayed, a definition that also embraces display texts written in lapidary style on nondurable surfaces such as cloth, papier-mâché, cardboard, or wood and inserted on impermanent monumental structures doomed to a brief life span. We have varied testimony of this practice dating from the early Cinquecento. In a letter dated 1513, Baldassarre Castiglione describes stage sets for a performance of *Calandria* as having "big white letters on a blue background" inscribed on an "imposing cornice." That same year in Rome, Leo X's coronation procession was greeted by a series of well-wishing inscriptions. Later the mannerist love of ceremony and of the theater found triumphant expression in the ephemeral, yet complex, ceremonial architecture created and decorated according to the new European fashion for various public fetes, funerals, and celebrations throughout the major cities of Italy, from Florence (famous for the Medicis' celebrations in the last quarter of the Cinquecento) to Naples, Parma, Milan, and Turin. During the sixteenth and seventeenth centuries Rome and Venice were undoubtedly the most important centers of this vogue for the ephemeral-monumental. Through the documentation furnished by these two cities, we may trace the evolution and basic characteristics of this phenomenon and study its relationship to script.

Tesauro was quite right to be concerned with the legibility of display texts, as this attitude was shared by the organizers of public festivities and by the great creators of what we might call ephemeral architecture. In 1637, for example, on the occasion of a celebration held in Rome in the Piazza di Spagna, pamphlets explaining the machinery, mottoes, and inscriptions created by Luigi Manzini were distributed to the public. This was not done merely out of concern for rhetoric or convention, but also to make sure that the public understood them, given that the legibility of the inscriptions was hampered by various factors.

First among these factors was the "capriciousness" typical of these texts, which Tesauro praised as a special feature of the genre. This capriciousness was due to the lack of predetermined spatial constrictions, however, which sometimes produced certain negative consequences—for example, an exaggerated number of inscriptions and mottoes or a chaotic arrangement. (There were over eighteen epigraphic texts on the facade of the structure

erected in Rome in 1687 to celebrate the recovery of Louis XIV.) Further-more, the excessive length of the individual texts and the poor choices of location (they were often placed too high) made them difficult to read.

These ephemeral architectural structures generally consisted of a wooden framework covered with canvas, wood, papier-mâché, and cardboard. The inscriptions were usually painted in gold on a colored wooden or cloth background that was generally dark or bronze in color or sometimes white, red, or blue. The use of color was a distinctive feature of ephemeral epigraphy and distinguished it from permanent stone inscription.

Yet these two forms of display writing were related, and naturally enough they did mutually influence each other. Ephemeral monumental writing offered traditional epigraphy new and bold experimental ideas for layouts, arrangements, text length, and the daring use of color. Hard-surface epigraphy, in its turn, furnished its ephemeral cousin with a fixed model that was difficult to alter as far as the relationship between writing and figurative monument was concerned, so that often it may seem that ephemeral epigraphy is merely a copy of the more noble, permanent form. Indeed, this is true of the catafalque in pure epigraphic form created in Rome in 1644 for Cecilia Renata, queen of Poland, and of the one designed by Bernini in 1669 in Santa Maria in Aracoeli for the duke of Beaufort, where the inscription, given a very traditional presentation, was the central focus of the monument. At other times we find a more conflictual relationship between these two forms of monumental writing. On the occasion of Urban VIII's coronation procession, the arches of Titus and Settimus Severus in Campo Vaccino were decorated with ephemeral "pictures, festoons, and inscriptions." Of course it is very likely that the origin of one of the chief features of baroque epigraphy—the carving of inscriptions on stone or marble surfaces fashioned to suggest unsuitable materials (e.g., animal skins, wood, or drapery)—may be traced back to ephemeral epigraphy, which was freer than carved inscription and more suited to woven materials or pliable and light-weight ones such as papier-mâché, wood, or cardboard.

Between these two major forms of monumental writing there existed a third, intermediary form in the written culture of baroque Europe. This was represented by the "monumental paper" form, a characteristic product of European publishing during the 1600s and 1700s, a category that includes books of epigraphic texts, collections of engraved plates depicting mobile structures and ephemeral machinery, and title pages and illustrations in epigraphic or lapidary style. These were luxurious and monumental works designed for specific ceremonial purposes. Their existence, which flowered over the course of these two centuries, created a model of the book that

was quite different from that of the Renaissance tradition. The new model was distinguished by its spectacular and visual use of script, its impressive page size, its unusual arrangement of text and illustration, and the very close relationship it displayed between figurative sign and graphic sign. Furthermore, its functions and the ways in which it was displayed and preserved were all quite new.

The book in all its functions and typologies represented and summed up the various features of seventeenth-century culture and exercised a certain preeminence during this period over all other tools of learning and forms of writing. In his *Cannocchiale,* Tesauro praised books as the "marvellous dwelling of the intellect that have words yet no tongue, have no speech and yet speak, cannot read and yet teach us all the sciences." The monumental book, of large format and richly illustrated, packed with type representing every sort of character and letter size, was not limited to luxury editions. We need only peruse Manzoni's description of don Ferrante's library to discover that on the bookshelves of the moderately educated person of the seventeenth century, noble or bourgeois, a vast array of books with imposing formats were to be found, dealing with the subjects of law, theology, the classics, the Bible, medicine, science, and so on.

Though produced and disseminated in significantly smaller numbers compared with the other typologies, the baroque luxury book represented an innovation in the very essence of seventeenth-century book design. Significantly, in a thorough study of the editions of German theatrical works of this period, Walter Benjamin underlines the "vast connections between language and writing" in seventeenth-century culture, "the unity of the baroque linguistic and the baroque figurative," and "the intense attention" devoted by "baroque poets . . . to the image of writing."

In the baroque luxury book the image or appearance of the typography regains its autonomous value as an element possessing its own meaning and begins to prevail over the other values inherent in lettering. It is not the first time—nor will it be the last—that the signifier prevails over the signified, but the baroque luxury book developed within a context of concurrent factors that, taken together, render this fact particularly significant. The first of these factors was the pervasive concept of the book as an object-product, composed equally of text and image, the fruit of the collaboration of the author or authors of the text, the designers of the illustrations and engravings, the editor, the publisher and the printer, and, finally, the patron or patrons. In this hierarchy, the compiler of the text played the least-important role.

Second, the illustrations of the monumental book required new formats, and this brought about the appearance of the large or oblong album format, one of many possibilities suitable for the presentation of epigraphic texts and the format preferred for musical works, which became more and more popular in the cultivated circles of the city and court during the 1600s and 1700s.

Furthermore, as far as concerns the scripts used in these texts, two trends may be identified. First was the continual alternating of many different letter sizes and styles in the texts and titles, as if to emphasize the visual expressiveness of letter signs through the varying of forms. Second was the inclusion of engraved, rather than typographical, lettering in the illustrations and decoration, creating a freer, more intimate and direct relationship between figurative design and letter design—a process that culminated in the writing manuals of the period (also in oblong format) and in the "calligram" title pages of famous books of the era.

Finally, we must mention the introduction of the illustrated frontispiece in the design of seventeenth-century books, especially luxury books. The illustrated frontispiece (the page facing the title page) is an element that not only enhances the meaning and weight of the figurative symbology of the work as a whole but also creates a subtle and vital balance between a single unit composed of figurative design plus writing on one page (the frontispiece, on which a small amount of engraved writing is present) and a single unit composed of writing plus figure on the facing page (the title page, where the decoration and the publisher's logo contain figurative elements). This relationship could even be competitive. (In a well-known edition of Shakespeare's plays dated 1640, a portrait of the playwright appears as a frontispiece with the following inscription: "Reader look not on his Picture, but his Booke.") It ultimately contributed to the shift in the orientation of the open book from the rectangular axis of the medieval book, suitable for reading on an inclined surface, to the oblong axis of the modern book, suitable for reading on a flat table surface.

The modes of expression and techniques of this phenomenon (primarily copperplate engraving, which is a freer, more fluid and malleable medium as far as drawing and shading are concerned) were not only Italian but European, and the baroque luxury book developed along similar lines in Germany, France, Spain, and England. In France under Louis XIV, the royal *Imprimerie* published a series of lavish ceremonial volumes whose sumptuous typography and engraving have never been surpassed.

In Italy, where German, Dutch, and French engravers collaborated with Italian artists and publishers throughout the 1600s and 1700s, we continue

to find curious epigraphic collections of monumental texts composed in the lapidary style by one or more authors published at the beginning of the eighteenth century. This genre, which, according to the Jesuit Menestrier in 1684, was "more to the Italian taste than our own," soon spread throughout Europe. Likewise, books on handwriting and calligraphy manuals became very common and were especially popular in the German-speaking countries and in France and Spain.

In Italy the major centers producing monumental luxury books, considered as such not only because they were very costly to produce but also because of the ceremonial function for which they were created, were the large cities: Venice, Florence, and especially Rome. In Florence, where the fashion for the ephemeral monumental had been endorsed during the last quarter of the Cinquecento by the Medicis, who were great lovers of celebrations and ceremony, we find two great artists of this genre at work: Jacques Callot and Stefano Della Bella. These two engravers, whose work was mainly associated with official publications of the grand duchy, introduced new baroque innovations in book illustration and stage-set design, for example, Callot's cycle of illustrations for Prospero Bonarelli's tragedy *Solimano* published in Florence in 1620, or Stefano Della Bella's title page for a treatise by G. Nardi, dated 1634, where the title appears on a background of curved drapery.

Thus in Florence, as in Genoa, Milan, and Turin, the use of monumental lettering in book design followed stylistic trends similar to the tendencies prevalent in the epigraphy of the period, in both funerary and ephemeral forms. The title pages and frontispieces, engraved in copperplate, usually portray scenes containing one or more written texts, sometimes in capital letters suggestive of stone inscriptions, other times written in more capricious, cursive scripts on drapery, scrolls, and even animal skins, all of which were quite typical of the baroque epigraphy of the period, and more particularly of ephemeral inscriptions on woven and fragile surfaces. It is difficult to classify the examples of this vast, repetitive, and substantially homogeneous phenomenon, but a few especially striking ones deserve mention here. The elegant title page engraved by P. Thomassin for G. V. Imperiale's *Stato rustico* (Genoa, 1611) shows a young peasant boy writing the title with a pen on a ragged cloth hanging from an arbor where Pan and a group of shepherds are gathered, a scene quite suited to the book's subject (see FIG. 56). In the frontispiece for G. Pasta's *Demanda, ovvero il principe sofferente* (Milan, 1638), the title of the book appears on a map of the world. Finally, in the title pages of *Venaria reale,* by Armedio di Castellamonte (Turin, 1674), and *Il sontuoso apparato,* ded-

icated to Cardinal Morosini (1600), the titles are written on deer skins. In the former a pair of dogs are stretching the skin taut so that we may read the title (see FIG. 57); in the latter a lion is holding up the skin (see FIG. 58).

Between the seventeenth and eighteenth centuries Rome was the major center for the application of lapidary epigraphy to the field of book design, a phenomenon that drew inspiration from hard-surface carving and led to illustrating title pages and frontispieces with texts printed or engraved on the pedestals of statues, ancient ruins, columns, steles, altars, or monumental plaques. It is difficult to furnish a list of examples. We might mention here two very witty creations by Pietro da Cortona, engraved in copperplate by J. F. Greuter for *Flora* and for G. B. Ferarri's *Hesperides* (1646) The *Flora* frontispiece is quite complex and includes two epigraphs, one of which is carved on a triumphal arch, the other on a slanting stele, which reduces the legibility of the inscription. (Recall that in this same period Poussin had created a similar effect in his *Et in Arcadia ego.*) The design of *Hesperides* is much simpler. The title appears on an altar, in imitation of a classical inscription. (See FIG. 59.)

In the frontispiece of another masterpiece of Roman book design, *Aedes barberinae* by Girolamo Teti (also published by Mascardi, 1642), graphic and epigraphic elements are delightfully combined in a game of multiple mystification. (See FIG. 60.) The illustration shows a woman (Clio) writing the title of the book with a pen (or something that looks very much like a pen) on a slab of marble held up by a cherub. Here the calligraphic script (the graphic element) and the antiquarian inclinations of the author and of the times (the epigraphic element) are juxtaposed in an allusive and charming joke, for in writing with a pen on a marble surface, the woman is doing something quite impossible—yet she is quite unaware of this fact, as are we the readers, her accomplices.

In the midst of this setting, we must place the frenetic activity of Father Athanasius Kircher, a German Jesuit transplanted to Rome in 1634 while the Barberini era was in full force. To the world of Italian baroque, Kircher brought his fanciful, yet erudite enthusiasm for lettering, exotic alphabets, and paper epigraphy, a passion that pervades his works on Egyptian monuments, Oriental religions, China, and other topics. These were first illustrated and printed in Rome and later in Germany and the Netherlands, replete with lavish title pages decorated with scrolls, inscriptions, and books, open and closed. (See FIG. 62.)

In those same years in Rome and in Italy in general, among poets and litterateurs (especially clerical ones), there was a great vogue for visual or

"concrete" poetry, from anagrams to calligrams, acrostics, circular poems, and hundreds of other intricate and subtle systems for the combining of writing and figure, creating new forms of iconic texts. Among these visual poets was Father Giovanni Caramuel, a Spaniard who had come to Rome in 1655 and who later became bishop of Campagna (Salerno). In his treatise *Primus Calamus* (Rome, 1663), Caramuel celebrated the triumph of verse forms that trace labyrinths of poetry running this way and that, ascending, descending, weaving full circles, engraved on bronze, carved on boxwood, or cast in lead ("aut aere incisos aut buxo insculptos aut plumbo infusos"). (The career of this complex Catholic thinker has recently been treated by G. Pozzi.)

The culture to which Tesauro, Kircher, and Caramuel belonged firmly believed that the *calamus,* or reed pen, was, as Carameul wrote, "potentior lingua"—more powerful than the tongue. These writers' obsession with obscurity; their intentional concealing of texts so that these might be read and deciphered; and their fondness for ancient, exotic, or foreign writing systems often misunderstood and poorly displayed, yet always most adventurously interpreted were all complementary aspects of a culture that progressively came to identify itself with the literary-textual process and with baroque figurative expression, organically fused in a unique and distorted vision of the world, manifest on stone, paper, cloth, and metal that were covered with signs and writing in all forms and dating from all periods of history.

The great architects of the times also worked with the medium of "paper" epigraphy as they had with "ephemeral" epigraphy. Bernini provided designs for at least two luxury editions: one, a collection of Urban VIII's poetry published in Rome in 1631 with engravings by Claude Mellan; the other, *Prediche,* by G. P. Olive, published in Venice with engravings by F. Spier, where the title appears along the fold of the lower margin. During the next century, Filippo Juvarra was even more active in the field of book design. Juvarra's work followed trends dominant in Rome during the early eighteenth century and rendered more complex by the artist's strong interest in funerary epigraphy. In fact, in 1733 he printed a collection of a hundred tomb drawings that may be seen today at the Museo Civico in Turin. In his illustrations, the evolution of which may be traced through his sketches, we find emblematic elements as well as the suggestion of epigraphic motifs, as is evident in the title page of *Osservazioni* by A. Adami (Rome, 1711). (See FIG. 61.) In its finished form the engraved title page includes allegorical references to the book, whereas the original sketch was purely lapidary in inspiration.

Somewhat less innocent and neutral was the common practice during the 1600s (recently studied by Luigi Salerno) of inserting mottoes, captions, epigrams, and other texts in the illustration that refer to the picture or comment on it, contesting or criticizing it sometimes in very subversive ways. Among these dissenters we find artists such as Grechetto, Pietro Testa, and Salvator Rosa. In this category, though on a somewhat lower level, we must also place the engravings of Giuseppe Maria Mitelli, active at the end of the 1600s and the beginning of the 1700s, whose work was part of a long-standing tradition of popular engraving designed to appeal to the lower classes. The large and spatially dominating captions of Mitelli's engravings at times show evidence of cultured influences in their complex layouts and letter forms (see FIG. 64), while the simple linear layouts and majuscules that appear in other engravings are reminiscent of the language and style of ex-votos and religious images. A common theme in his work is the ironic portrayal of the humble, wandering peddler of popular prints (who represented the chief means of diffusion of this particular iconographic-textual form) and his impact on people passing in the street. (See FIG. 63.)

Chapter Eight

THE RETURN TO ORDER

Returning once again to Rome and Venice, the two great capitals of Italian graphic culture, we find in the eighteenth century a further accentuation of late baroque tendencies and trends.

The attempt to imitate in stone the semblances of materials unsuitable as writing surfaces continues (cloth, shells, animal skins fashioned out of marble, colored stone, or stucco), as does the use of gold or metal letters. There is a notable emphasis on color and much creative experimentation with variegated marble and colored inlaid stone surfaces. These trends all corresponded to the tastes of the era also expressed in the leather bindings of luxury editions, which were colored with wax or decorated with leather mosaic designs.

In Rome we find many examples of these late-baroque tendencies: the monument to Carlo Maratta (d. 1704) which he designed himself, decorated with a prophyry vase (see FIG. 65); the complex monument to Henri Langrange (d. 1707) in San Luigi dei Francesi; the striking epigraphs inscribed on marble animal skins on the tombs of B. Pasquini (d. 1710) in San Lorenzo in Lucina (see FIG. 66) and of P. Carcarasio (d. 1716) in San Francesco a Ripa; the epigraph engraved on a marble shell on the tomb of Cardinal F. Paolucci (d. 1726) in San Marcello; and the complex tomb of A. G. Capponi (d. 1746) in San Giovanni de' Fiorentini, designed by F. Fuga with sculptures by R.-M. Slodtz (see FIG. 67). Further evidence of the continuing baroque fashion is the tomb of the architect C. Pio Balestra (d. 1772) built by Tommaso Righi in the Church of SS. Luca and Martina (see FIG. 68), a monument that Piranesi dismissed rather contemptuously as "a rag, a medallion, and a cherub." In Venice we should note the gilded inscriptions carved on black banners in the Valier mausoleum (1708) in SS. Giovanni and Paolo and the large plaque with relief lettering, which was perhaps gilded originally, mounted on the facade of the Church of the Gesuati in 1736. (See FIG. 70.)

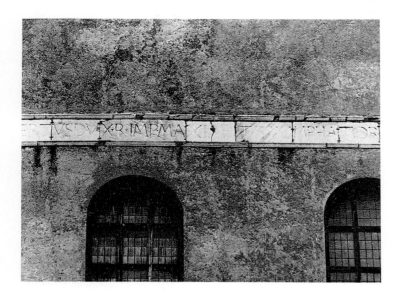

1. Inscription commissioned by Robert Guiscard for the founding of the duomo (detail), 1081. Salerno. (Photo: Grimaldi, Salerno)

2. Inscription commemorating the founding of the duomo, after 1064. Pisa. (Photo: O.p.p.)

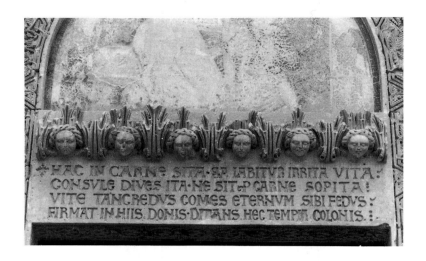

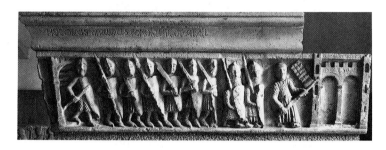

3. Inscription mounted on the Church of SS. Niccolò and Cataldo by Tancredi, count of Lecce, 1180. Lecce. (Photo: Leone, Lecce)

4. Inscription commemorating the reentry of the Milanese into their city, after 1171. Milan, Museo d'Arte Antica del Castello Sforzesco (previously located on the Porta Romana). (Photo: Einaudi, Turin)

+ ANNO DNICE INCAR MILE CE
SIMO SEXAGESIMO SEPTIMO D
IOVIS QVINTO HAE MAGIT MEDI
LANENSES INTRAVERVNT CIV
TATEM
+ ANNO DNICE INCAR MILE CE
TESIMO SEPTVAGESIMO PRIM
MENSE MARTII HOC OP TVRRIV
ET PORTARVM HABVIT INITIVM
CONSVLES REI PVBLICE QVI TVI
ERANT ET HOC OP FIERI FECER
VNT FVERVNT PASSAGVDVS
DE SETARA ARDERICVS DE LA
TVRRE PINAMONTE DE VIMERCA
TO OBERTVS DE ORTO MALCONVE
NTVS COTTA ARNALDVS DE MI
RIOLA ADOBADVS BVTRAFFVS
MALAGALLIA DE ALLIATE MAI
FILLIOCIVS DE ERMENVLFIS RO
GERIVS MARCELLINVS ET
IPSIMET OPVS DE LACLVSA
FIERI FECERVNT

5. Inscription commemorating the rebuilding the city walls of Milan, after 1171. Milan, Museo d'Arte Antica del Castello Sforzesco. (Photo: Einaudi, Turin)

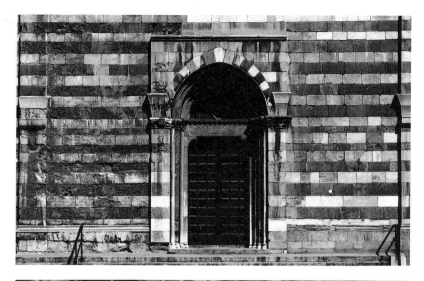

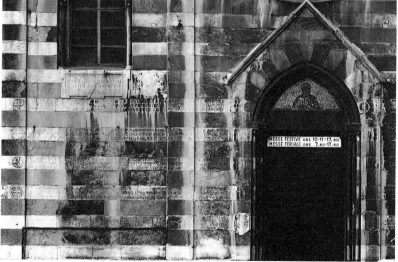

6. Inscriptions celebrating the Da Passano family, 1100–1500s. Genoa, Santo Stefano. (Photo: Pellion, Turin)

7. Inscriptions celebrating the Doria family, 1200–1500s. Genoa, San Matteo. (Photo: Pellion, Turin)

8. Inscription commissioned by Cardinal Giovanni of Sutri on the portico of the Basilica of SS. Giovanni and Paolo, mid–twelfth century. Rome. (Photo: Savio, Rome)

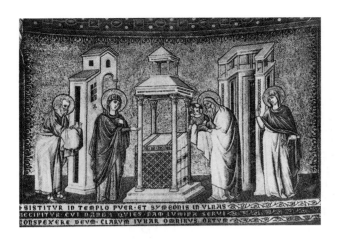

SISTITVR IN TEMPLO PVER ET SYMEONIS IN VLNAS
ACCIPITVR CVI DANDA QVIES NAM LVMINA SERVI
CONSPEXERE DEVM CLARVM IVBAR OMNIBVS ORTVM

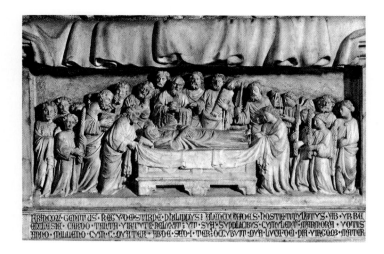

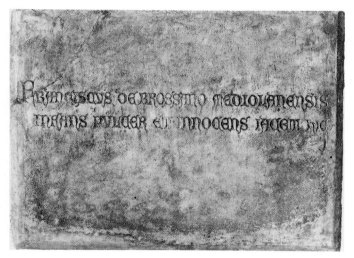

9. Pietro Cavallini, *La presentazione al Tempio,* mosaic, 1291. Rome, Santa Maria in Trastevere. (Photo: Alinari Archives, Florence)

10. Cimabue, *Ytalia* (detail of a fresco depicting *San Matteo Evangelista*), 1277–80. Assisi, San Francesco, upper basilica.

11. Example of a Gothic epigraph on the funerary monument to Cardinal Filippo d'Alençon, 1397. Rome, Santa Maria in Trastevere. (Photo: Alinari Archives, Florence)

12. Tombstone of Petrarch's nephew, Francescuolo da Brossano, 1368. Pavia, Musei Civici del Castello Visconteo (previously in the Church of San Zeno). (Photo: Carraro, Pavia)

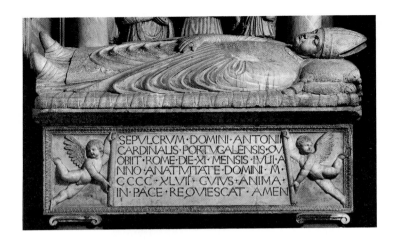

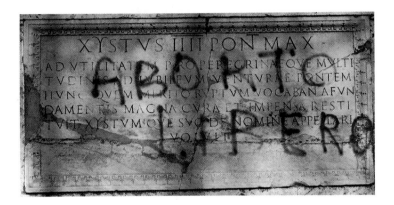

13. Example of the "Florentine" epigraphic capital in the funerary monument to Cardinal Antonio Martinez de Chaves di Isaia of Pisa, 1447. Rome, San Giovanni in Laterano. (Photo: Alinari Archives, the Anderson Collection, Florence)

14. An example of "Sistine epigraphy," one of two celebrative inscriptions located on the Ponte Sisto, 1475. Note the "natural palimpsest" written in spray paint, 1977. Rome. (Photo: Savio, Rome)

15. Example of "Sistine epigraphy" in the funerary inscription of Captain Antonio de Rio, 1475. Rome, Santa Francesca Romana. (Photo: Alinari Archives, the Anderson Collection, Florence)

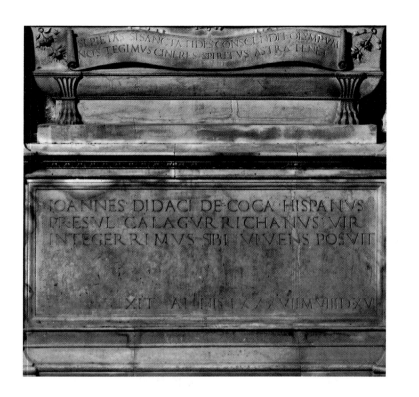

SI PIETAS SANCTA FIDES CONSCENDIT OLYMPVM
NOS TEGIMVS CINERES SPIRITVS ASTRA TENET

IOANNES DIDACI DE COCA HISPANVS
PRESVL CALAGVRRICHANVS VIR
INTEGERRIMVS SIBI VIVENS POSVIT

VIXIT ANNIS LXXXVIIM VIIID XVI

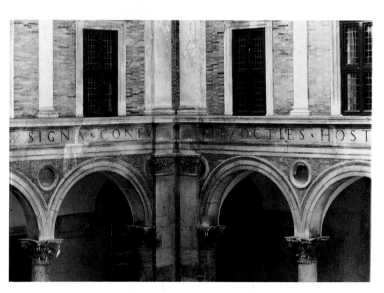

SIGNA CONIV IT OCTIES HOST

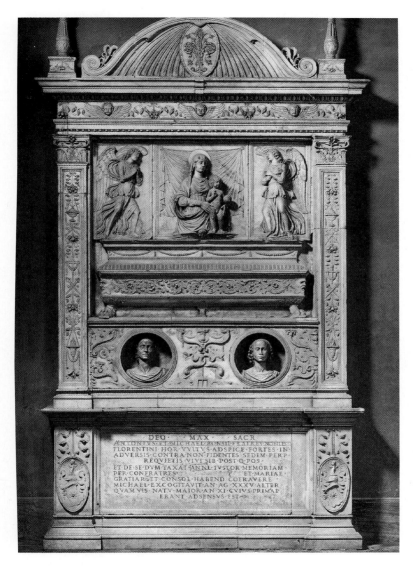

DEO · MAX · SACR
ANTONIVS · ET · MICHAEL · BONSII · FRATRES · NOBILES
FLORENTINI · HOR · VVLTVS · ADSPICE · FORTES · IN
ADVERSIS · CONTRA · NON · FIDENTES · SEDEM · PERP
REQVIETIS · VIVI · SIB · POST · Q · POS ·
ET · DE · SE · DVM · TAXAT · [ANNI · IVSTOR MEMORIAM ·
PER · CONFRATRES ·] C · ET · MARIAE ·
GRATIAR · ET · CONSOL · HABEND · COERAVERE
MICHAEL · EXCOGITAVIT · AN · AG · XXXXV · ALTER ·
QVAM · VIS · NATV · MAIOR · AN · XI · CVIVS · PRIMAE
ERANT · ADSENSVS · EST →

16. Double inscription on the funerary monument of Cardinal Juan Diáz de Coca, 1477. Rome, Santa Maria Sopra Minerva. (Photo: Alinari Archives, the Anderson Collection, Florence)

17. Inscription in the courtyard of the Ducal Palace, commissioned by Guidobaldo I, late fifteenth century, Urbino. (Photo: Moderna, Urbino)

18. Sistine inscription on the antique-style funerary monument to the Bonsi brothers, dating from the end of the fifteenth century. Rome, San Gregorio al Celio. (Photo: Alinari Archives, the Anderson Collection, Florence)

Questo nobile & spectatissimo fragmento in uno solido frusto anco
ra & una portiúcula dil suo fastigio, o uero frontispicio se retinea egregia
méte liniato. Nella triangulare planitie dilquale dui figmenti io uidi in-
scalpti, & non integri. Vno uolucre decapitato, arbitrai fusse di Bubone,
& una uetusta lucerna, tuto di perfecto alabastryte. Cusi io le interpretai.
VITAELETHIFER NVNTIVS.
 Peruenuto daposcia in la mediana parte dil tempio, alquanto ímune
& disoccupata di fressidine la trouai. Oue ancora il cósumabile tempo,
ad una opera pclara di narrato, tuta di rubicundo porphyrite, solamente
hauea perdonato. Laquale era sexangula, cum le base sopra una solida pe
tra ophites dillamedesima figura nel pauimento ipacta, & sei columnelle
distáte una dalaltra pedi sei, cú lo epistilio. zophoro, & coronice, sencia al
cuno liniaméto & signo, ma simplicemente terso & puro. Gliquali erano
extrinseco la forma imitanti. Ma intersticii in figura circinata. Oue sopra
la piana dilla corona nasceua una cupula di unico & solido saxo, mirabi
le artificio. Laquale graciliua nel acumine, quale uno peruio infu-
mibulo strisso & speculare copriua una subterranea uacui-
tate illuminata p una circulare aptione di egre-
gia cancellatura impedita di metal
lina fusura. Ilquale spectando ci
borio di maxima pol-
litura cusi il tro
uai.

19. Antique-style inscription on the house of the Lorenzo Manilio
(detail), 1468, with an example of the reusing of an inscription from
the classical age. The small epigraph above dates from the eighteenth
century. Rome, Portico d'Ottavia. (Photo: Savio, Rome)

20. Example of an imaginary epigraph from the *Hypnerotomachia Pol-
iphili* (Venice, 1499). (Photo: F. Petrucci, Rome)

21. Tombstone of P. M. Bazariotti, 1512. Venice, SS. Giovanni and Paolo. (Photo: Böhm, Venice)

22. Tombstone of M. A. Trevisan, doge of Venice, 1554. Venice, San Francesco Alla Vigna. (Photo: Böhm, Venice)

23. Tombstone of Alvise Marcel, 1517. Venice, Frari, sacristy. (Photo: Böhm, Venice)

24. Epigraph celebrating Filippo Colonna, constable of the kingdom of Naples. Rome, Palazzina of Pius IV in Via Flaminia. (Photo: Natale, Rome)

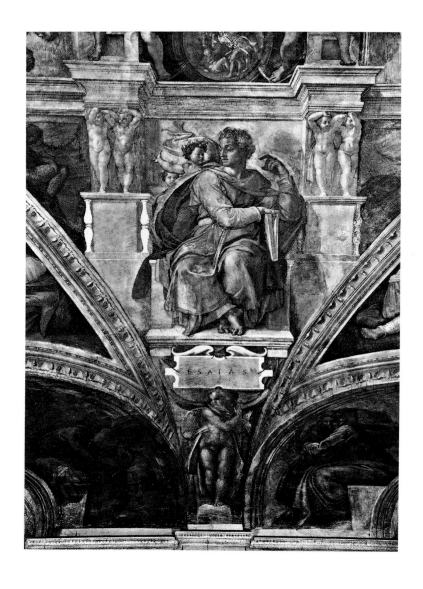

25. Michelangelo, *The Prophet Isaiah,* 1508–10. Rome, Sistine
Chapel. (Photo: Gabinetto Fotografico Nazionale, Rome)

PAVLVS III PONT. MAX. STATVAM AENEAM
EQVESTREM. A. S. P. Q. R. M. ANTONINO PIO ETIAM
TVM VIVENTI STATVTAM VARIIS DEIN VRBIS
CASIB: EVERSAM ET A SIXTO IIII PONT. MAX. AD
LATERAN, BASILICAM REPOSITAM VT MEMO
RIAE OPT, PRINCIPIS CONSVLERET PATRIAEQ.
DECORA ATQ. ORNAMENTA RESTITVERET
EX HVMILIORI LOCO IN AREAM CAPITOLINAM
TRANSTVLIT ATQ. DICAVIT
ANN SAL. M. D XXXVIII

26. Michelangelo's inscription on the base of the equestrian statue
of Marcus Aurelius. Rome, Piazza del Campidoglio. (Photo: F. Pe-
trucci, Rome)

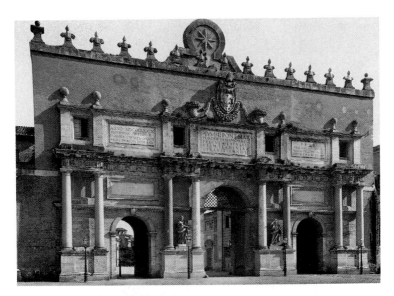

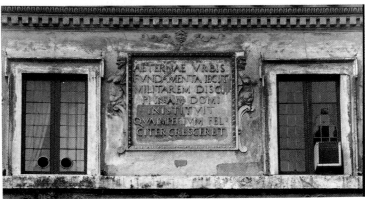

27. Giovanni Battista Palatino, inscription on the Porta del Popolo, 1562–63. Rome, Piazzale Flaminio. (Photo: Alinari Archives, the Anderson Collection, Florence)

28. Example of a relief inscription, plaque on the facade of Palazzo Spada, 1556–60. Rome. (Photo: Savio, Rome)

29. Michelangelo, inscription on the inner facade of Porta Pia, 1565. Rome. (Photo: F. Petrucci, Rome)

30. Celebrative inscription commissioned by Cardinal Alessandro Farenese for the inner facade of the Church of Gesù, 1575. Rome. (Photo: Savio, Rome)

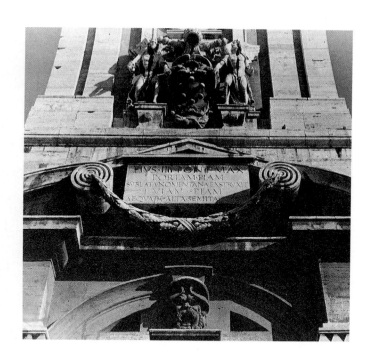

PIVS · IIII · PONT · MAX
PORTAM · PIAM
SVBLATA · NOMENTANA · EXSTRVXIT
VIAM · PIAM
A · PORTA · AD · ALTA · SEMITA

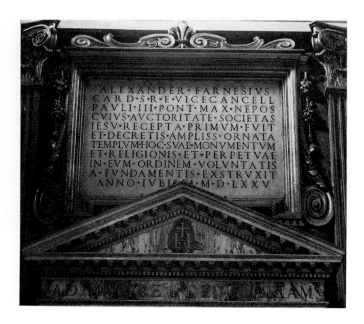

ALEXANDER · FARNESIVS
CARD · S · R · E · VICECANCELL
PAVLI · III · PONT · MAX · NEPOS
CVIVS · AVCTORITATE · SOCIETAS
IESV · RECEPTA · PRIMVM · FVIT
ET · DECRETIS · AMPLISS · ORNATA
TEMPLVM · HOC · SVAE · MONVMENTVM
ET · RELIGIONIS · ET · PERPETVAE
IN · EVM · ORDINEM · VOLVNTATIS
A · FVNDAMENTIS · EXSTRVXIT
ANNO · IVBILAEI · M · D · LXXV

AD · MAIOREM · DEI · GLORIAM

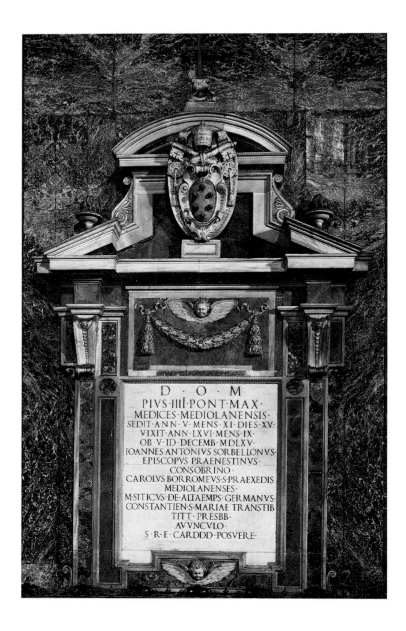

D · O · M
PIVS · IIII · PONT · MAX ·
MEDICES · MEDIOLANENSIS ·
SEDIT · ANN · V · MENS · XI · DIES · XV ·
VIXIT · ANN · LXVI · MENS · IX ·
OB · V · ID · DECEMB · MDLXV ·
IOANNES ANTONIVS SORBELLONVS ·
EPISCOPVS PRAENESTINVS ·
CONSOBRINO ·
CAROLVS BORROMEVS·S·PRAEXEDIS
MEDIOLANENSES ·
M·SITICVS · DE · ALTAEMPS · GERMANVS·
CONSTANTIEN·S·MARIAE TRANSTIB ·
TITT · PRESBB ·
AVVNCVLO ·
S · R · E · CARDDD · POSVERE ·

31. Inscription engraved by Alessandro Cioli on the tomb of Pope Pius IV. Rome, Santa Maria degli Angeli. (Photo: Alinari Archives, Florence)

32. Tombstone of Francesco Maria I Della Rovere. Urbino, Santa Chiara. (Photo: Moderna, Urbino)

TOT RVINIS SERVATAM IVL CÆSAR SIXTI IIII PONT NEPOS HIC STATVIT

SIXTO V PONT MAX
ORD MIN CON
IVSTITIAE VINDICI
PROPAGATORI
RELIGIONIS
A · M · D L X X X VI

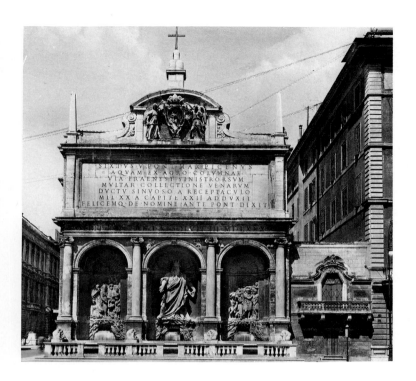

33. An illustration of the relationship between the Sistine-style and the Horfei-style epigraph. Rome, SS. Apostoli, portico. (Photo: Savio, Rome)

34. Inscription engraved by Luca Horfei on the obelisk facing the apse of Santa Maria Maggiore, 1587. Rome, Piazza dell'Esquilino. (Photo: Savio, Rome)

35. Inscription engraved by Luca Horfei for the Fontana dell'Acqua Felice, 1587. Rome, Piazza San Bernardo. (Photo: Alinari Archives, Florence)

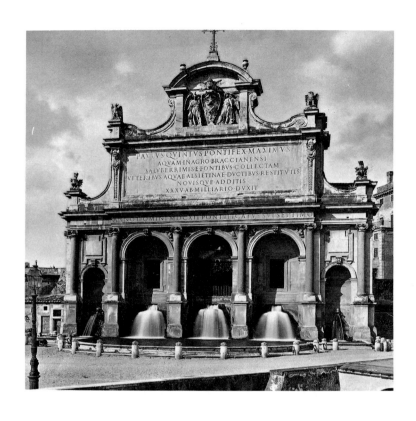

36. Epigraph commissioned by Pope Paul V on the Fontana dell'Acqua Paola, 1612. Rome, Janiculum. (Photo: Alinari Archives, Florence)

37. Long inscription on the nymphaeum of Villa Aldobrandini, 1619. Frascati. (Photo: Natale, Rome)

38. Guercino, *Et in Arcadia ego,* 1621–23. Rome, Galleria Nazionale d'Arte Antica. (Photo: Gabinetto Fotografico Nazionale, Rome)

39. Nicolas Poussin, *Et in Arcadia ego* (second version), 1635. Paris, Louvre. (Photo: Louvre, Paris)

40. Nicolas Poussin, *Et in Arcadia ego* (first version), 1630. Chatsworth, from the collection of the duke of Devonshire.

41. Jacopo del Duca, funerary monument to Elena Savelli, 1570. Rome, San Giovanni in Laterano. (Photo: Savio, Rome)

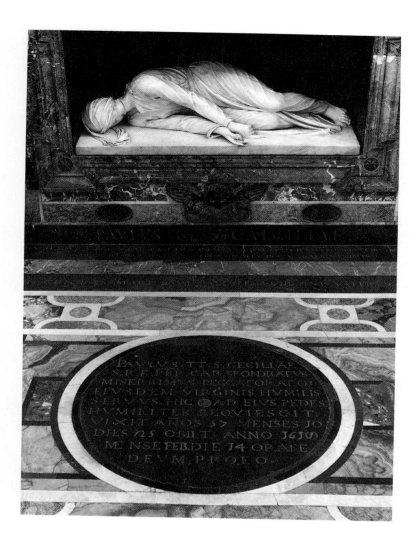

42. Tombstone of Cardinal Paolo Sfrondato, located below the
monument to Santa Cecilia by Stefano Maderno, 1618. Rome, Santa
Cecilia in Trastevere. (Photo: Savio, Rome)

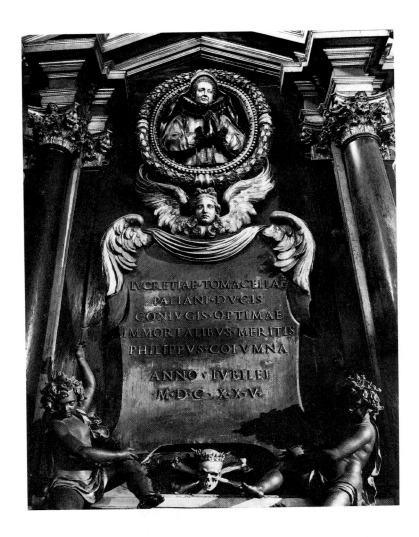

43. Epigraph celebrating Lucrezia Tomacelli, 1625. Rome, San Giovanni in Laterano, Cappella Colonna. (Photo: Savio, Rome)

44. Epigraph on marble drapery celebrating Francesca Caldarini Pecori Riccardi, 1655. Rome, San Giovanni dei Fiorentini. (Photo: Savio, Rome)

45. Epigraph on marble drapery celebrating Luca Holstenio, 1661. Rome, Santa Maria dell'Anima. (Photo: Savio, Rome)

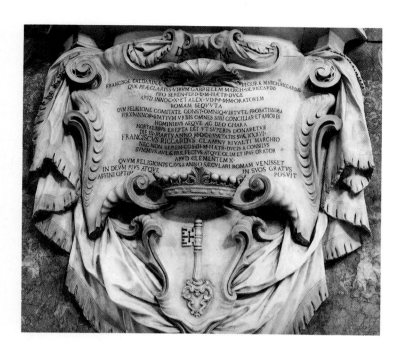

FRANCISCÆ CALDARINÆ · · · · · DECORÆ MARCH · RICCARDÆ
QVÆ PRÆCLARISS · VIRVM GABRIELEM MARCH · DE RICCARDIS
PRO SEREN · FERD · II · M · HÆTR · DVCE
APVD INNOC · X · ET ALEX · VII · P · P · M · M · ORATOREM
ROMAM SEQVVTA
DVM RELIGIONE COMITATE CONST · OMNIQ · VIRTVTE PROBATISSIMA
PER XI ANNOR · SPATIVM VRBIS OMNES SIBI CONCILIAR ET AMORES
HOMINIBVS ÆQVE AC DEO CHARA
MORTALIBVS EREPTA EST VT SVPERIS DONARETVR
DIE III · MARTY ANNO M DCC LV ÆTATIS SVÆ XXXVI ·
FRANCISCVS RICCARDVS GLAMNY RIVALTI MARCHIO
NEC NON SEREN · COS · III · M · HÆTR · DVCIS A CONSILYS
SVMMVS AVLÆ PRÆFECTVS ATQVE OLIM ET IPSE ORATOR
APVD CLEMENTEM X ·
QVVM RELIGIONIS CAVSA ANNO SÆCVLARI ROMAM VENISSET
IN DEVM PIVS ATQVE IN SVOS GRATVS
AFFINI OPTIM POSVIT

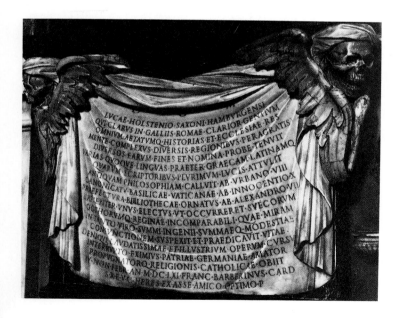

LVCÆ · HOLSTENIO · SAXONI · HAMBVRGENSI
QVI · CLARVS · IN · GALLIIS · ROMÆ · CLARIOR · RES
OMNIVM · ÆTATVMQ · HISTORIAS · ET · ECCLESIÆ · RES
MENTE · COMPLEXVS · DIVERSIS · REGIONIBVS · PERAGRATIS
DIVERSOS · EARVM · FINES · ET · NOMINA · PROBE · TENVIT
VARIAS · QVOQVE · LINGVAS · PRÆTER · GRÆCAM · LATINAMQ
QVARVM · SCRIPTORIBVS · PLVRIMVM · LVCIS · ATTVLIT
ANTIQVAM · PHILOSOPHIAM · CALLVIT · AB · VRBANO · VIII
CANONICATV · BASILICÆ · VATICANÆ · AB · INNOCENTIO X
PRÆFECTVRA · BIBLIOTHECÆ · ORNATVS · AB · ALEXANDRO VII
FELICITER · VNVS · ELECTVS · VT · OCCVRRERET · SVECORVM
GOTHORVMQ · REGINÆ · INCOMPARABILI · QVÆ · MIRAM
IN · TATO · VIRO · SVMMI · INGENII · SVMMÆQ · MODESTIÆ
CONIVNCTIONEM · SVSPEXIT · ET · PRÆDICAVIT · VITÆ
DENIQVE · LAVDATISSIMÆ · ET · ILLVSTRIVM · OPERVM · CVRSV
INTERRVPTO · EXIMIVS · PATRIÆ · GERMANIÆ · AMATOR
PROPVGNATORQ · RELIGIONIS · CATHOLICÆ · OBIIT
IIX · NON · FEBR · AN · M · DC · LXI · FRANC · BARBERINVS · CARD
S · R · E · VICE · HERPS · EX · ASSE · AMICO · OPTIMO · P

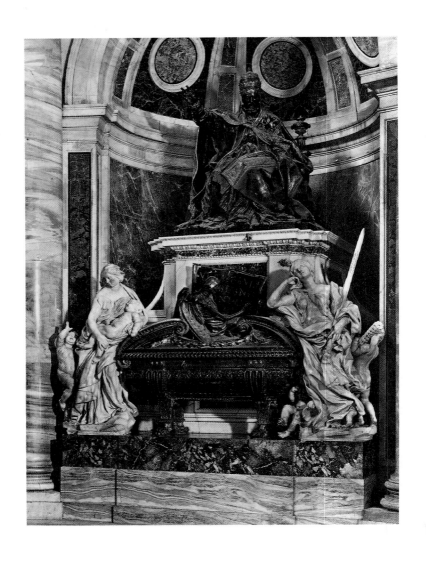

46. Gian Lorenzo Bernini, tomb of Urban VIII, 1628. Rome, Saint
Peter's. (Photo: Alinari Archives, Florence)

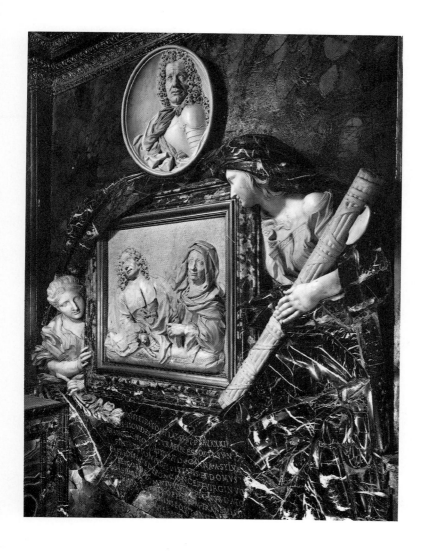

47. Gian Lorenzo Bernini, funerary monument to Francesco and Giovanna De Silva. Rome, Sant'Isidoro. (Photo: Alinari Archives, the Anderson Collection, Florence)

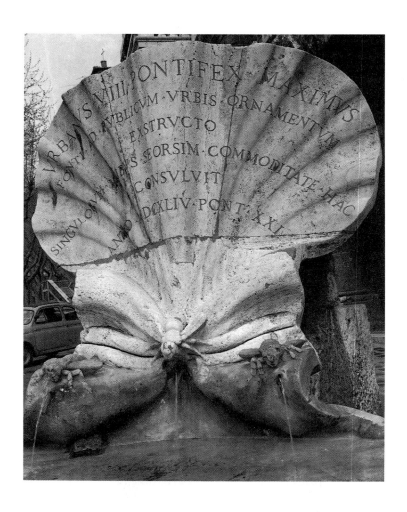

48. Gian Lorenzo Bernini, the Fontana delle Api showing the Bar-
berini bee, 1644. Rome, Piazza Barberini. (Photo: Savio, Rome)

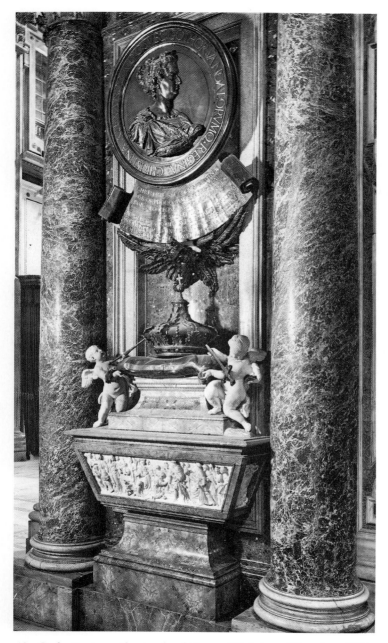

49. Carlo Fontana, the tomb of Queen Christina of Sweden, 1702. Rome, Saint Peter's. (Photo: Alinari Archives, Florence)

50. Tombstone of Cardinal Andrea Barberini, 1646. Rome, Church of the Capuchins. (Photo: Savio, Rome)

51. Tombstone of Lazzaro Ferro, 1692. Venice, Santo Stefano. (Photo: Böhm, Venice)

COM. LAZARI FERREI
VIRI PATRITII
CINERES.

IOANNES
AMANTISSIMUS FRATER
P.
ANNO M.DC.XCII.

52. Funerary monument to Lazzaro Ferro, 1692. Venice, Santo Ste-
fano. (Photo: Böhm, Venice)

53. Inscription on the funerary monument to Vincenzo Fini, founder of San Moisè, 1683. Venice, facade of the Church of San Moisè. (Photo: Böhm, Venice)

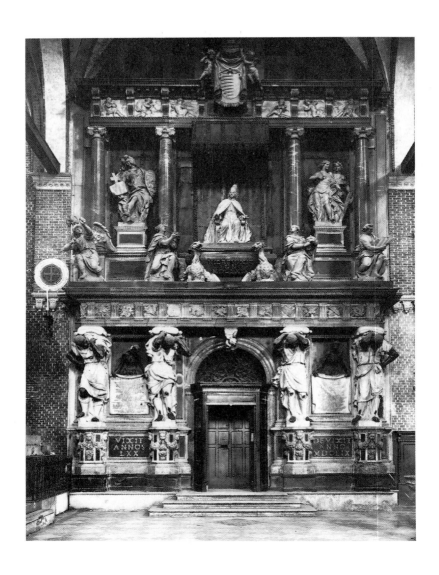

54. Emanuele Tesauro, epigraphs adorning the tomb of Doge Gio-
vanni Pesaro, built by Baldassarre Longhena, 1659. Venice, Frari.
(Photo: Böhm, Venice)

55. Inscription on the facade of Sant'Angelo (detail), 1663. Note the
rounded, sculpted letter forms and the cupids. Lecce. (Photo: Le-
one, Lecce)

56. Philippe Thomassin, engraved title page. In G. V. Imperiale, *Lo stato rustico* (Genoa, 1611). (Photo Pisseri, Parma)

57. Engraved title page. In Amedeo di Castellamonte, *La Venaria reale* (Turin, 1672). (Photo: Crea, Rome)

58. Engraved title page. In *Il sontuoso apparato* (Brescia, n.d.) (Photo: F. Petrucci, Rome)

HESPERIDES
SIVE
MALORVM
AVREORVM
CVLTVRA
ET VSVS

PETR. BERRET. IN. CORTON. DELIN.

I. GREVTER. INCID.

59. Pietro da Cortona (the original drawing) and Johann Friedrich Greuter (the engraving), frontispiece. In G. B. Ferrari, *Hesperides* (Rome, 1646). (Photo: Savio, Rome)

60. Engraved frontispiece. In
Girolamo Teti, *Aedes barberinae*
(Rome, 1642). (Photo: Savio,
Rome)

61. Filippo Juvarra, engraved title
page. In Andrea Adami, *Osservazi-
oni per ben regolare il Coro della Cap-
pella Pontificia* (Rome, 1711).
(Photo: Savio, Rome)

ATHANASII KIRCHERI E SOCIETATE IESV
OEDIPVS ÆGYPTIACVS
AD FERDINANDVM III CÆSAREM SEMPER AVGVSTVM.

62. Athanasius Kircher, *Oedipus Aegyptiacus* . . . vol. 1 (Rome, 1602).

63. Giuseppe Maria Mitelli, *Compra chi vuole,* copperplate engraving, 1688.

64. Giuseppe Maria Mitelli, *La Cucagna nuova,* copperplate engraving, 1703.

65. Funerary monument to Carlo Maratta, 1704. Rome, Santa Maria degli Angeli. (Photo: Alinari Archives, Florence)

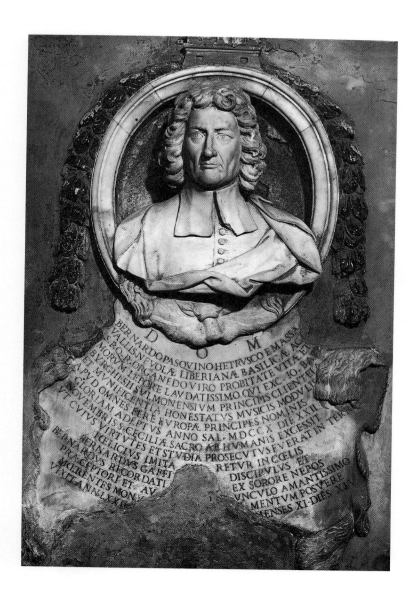

66. Inscription on surface carved in the shape of an animal skin on the funerary monument to Bernardino Pasquini, 1710. Rome, San Lorenzo in Lucina. (Photo: Alinari Archives, Florence)

ALEXANDER·GREGORIVS·MARCHIO·CAPPONIVS
ORIGIN·FLORENTINVS·NATV·ROMANVS
SACRI·PALATII·APOSTOLICI
CLEMENTI·XII·ET·BENEDICTO·XIV·PONT·MAX·
FORERIVS·MADE
CAPPONIAE·STIRPIS·ROMAE·ANTE·ALTERAM
ABHINC·SAECVLI·COMMORANTIS
POSTREMVS
QVI
AVITA·QVOAD·LICVIT·SECTATVS·EXEMPLA
SEMIPARALYSI·PRIDEM·CORREPTVS
AB·EA·SOSPES·MORTIS·TAMEN·MEMOR
VT·PIE·DEVM·PRO·EO·OMNES·DEPRECENTVR
VIVENS·ET·COELERS·SIBI·FECIT
A·D·MDCCXLVI
AETATIS·SVAE·LXIII

67. Ferdinando Fuga and René-Michel Slodz, funerary monument to Alessandro Gregorio Capponi, 1746. Rome, San Giovanni dei Fiorentini. (Photo: Savio, Rome)

68. Tommaso Righi, funerary monument to C. Pio Balestra, 1776. Rome, Church of SS. Luca and Martina. (Photo: Savio, Rome)

EST VULTV, EST ANIMO, GESTISQVE INSIGNIBVS HERO.
SED VIRTVTE MAGIS QVEM LAPIS ISTE REFERT.
ARS VIOLARE TIMENS VENERANDÆ FRONTIS HONORE
NON AVSA EST FERRO SCVLPERE, SCVLPSIT AQVA.

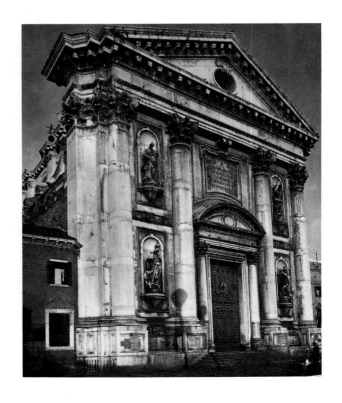

69. C. F. Diana, inscription celebrating Clement XII, after 1740. Rome, Biblioteca dell'Accademia Nazionale dei Lincei, atrium. (Photo: Savio, Rome)

70. Dedicatory inscription in relief lettering, 1736. Venice, Church of the Gesuati alle Zattere, facade. (Photo: Böhm, Venice)

71. Tomb of Alessandro Sobieski, 1714. Rome, Church of the Capuchins. (Photo: Savio, Rome)

72. Engraved title page. In Ridolfino Venuti and Antonio Borioni, *Collectanea antiquitatum romanarum* (Rome [1735]). (Photo: Savio, Rome)

73. Engraved title page. In Silvano Razzi, *Vita di Piero Soderini* (Padua, 1737). (Photo: F. Petrucci, Rome)

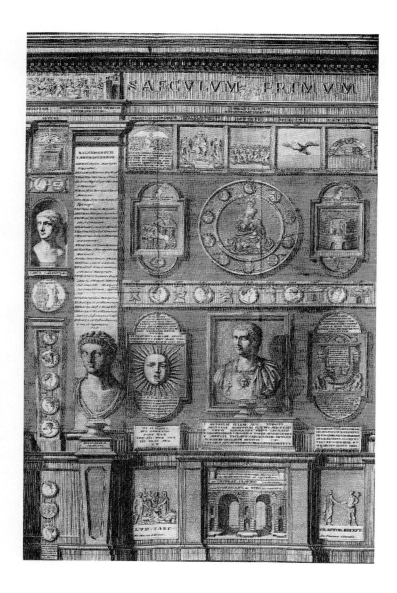

74. Francesco Bianchini, *Demonstratio historiae ecclesiasticae,* copperplate engraving (Rome, 1752–54), vol. 2, tabula secunda, saeculi primi, quarta parte.

75. Giambattista Piranesi, engraved title page. In G. B. Piranesi, *Lapides Capitolini* (Rome, 1762). (Photo: Savio, Rome)

76. Giambattista Piranesi, engraved title page. In G. B. Piranesi, *Antichità di Cora* (Rome, 1764). (Photo: Savio, Rome)

77. Inscription commissioned by Emperor Claudius in 51 A.D. cele-
brating the conquest of Britain. Rome, Campidoglio, courtyard of
the Palazzo Senatorio. (Photo: F. Petrucci, Rome)

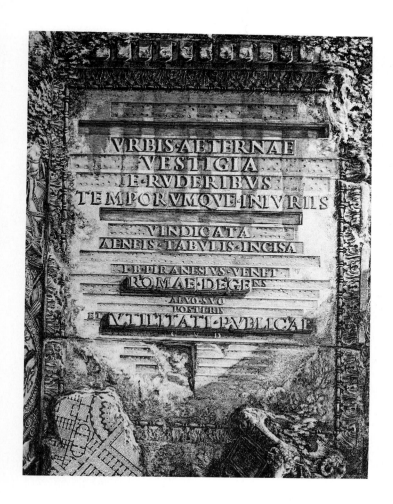

78. Giambattista Piranesi, engraved title page (3d ed.). In G. B. Piranesi *Le Antichità romane* (Rome, 1757). The dedication to Lord Charlemont has been obliterated. (Photo: Savio, Rome)

IOANNES · BAPTISTA
REZZONICO
SS·DOMINI·NOSTRI
CLEMENTIS·PP·XIII
FRATRIS·FILIVS
AC·MAGNVS·PRIOR
VT·LOCI·MAIESTATEM
AVGERET
AREAM·HANC
LAXANDAM·CVRAVIT
A·P·C·N
MDCCLXV

79. Epigraph designed by Giambattista Piranesi for the priorate of the Knights of Malta, 1765. Rome. (Photo: Natale, Rome)

80. Giambattista Piranesi, *Via Appia,* engraving. In G. Piranesi, *Le Antichità romane* (Rome, 1756). (Photo: Savio, Rome)

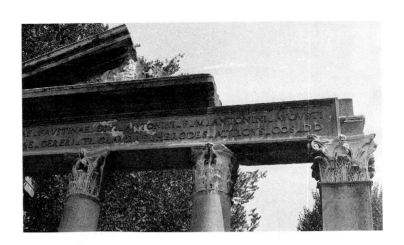

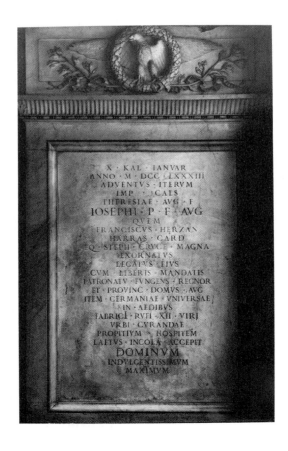

X · KAL · IANVAR
ANNO · M · DCC · LXXXIII
ADVENTVS · ITERVM
IMP · CAES
THERESIAE · AVG · F
IOSEPHI · P · F · AVG
QVEM
FRANCISCVS · HERZAN
HARRAS · CARD
EQ · STEPH · CRVCE · MAGNA
EXORNATVS
LEGATVS · EIVS
CVM · LIBERIS · MANDATIS
PATRONATV · FVNGENS · REGNOR
ET · PROVINC · DOMVS · AVG
ITEM · GERMANIAE · VNIVERSAE
IN · AEDIBVS
FABRICI · RVEI · XII · VIRI
VRBI · CVRANDAE
PROPITIVM · HOSPITEM
LAETVS · INCOLA · ACCEPIT
DOMINVM
INDVLGENTISSIMVM
MAXIMVM

SCHOLA·ITALICA·PICTVRAE

SIVE

SELECTAE·QVAEDAM·SVMMORVM·E·SCHOLA

ITALICA·PICTORVM·TABVLAE

AERE·INCISAE·CVRA·ET·IMPENSIS

GAVINI·HAMILTON·PICTORIS

ROMAE·CIƆIƆCCLXXIII

81. Neoclassical inscription on the imitation neoclassical temple of Antonino and Faustina built by Antonio Asprucci (detail), 1783. Rome, Villa Borghese. (Photo: Savio, Rome)

82. An example of Roman neoclassical epigraphy directly inspired by classical figurative and epigraphic models of the Renaissance, 1772. (See also FIG. 33.) (Photo. Savio, Rome)

83. Giuseppe Perini, engraved title page. In Gavin Hamilton, *Schola italica picturae* (Rome, 1773). (Photo: Savio, Rome)

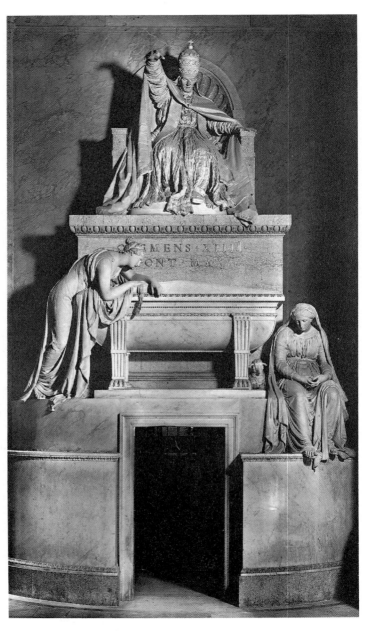

84. Antonio Canova, tomb of Pope Clement XIV, 1787. Rome, SS. Apostoli. (Photo: Alinari Archives, the Anderson Collection, Florence)

Q.

HORATII

FLACCI

OPERA

PARMAE
IN AEDIBVS PALATINIS
CIƆ IƆ CC LXXXXI.
TYPIS BODONIANIS.

85. Giambattista Bodoni, title page. In Horace, *Opera* (Parma, 1791). (Photo: F. Petrucci, Rome)

86. Large inscription in Palazzo Serbelloni, 1794. Milan. (Photo: Pellion, Turin)

87. Inscribed loculi in the sepulchral chapel of the dukes of Parma, 1823. Parma, Santa Maria della Steccata. (Photo: Soprintendenza ai Beni Artistici e Storici, Parma)

88. Large inscription on Palazzo Belgioioso d'Este, 1787. Milan. (Photo: Pellion, Turin).

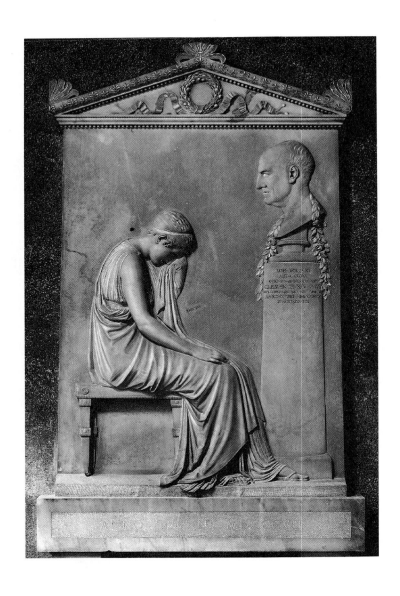

89. Antonio Canova, funerary monument to Giovanni Volpato, 1807. Rome, SS. Apostoli. (Photo: Savio, Rome)

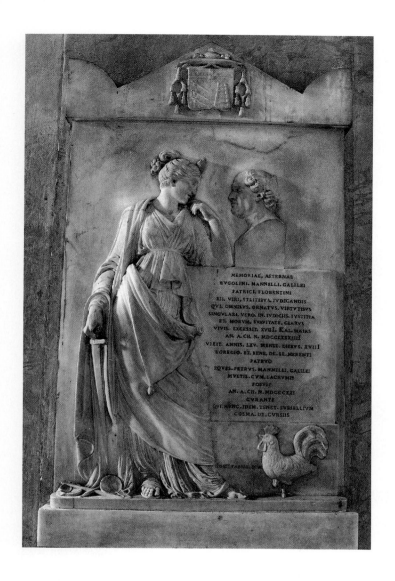

90. Giovanni Fabris, funerary monument to U. Mannelli Galilei, 1821. Rome, San Giovanni dei Fiorentini. (Photo: Savio, Rome)

91. Inscription in metal letters commissioned by Pius VII on the obelisk in Piazza del Quirinale, 1818. Rome. (Photo: Savio, Rome)

92. Inscription on the fronton of the Teatro Argentina, 1837. Rome. (Photo: Savio, Rome)

93. One of two inscriptions mounted by Pius IX on Porta Pia, 1861.
Rome. (Photo: Savio, Rome)

94. Epigraph in classical style drafted and signed by Giuseppe Gari-
baldi. Camogli, Piazza Schiaffino. (Photo: F. Petrucci, Rome)

95. Sano di Pietro, *Callisto III e la Madonna,* oil on wood panel, 1456. Siena, Pinacoteca Nazionale. (Photo: Alinari Archives, the Anderson Collection, Florence)

MERCVRIO E PIANETA MASCVLINO·POSTO NEL SECONDO CIELO ET SECHO MA PERCHE LA SVA SI
·CCITA·E MOLTO E·PASSIVA LVI·E FREDO· CONQVEGLI·SEGNI CHE SONO FRDDI EVMIDO COGLI HVM
DI E ELOQVENTE· INGEGNIOSO·AMA LE SCIENTIE MATEMATICHA E STVDIA NELLE·DIVI NATIONE
HA·ILCORPO· GRACILE COE SCHIETTO·E LABRI SOTTILI STATVRA CONPIVTA DE METALLI A LALA
RGENTO VIVO ELDISVO E MERCOLEDI·COLLA PRIMA·ORA· 8·15 E 22 LA NOTTE SVA E DELDI·DELLA
DOMENICA·A·P AMICO·ILSOLE·P NIMICHA· VENERE· LA SVA· VITA· OVERO· ESALTATIONE·E VIRGO·L
A SVA·MORTE· OVERO· HVMILIATIONE· EPISCE HA DVA HABITATIONE· GEMINI·DIDI·VIRGO DIN·
OTTE· VA E 12 SEGNI· IN 5 38 DI COMINCIANDO DA VIRGO· IN ZO DI E 2 HORE VAVN SEN·
DO

96. Florentine engraving, *Mercurio*, 1460. (Photo: F. Petrucci, Rome)

97. Florentine engraving, *La Sibilla Tiburtina*, 1470. (Photo: F. Petrucci, Rome)

98. Albarello di Faenza, ceramic jar, 1480.

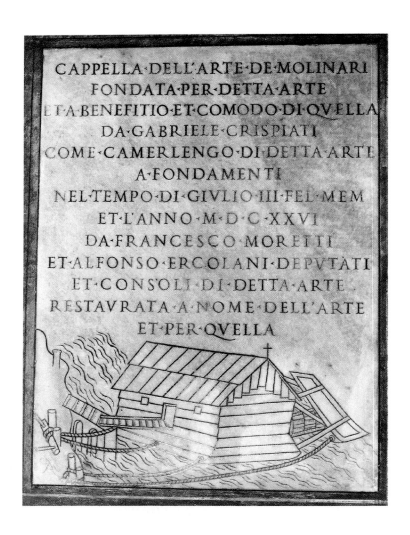

CAPPELLA·DELL'ARTE·DE·MOLINARI
FONDATA·PER·DETTA·ARTE
ET·A·BENEFITIO·ET·COMODO·DI·QVELLA
DA·GABRIELE·CRISPIATI
COME·CAMERLENGO·DI·DETTA·ARTE
A·FONDAMENTI
NEL·TEMPO·DI·GIVLIO·III·FEL·MEM
ET·L'ANNO·M·D·C·XXVI
DA·FRANCESCO·MORETTI
ET·ALFONSO·ERCOLANI·DEPVTATI
ET·CONSOLI·DI·DETTA·ARTE
RESTAVRATA·A·NOME·DELL'ARTE
ET·PER·QVELLA

99. Inscription in Italian located in the Chapel of the Millers Guild, commemorating restoration done in 1626. Rome, San Bartolomeo all'Isola. (Photo: Savio, Rome)

100. Venetian *toleta* of the oarmakers guild, oil on wood panel, 1619. Venice, Correr Museum. (Photo: Giacomelli, Venice)

101. Venetian *toleta* of the distillers guild, oil on wood panel, 1721. Venice, Correr Museum. (Photo: Giacomelli, Venice)

102. Epigraphic decree issued by the monsignor president of the streets, 1757. Rome, Via di Santa Maria in Via Lata. (Photo: Savio, Rome)

103. Inscription in vernacular on the tombstone of Maria Ruffini Cerchieri, 1676. Venice San Zaccaria. (Photo: Böhm, Venice)

FERDINANDI II SICILIARUM
REGI
OPTIMI AUGUSTI FIL
DEPLOMATE
HOCCE XENODOCHIUM
EX ARTIUM MEDICINE DOCTORE
D. ANDREA VULTAGGIO
FILIIS CARENTE
ERYCINOS PAUPERES IN SUOS
ADOPTANTE
FUNDITUS ERECTUM
REDDITIBUS ET INSTITUTIS EJUS STABILITUR
PERVIGILI MAZARIEN'ANTISTUT CURÆ COMMISSO
PROVENTUS ACQUIRENDI GRATIA
REGGIO QUOQUE CHIROGRAPHO DECORATUR
ANNO DNI MDCCCXX

104. Inscription for the hospital, 1820. Erice (formerly Monte San
Giuliano). (Photo: Adragna, Erice)

105. Ex-voto panel, end of the fifteenth century.

106. Ex-voto panel, beginning of the sixteenth century.

107. Defamatory poster found in Rome on June 27, 1601. Rome, Archivio di Stato, the Governor's tribunal, seventeenth–century trials, b. 12, c. 107. (Photo: Savio, Rome)

108. Defamatory poster found in Rome on November 27, 1620. Rome, Archivio di Stato, the Governor's Tribunal, seventeenth–century trials, b. 167, cc. 677–78. (Photo: Savio, Rome)

Marcho 1 Cialdone

Lumai le porca che ognuno le uede
e nel uicinato o tale uno le mette
che nõ se lo crede

uoi dicho omini amogliati
he cõ il uoatro cosire de mõte
ni tutti ui fano diuttaue be
choni

e che dine di alfoto mutina
cõ il solito suo arubaue difa
uina tutte il giorno uirta
incorno alle case che apa
date o babioni

VI STAN LI GRAN. BECCO
ERDINDO. RACAMATOR
PUTANISSIMA SUA MOGLIE
IFIUTO DE GINDE I
HE SOL IL BOIA, RESTA
HI NE, VOL DE INEAMI
ENGA, CON, POCHI QUATRIN
AMI, LA, QUERELA BECCONE
IE, TE, HO IN CULO
VE, SOLETE, TENER IL CAZZO
IE, VE, SE, TAGLIARA LI MOSTCI

109. Adolfo de Carolis, title page, woodcut. In Gabriele D'Annunzio, *Alcione* (Milan, 1908).

110. Giulio Aristide Sartorio, page. In G. A. Sartorio, *Sibilla,* 1913–22. Velletri, the Sartorio Estate. (Photo: Istituto di Paleografia, Rome)

111. Lorenzo Viani, woodcut. (Photo: Savio, Rome)

112. Armando Cermignani, *Lu palazze,* by Alfredo Luciani, woodcut. (Photo: Savio, Rome)

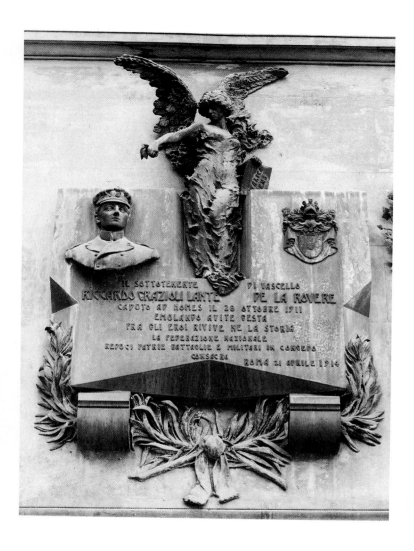

113. Bronze plaque with Art Nouveau letter forms celebrating R. Grazioli Lante Della Rovere, 1914. (Photo: Savio, Rome)

114. Fortunato Depero, advertising poster for Campari Cordial. (Photo: Giudotti, Rome)

115. *Campo grafico*, II, February 1934, no. 2. (Photo: Vivarelli, Rome)

Factum a nobis pueris est et quidem se-
dulo, Angele, quod meminisse te certo
scio, ut fructus studiorum nostrorum,
quos ferebat illa aetas non tam maturos
quam uberes, semper tibi aliquos pro-
meremus. Nam sive dolebas aliquid, si-
ve gaudebas, quae duo sunt tenerorum
animorum maxime propriae affectio-
nes, continuo habebas aliquid a me,
quod legeres, vel gratulationis, vel con-
solationis, imbecillum tu quidem illud
et tenue, sicuti nascentia omnia et in-
cipientia, sed tamen quod esset satis
amplum futurum argumentum amoris
summi erga te mei. Verum postea quam
annis crescentibus et studia et iudicium
increvere, nosque totos tradidimus grae-
cis magistris erudiendos, remissiores
paulatim facti sumus ad scribendum ac
iam etiam minus quotidie audentiores.

II

A B C D E F G
H I J K L M N
O P Q R S T U
V W X Y Z 1 2
3 4 5 6 7 8 9 0
a b c d e f g h i j
k l m n o p q r s
t u v w x y z &

116. Giovanni Mardersteig, Griffo font, text engraved by Charles
Malin. In Pietro Bembo, De Aetna (Verona, 1969).

117. Paul Renner, Futura font, 1927–30. (Photo: Savio, Rome)

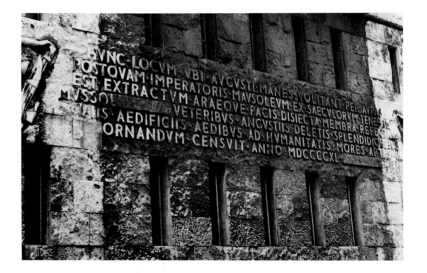

118. Inscription on the entrance gate to the University City (architect: Arnaldo Foschini), 1938. Rome. (Photo: Alinari Archives, Florence)

119. Celebrative inscription in Piazza Augusto Imperatore, 1940. Rome. (Photo F. Petrucci, Rome)

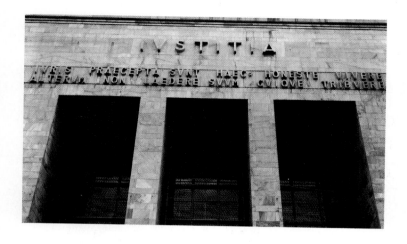

18 · NOVEMBRE · 1935 · XIV
A RICORDO DELL'ASSEDIO
PERCHÉ RESTI DOCVMENTATA NEI SECOLI
L'ENORME INGIVSTIZIA
CONSVMATA CONTRO L'ITALIA
ALLA QVALE
TANTO DEVE LA CIVILTÀ
DI TVTTI I CONTINENTI

120. Inscription on the entrance to the Palace of Justice (architect: Marcello Piancentini), 1939. Milan. (Photo: Pellion, Turin)

121. Inscription commemorating the "sanctions" and conforming to Mussolini's specific instructions concerning size, location, and format, which were obligatory throughout all Italian territory, including the colonies. In "*Illustrazione italiana,* November 22, 1936. (Photo: Savio, Rome)

122. Mino Maccari, front page of *Il Selvaggio,* April 30, 1935.
(Photo: Vivarelli, Rome)

PRESSO CAIAZZO
NEL LVOGO DETTO SAN GIOVANNI E PAOLO
ALCVNE FAMIGLIE CAMPAGNVOLE
RIFVGIATE IN VNA STESSA CASA
FVRONO IL XIII OTTOBRE MCMXLIII
FVCILATE E MITRAGLIATE
PER ORDINE
DI VN GIOVANE VFFICIALE PRVSSIANO
VOMINI DONNE INFANTI
VENTIDVE VMILI CREATVRE
NON D ALTRO COLPEVOLI
CHE DI AVER INCONSCIE
ALLA DOMANDA DOVE SI TROVASSE IL NEMICO
ADDITATO A LVI SENZ ALTRO LA VIA
VERSO LA QVALE SI ERANO VOLTI I TEDESCHI
IMPROVVISA VSCI DALLE LORO LABBRA
LA PAROLA DI VERITA
DESIGNANDO NON L VMANO AVVERSARIO
NELLE VMANE GVERRE
MA L ATROCE PRESENTE NEMICO
DELL VMANITA

VN AMERICANO
CHE VIDE CON ORRORE E PIETA
LE SALME DEGLI VCCISI
PONE QVESTA MEMORIA

123. Inscription dictated by Benedetto Croce commemorating victims massacred by German troops near Caiazzo on October 13, 1943. Caiazzo (Caserta) cemetery. (Photo: Maioriello, Caiazzo)

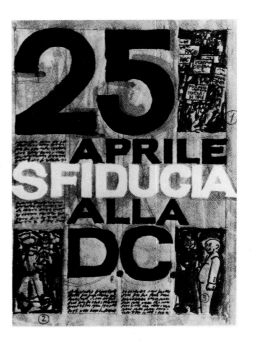

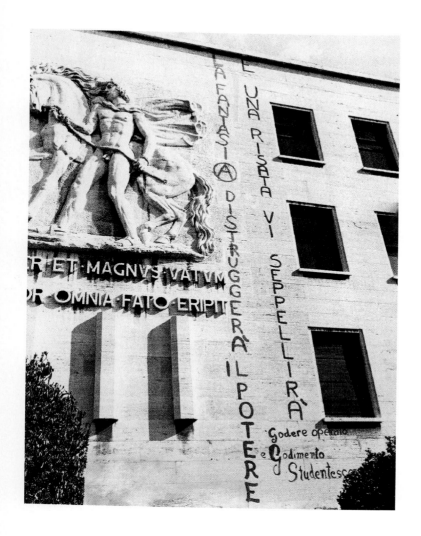

124. Albe Steiner, front page of *Il Politecnico,* September 29, 1945, no. 1.

125. Albe Steiner, cover design for a propaganda pamphlet, 1963.

126. Spontaneous wall inscriptions left by the student occupation of 1977. Rome, facade of the University of Rome Letters Faculty. (Photo: Mancia, Rome)

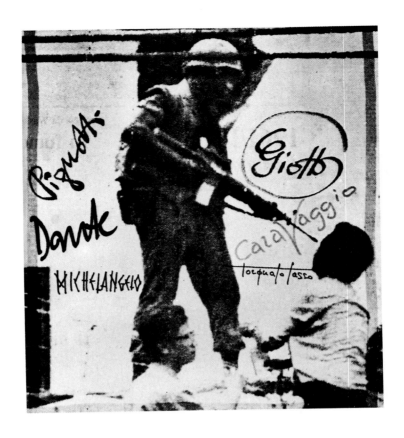

127. Lamberto Pignotti, *Fotoricordo,* 1975. (Photo: Giudotti, Rome)

128. Albe Steiner, *Graffito,* mural on cement. Carpi, museum monument to political and racial victims deported to Nazi concentration camps. (Photo: Museum, Carpi)

129. Inscription commemorating political deportees, with graffito by Corrado Cagli, 1974. Turin, Porta Nuova Station. (Photo: Garimoldi, Turin)

E voi, imparate che occorre vedere
e non guardare in aria; occorre agire
e non parlare. Questo mostro stava,
una volta, per governare il mondo!
I popoli lo spensero, ma ora non
cantiamo vittoria troppo presto:
il grembo da cui nacque è ancor fecondo.

BERTOLT BRECHT

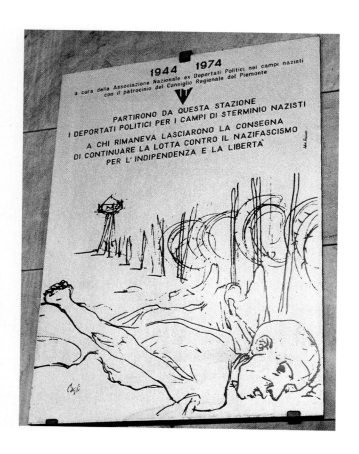

1944 1974

a cura della Associazione Nazionale ex Deportati Politici nei campi nazisti
con il patrocinio del Consiglio Regionale del Piemonte

PARTIRONO DA QUESTA STAZIONE
I DEPORTATI POLITICI PER I CAMPI DI STERMINIO NAZISTI

A CHI RIMANEVA LASCIARONO LA CONSEGNA
DI CONTINUARE LA LOTTA CONTRO IL NAZIFASCISMO
PER L' INDIPENDENZA E LA LIBERTA'

130. Bruno Caruso, *Il giornalaio,* 1952. Roma, Renato Giani Collection.

131. Massimo Dolcini, poster designed for the inauguration of the public library of Cagli, 1980.

132. Inscription in memory of Walter Rossi, 1977. Rome, Viale Medaglie d'Oro. (Photo: Romeo, Rome)

133. Metal inscription in memory of Mario Salvi, 1977. Rome, Via degli Specchi. (Photo: Romeo, Rome)

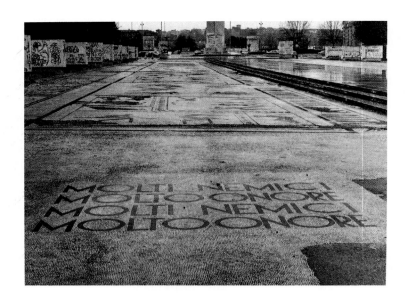

134. Foro Mussolini-Italico, Rome; inscribed floor mosaic and spray paint graffiti. Rome. (Photo: F. Petrucci, Rome)

In the realm of Venetian book printing, the luxury edition developed its own distinctive style, which was characterized by floral cover designs and ornate, baroque-inspired capital letters. In Tasso's *Gerusalemme liberata,* published in Venice by Albrizzi in 1745 and perhaps the most beautiful illustrated book of the eighteenth century, the close ties between typography and monumental lettering and between illustration and decoration are on the verge of dissolution. The various elements of this splendid work are actually very separate and remote from each other, and there is no ambiguous blending of the graphic and the figurative. The large plates by Piazzetta have little to do with book illustration or with writing, and the decorative borders framing the explanations at the head of each canto no longer suggest epigraphic motifs but are merely ornamental page borders typically used in printed books and engravings.

In Rome, somewhat before the middle of the century, new developments occurred in monumental lettering—in both lapidary and paper forms—which testify to the very close connection existing between monumental lettering and the antiquarian culture of the elite Roman Curia. Once again, because of a change in taste, monumental scripts began to obey precise geometric rules and to seek inspiration from ancient models, as in the past. This brought about a progressive rejection of polychrome treatment and of unusual shaped backgrounds. After so much drapery, color, and curving lines and letters, the return to the flat, plain epigraph of antiquity and of the Renaissance was by no means an insignificant event and was accompanied by a growing preference for plain materials such as stucco or pale marbles.

This was a slow and gradual development, initially brought about by external factors and often affected by extraneous elements. In this sense the monument to the Polish prince Alexander Sobieski, (d. 1714) in the Church of the Capuchins is most unique in its combining of metal relief letters on a plain background. (See FIG. 71.) Other examples of this mixing of elements are the solemn inscriptions in pure antique style decorated with rich gold frames mounted in San Gregorio al Celio in 1734 by the learned Cardinal A. M. Querini, patron of scholars, and the white inscriptions on a red background mounted on two round monuments erected ten years later in San Marco. In that same year, the scholar G. G. Bottari, who was not of Roman origin, though he had adopted the city for his own, supervised the building of the new Corsini Library in the Palazzo Corsini alla Lungara. In this structure, Bottari included two marble inscriptions in striking relief letters, white on a white background (see FIG. 69), celebrating the new epigraphic fashion that had drawn inspiration from antiquity yet relinquished

none of its own expressive language, which was distinguished by its search for beauty and by its fondness for obscure allusions.

In the realm of luxury-book production, closely connected to the erudite popes such as Clement XI Albani, Clement XII Corsini, and Benedetto XIV Lambertini, who did much to encourage scholarly pursuits, the very same artists and patrons were at work who had drafted or commissioned the ceremonial and funerary inscriptions now dominated by the new neoclassical taste: the Querinis, the Bottaris, the Venutis, and their friends, associates, and competitors, both Italian and foreign, who had been enticed to Rome by the flourishing antique trade. Thus it is no surprise to find in these books a much more rigorously epigraphic use of monumental writing than in the past. For example, the title page of *Collectanea antiquitatum romanarum,* by Ridolfino Venuti and A. Borioni, published without a date in 1735, consists purely of writing without any decoration. (See FIG. 72.) The title appears in large relief capitals set within a simple frame, very much like a classical inscription. A similar title page appears in the *Vita di Piero Soderini,* by S. Razzi, published in Padua in 1737, but in this case there is also an ornate frame in leaf motif that would seem to be modeled on designs used in the luxury bindings of the period. (See FIG. 73.)

The thriving of antiquarian and paleographic scholarship throughout Europe during this period brought about a renewed interest in classical epigraphy, which was much more rigorous and scientifically based than in the previous century. The books of epigraphs published in Rome in these years were no longer fantastic collections of literary texts cast in epigraphic mode, but rather genuine ancient inscriptions—ordered, read, and interpreted. In Rome, the famous local and foreign "ruin painters" reproduced many inscriptions from the classical period in their artworks. (See FIG. 74.) Though these inscriptions were often depicted in their actual monumental settings, the painters frequently made up quite a few of their own. Meanwhile antiquaries and ecclesiastics "completed" fragmented inscriptions and even forged a large number of them for the thriving antique trade that had made Rome an international emporium. In Rome, as we have said, the imitation of classical epigraphy came back into fashion for funerary monuments, public inscriptions, and luxury-book design. As a result of Rome's renewed and growing interest in the monumental writing of its classical past and its revived interest in the relationship between monumental writing and monument and in the functions and display of monumental writing, the foundation was laid for a radical revolution in graphic tastes that in the space of a few decades would profoundly modify the rules governing layout, presenta-

tion, and structure, not only of monumental lettering, but of all types and forms of script and of graphic products.

Thus it was to Rome that the leaders of this revolution flocked during the middle of the 1700s, finding there an environment rich in stimuli and very open to change and new ideas. Among these artists were Mengs, Winckelmann, Adami, and also the two greatest Italian exponents of this revolution: Giambattista Piranesi and Giambattista Bodoni, the former from Venice, the latter from the Piedmont. They were eighteen years apart in age.

Piranesi was in his twenties when he first came to Rome in 1740. Son of a builder and the nephew of an architect, he had learned engraving at a very young age and was never to free himself from the influence of these two media that had dominated his childhood—stone and hand-worked copperplate. Several distinct phases and elements may be distinguished in his graphic work, and in his indirect yet innovative contribution to the graphic revolution of the century.

First, Piranesi considered himself an architect and always referred to himself as such, and though he worked mostly as an engraver, he actually did little else than compile and publish books. These, however (and this is what is important here), were rather special books, composed almost entirely of engraved plates in large or even giant format, which belonged to the tradition of illustrated scientific treatises and to the tradition of funerary or celebrative volumes, which Piranesi had probably seen in Venice and in Rome. We need only recall the influence that Juvarra and Giuseppe Vasi, inventor and engraver of "machinery," had had on Piranesi's work.

We should also note that at first Piranesi showed little interest in Roman epigraphy, which in the early phase of his career does not seem to have had much influence on the monumental writing that he created for the title pages of his works, such as the first and second editions of *Architetture e prospettive* or *Capricci di carceri*. Finally, it should be pointed out that Piranesi's elaboration of a monumental capital alphabet was not the product of an abstract study of the alphabet as a system of signs, nor was it the result of experiments in calligraphy (with which he was unfamiliar). Rather, it was the fruit of his direct study of classical monuments, which he carefully examined, sketched, and analyzed in minute detail without the mediation of Palladio and with an enthusiasm that was quite unusual for his time.

Such an attitude and such enthusiasm reflect Piranesi's high esteem for classical inscriptions and for their graphic and formal aspects. The comments he makes concerning his experiments in lettering clearly indicate his paleo-

graphic interests: "the shape of the letters has been faithfully copied" (*Le Antichità romane,* II, pl. 5); "The letter forms and the shape of the stones have been accurately reproduced" (*Lapides Capitolini,* caption on the large plate); "I seem to note a variety of characters" (*Le Antichità romane,* IV, pl. 22), and so on. In Piranesi's hands, the medium of copperplate engraving miraculously re-created the inscriptions of antiquity. Especially in the large-format inscriptions he managed to reproduce the characteristics of ancient Roman monumental epigraphy in every technical detail, including the V-cut carving, shading, the alternating of letter size, and layout schemes. However, script is used not only to reproduce antique epigraphs but also as a creative motif in display texts for his title pages and in his more fanciful engravings. Thus on the one hand we find the capital used in *Vedutine* in 1745 and in the Plans of 1744 and 1748, which is devoid of any particular stylization. On the other hand in the first edition of *Carceri* (1745) we find the narrow, fringed capital with delicate strokes typical of the Venetian Tiepolo style, which is also used for the literary quotations based on epigraphs and for the illegible traces of writing in *Carceri* and in *Capricci.*

From the general cultural influences that we have mentioned here, and from his keen interest in graphics (and also the shedding of Tiepolo's influence), Piranesi created his monumental capital around the year 1750, which triumphantly appears in the colossal title pages of his great works, from *Antichità romane* (1756) to *Trofeo o sia magnifica Colonna Coclide* (1775–76). This was an epigraphic capital, engraved in copper that looked as though it had been carved in stone, presented in the manner of the great baroque tradition, though clearly tending toward the antiquarian. What most distinguishes these letters is the fact that in drawing them, Piranesi has managed to make them look as though they have been sculpted in relief and not chiseled in stone. (See FIG. 75.) This creates a very vivid effect of "unreal starkness," according to Focillon, which is further enhanced by the strong contrast between the thick and thin strokes, the clean squaring of the forms, and the striking emphasis of the serifs.

In the title page of *Antichità di Cora* (1764) the *littera piranesiana* looks as though it has been engraved in the surface and not sculpted in relief (see FIG. 76). But here the engraving is so clean, the V-cut so deep, the strokes so thick and dark, and the lettering so vivid that viewers have the impression (as they have in other works by Piranesi, for example, the corrections added to the chiseling of the *damnatio memoriae* in the third edition of the dedication of *Antichità romane* of 1757; see FIG. 78) that they are looking not at an epigraph, but at blocks of printer's type. The inspiration for this particular

specimen, however, may be traced back to ancient models such as the imperial inscriptions (especially those dating from the first century A.D. with large squared hollowed-out grooves that were filled in with metal letters attached to the marble background (see FIG. 77). In fact, in 1765 Piranesi designed and created a monumental epigraph of this kind for the priorate of Malta on the Aventine (see FIG. 79).

Indeed in the late and more eloquent examples of Piranesi's relief inscriptions, the rigid frame of the stone slab is no longer present. Rather, epigraphs appear somewhat more freely in architectural settings, where the letters seem to be about to spill off the surface of the stone blocks (e.g., *L'emissario del lago Albano,* 1762), on monuments of his own invention (*Diverse maniere d'adornare i cammini,* 1769), or in complex monumental antiquarian contexts in which we may suspect traces of Bodoni's influence (*Trofeo o sia magnifica Colonna Coclide*). The *littera piranesiana* was Piranesi's own very free and ingenious invention and has no precedents that we may identify in the ancient Roman inscriptions so admirably reproduced during this period, nor in the epigraphic models of the age. Thus it is hardly appropriate to compare his work with the rather poor examples of copperplate engraving already mentioned, which Piranesi may have been familiar with.

The *littera piranesiana* was born from the artist's architectural vision in response to specific technical demands. Piranesi was particularly fond of the scenic-dramatic perspective offered by "the corner view." He not only drew his monuments from oblique angles but also used this perspective for the inscribed slabs in his title pages. If the letters of these inscriptions had been engraved in the normal fashion (i.e., to seem "engraved" in stone rather than carved in relief), they would not have appeared so stark (as in the early examples), but when engraved with the three-dimensional system of relief, they appeared extremely vivid, even when drawn from an oblique perspective. Moreover, the *littera piranesiana* corresponded to an aesthetic and ideological view of the function of monumental public lettering that Piranesi had gained from classical sources but that he had also elaborated on his own. At the center of this vision was the bold, new (yet ancient) image of the monumental written city, as imperial Rome had once been. This move away from the accurate reconstruction of the past, re-created through his technical mastery, to a global idealization of the documentary detail within a vaster framework may furnish the key to our understanding of Piranesi's contribution to modern monumental lettering.

His idealized vision of Via Appia, literally bedecked with inscriptions mounted on the most strange and unique monuments existing purely in his

imagination, reveals a global conception of monumental lettering projected out into the vaster urban space, both a historical revelation and an urban prophecy. (See FIG. 80.)

Three years after Piranesi's death, Stefano Antonio Morcelli, a librarian and former Jesuit priest, published a lengthy treatise entitled *De Stilo inscriptionum latinarum* (Rome, 1781), which represented the definitive codification of the neoclassical norm for epigraphy. This work was not merely addressed to an aristocratic audience of court and clergy, or even more generally to readers of culture and good taste; rather, it was specifically addressed to the "cultoribus antiquitatis" (connoisseur of antiquities). It was to all effects a manual, divided into several sections and consisting of rules and examples for the creation of antique-style inscriptions of every kind and for every occasion. In sum, Morcelli's point of view was diametrically opposed to Tesauro's, and indeed in his foreword, Morcelli reminds the reader that Tesauro was responsible for the creation of a new epigraphic style that he describes as monstrous.

According to the new tastes in epigraphy so eloquently expounded by Morcelli, the text of an epigraph must be concise, simple, and direct. As these three factors are related to text length, they could not help but affect line arrangement and layout and more generally also had a deep impact on the use of lettering in urban public areas (indoors and outdoors) as well as on its function as a sign system. Given this reduction of content in monumental inscriptions and its dislocation in urban areas, the presence and function of monumental script underwent a profound change that corresponded to the new architectural and urbanistic sensibility emerging during this period. This welcome process of restoration embraced not only the content but also the lettering of epigraphic inscriptions, and in fact Morcelli explicitly recommends the Roman capital, in either Trajan or Hadrian style, for all imitation-Roman stone inscriptions and forbids the use of all characters other than capital letters. Thus the myth of the Roman square capital was established, a myth that was to enjoy a long life in epigraphy and to delay significantly a correct historical understanding of classical graphic culture as a whole.

In Rome after the time of Piranesi, dominated by the patronage of Pius VI, many varied influences (including the strict Roman inclinations of Morcelli and Piranesi and the Hellenic elements introduced by Winckelmann; see FIG. 82) converged with the surviving antiquarian and baroque tendencies to create new styles of monumental scripts. A few years earlier Michelangelo had served as the inspiration for the most beautiful neoclassical title page produced in Rome at that time, engraved by Giuseppe Perini for

Schola italica picturae by Gavin Hamilton (1773; see FIG. 83), a copy of which was in Piranesi's possession, while the inscription commissioned by Pius VI for the obelisk in Piazza Montecitorio (1792) clearly shows that its carvers modeled their work on Horfei. In these same years, Morcelli's rigid standards, along with the new fashion for relief lettering, found their first expression in the bold and much-admired examples of the new neoclassical taste. Among these were a series of curious monuments built in imitation-antique style by Antonio Asprucci and scattered through the park of Villa Borghese, where large letters (in Greek) appear carved in relief on the architrave of the temple of Aesculapius and on the fake ruins of the temple of Antonino and Faustina (1783; see FIG. 81). The great sepulchral monument to Clement XIV erected by Canova in 1787 in the Church of the Santi Apostoli represented the figurative manifesto of the new creed, but neither the gold relief letters on the pedestal spelling out the pope's name nor the charming pastiches of the Villa Borghese inscriptions are genuine examples of the *littera piranesiana*. (See FIG. 84.) If we wish to find an echo of the latter, we must turn to the work of another great innovator of eighteenth-century graphic styles: Bodoni.

There is no evidence that Bodoni ever had any direct contact with Piranesi, but Bodoni was in Rome between 1758 and 1765, the same period when Piranesi was publishing his most important works, and it is more than likely that this young engraver of letters, avid for new knowledge and experience in the field of printing, had seen and appreciated Piranesi's work. We do know that in 1766 Bodoni considered moving to London so that he could study with William Caslon and John Baskerville, who had renewed English typography and book design through the introduction of the neoclassical style. We also know that in 1768, when entrusted with the task of reorganizing the royal printing office in Parma, Bodoni turned to Paris, to the renowned master typographer, Pierre Fournier the Younger to refurnish his fonts. Indeed, in his treatise *Fregi e majuscole,* published in 1771, Bodoni claims that he is the exact imitator of the French typographer. Thus at the basis of Bodoni's stylistic development we find an intermingling of European influences, but we must not underestimate the impact of Piranesi's great works—given the pronounced graphic tastes of the Venetian architect and his *littera piranesiana*—on Bodoni, whose own work evolved through a series of phases in which varied trends and interests may be identified. Bodoni was not only a designer of type alphabets and an engraver of letters but also a typographer, that is, a printer and designer of books and a self-employed publisher. In the latter phase of his life he was also to become a theorist of the art of typography.

Bodoni's first endeavors in Parma as director of the royal printing office after October 1768 followed in the wake of the antiquarian and baroque traditions of the period, which relied heavily on the use of engraved illustrations and ornamentation in book design. After 1770, however, when he had come into possession of his own private printing-publishing house, he began to devote greater attention to the graphic element. Bodoni created many Latin type fonts, but he also created characters for several other alphabets, including the Greek, Cyrillic, Coptic, and Syriac. His work with these varied sign systems, which were always treated with keen aesthetic sensibility, was always based on sound research, often drawing on models of the highest historical value.

We cannot judge his efforts as "creator of graphic models" unless we consider his work with printing as a whole throughout the various stages of his artistic development. Bodoni's experimentation in graphics cannot be separated from his work with book, pamphlet, and single-sheet (poster) design, and the innovations he brought to the typography of Latin characters went hand in hand with his innovative work with the Greek and other non-Latin alphabets.

The type font still known today as Bodoni remains his most characteristic and well-known creation. Although this font was indeed Bodoni's personal handiwork, it had a hundred-year-old tradition behind it. It first appeared at the beginning of the seventeenth century in Philippe Grandjean's type design Romain du roi and was continued in England by Caslon and Baskerville and in France by Fournier the Younger. The efforts of Bodoni in Parma and of Didot in Paris represent the further evolution of this style, which provided Napoleon's Europe with a new graphic standard suited to the neoclassical taste and generally appropriate for practical purposes.

What were the theoretical and aesthetic principles of the new style? Bodoni's *Manuale Tipographico,* published posthumously by his widow in 1818, may give us an idea. Letters were to be based on a stark contrast of strokes, on "regularity," "absolute uniformity in those parts common to several letters," "sharpness" in the punch-cutting technique, "gracefulness," "perfect symmetry" in line arrangement, and uniform spacing. From these principles an extremely rigid standard for typographical writing was derived, consisting of easily recognizable signs that were strikingly homogeneous because of their uniformity of stroke. In these letter forms, the rigidity and verticality of the overall effect is accentuated by the sharp contrast between full and thin strokes and by the thickness of the verticals. These characteristics of Bodoni's monumental majuscule, together with their square shape,

bear unmistakable resemblances to their not-too-distant model: the *littera piranesiana.*

Bodoni's theoretical principles did not regard only individual graphic signs, but also the relationship between writing and blank spaces (i.e., layout), the use of decoration, and the measured use of writing in the title pages, which, with lapidary sobriety, were reduced to the bare essentials. They also dealt with the format, diffusion, and function of books. Breaking with a tradition of many centuries, Bodoni slowly began to eliminate figurative and ornamental elements from his luxury editions, claiming that "the more classical a book is, the more its beauty should depend on type alone." He also favored spacious white margins and extremely large formats, which he believed were the only formats that would resist the wear of centuries because books of this kind were "better cared for and moved less often" than other books. He concluded that "it behooves us to seek the beautiful in the large." This opinion would doubtless have been shared by Piranesi, architect of big-format books and large-scale projects.

The principles that informed the theoretical basis of Bodoni's work in typography and book design found full expression in the series of Latin, Greek, and Italian classics that he launched in 1791 (after a visit to Rome and Naples in 1788) for Azara, including a splendid edition of Horace (see FIG. 85), a Callimachus in 1792, a Virgil and a Pseudo-Longinus in 1793, an edition of Dante in 1795, and an edition of the Homeric hymns in 1805. They are also reflected in his minor publications and in the admirable epigraphic texts he printed on single sheets, which obey the purist-imitative fashion of the day and represent a unique example of "paper epigraphy" created exclusively through typographical means, though this purely typographical approach was already present in his edition of *Epithalamia exoticis linguis reddita,* published in 1775.

Bodoni's books were printed in extremely limited editions, generally ranging from 130 to 150 copies, and his work in book design was typically experimental. His large formats, which inevitably were very costly to produce and were very useful for working out new formal ideas that could later be reduced in size, furnished the Italian graphic culture of his own and of later times with an inexhaustible source of inspiration and of models not only for typography but also for epigraphy, for book design, and generally for all forms of printing.

To find evidence of his extensive influence, we need only wander through those streets of Parma, where the presence of the Bourbons and the Hapsburgs may still be felt, and step inside its churches and palaces, where we will discover a great number of epigraphs dating from the end of the

eighteenth century and from the beginning of the next, all of which are cut in Bodonian letters. (At times, though, they may be coarsely rendered with thick strokes or crammed together in overly dense layouts, fancifully gilded, or inscribed on colored backgrounds, as in the double series of nineteenth-century slabs in San Giovanni Evangelista.) Or we need only pay a visit to the dukes' funerary monument in Santa Maria della Steccato, modeled on an antique hypogeum with small inscribed loculi. (See FIG. 87.)

Though in Italy Bodoni has been credited with the invention of this new standard for monumental writing, in reality he provided canons for a trend that had existed for some time. Its popularity was not limited to Parma. Milan offers many examples dating from the Napoleonic era: the large and relatively early bronze inscriptions on the facade of the Palazzo Belgioioso d'Este (dated 1787; see FIG. 88), the splendid inscription on the Palazzo Ser-belloni (1794; see FIG. 86), and the dedication on the Arco di Porta Tici-nese in 1815. It would be very easy to extend this list to the other major Italian cities—Turin, Florence, Bologna, Naples—especially if we con-sider not only official outdoor epigraphy chiefly consisting of large metal relief letters but also inscriptions created for private patrons mainly for fu-nerary monuments, a field dominated by the neoclassical style for many decades.

In the climate of cultural and political isolation that dominated Rome during the pontificates of Pius VII, Gregory XVI, and Pius IX, a period ranging from 1800 to 1878 (the era of the Roman poet Belli), the creative and autonomous elaborating of new graphic and figurative styles that had distinguished the last quarter of the previous century now deteriorated into provincial imitation. The work of the engraver Luigi Rossini (1818–50) be-longs to this period. His title pages, replete with classical-style capitals and with Bodonian and neo-Gothic majuscules, are the product of shoddy tech-nique and reveal the technical and aesthetic limits of Piranesi's letter forms when imitated without either skill or good taste. One of the exponents of the new style was the publisher De Romanis, a follower of Bodoni. (See FIGS. 89–90.) The new style was also amply represented by a great deal of public and funerary inscriptions of neoclassical inspiration. Examples in-clude the inscription in metal relief letters commissioned in 1818 by Pius VII for the Quirinale Obelisk (see FIG. 91), the inscription in similar style on the entrance to Villa Borghese (1826), the large relief inscription decor-ating the facade of the Teatro Argentina (1837; see FIG. 92), the epigraph engraved on the architrave of the portico of Palazzo Wedekind in Piazza Colonna (a site very closely connected with the antiquarian tradition), the

ornate and classically harmonious epigraphs adorning the interior of the Church of San Nicola di Bari ai Prefetti, the two large inscriptions commissioned by Pius IX for Porta Pia (see FIG. 93), and the large plaque with gilded letters mounted on the counterfacade of San Carlo ai Catinari in 1861.

In the mid–nineteenth century throughout Italy and most especially in the great cities of the North, the stark simplicity of the early neoclassical style (often accentuated by the recourse to formal and textual elements of an antique flavor) gave way to a new trend that appeared in both printing and epigraphy and that involved the use of color and of decorative and figurative elements, though maintaining neoclassical letter forms. Thus once again, at least in certain cases, the combining of letter forms with figurative design became an essential aspect of monumental lettering and of artistic or luxury graphic products in general.

Nonetheless, in what we might define as public and standard graphic production, the dominant graphic style remained the neoclassical, which derived more or less directly from Bodoni and Didot's models. At times elegant, other times slipshod, heavily accentuated or adulterated, it continued to dominate nearly all printed matter designed for medium- and large-range dissemination, including the new products such as magazines, daily newspapers, wall signs, and posters, as well as public and private epigraphy. (See FIG. 94.)

Some of the basic characteristics of this phenomenon are particularly important. First, the new graphic style spread quickly and widely, implying an equally universal acceptance of the expressive autonomy of typographic lettering. Second, public taste was substantially uniform, and therefore the aesthetic compactness of this new fashion not only invaded France and Italy but also spread through Napoleonic expansion to the other European nations where the non–Gothic alphabet was in use. Finally, there was a standardizing of all quality graphic products, not only books or public epigraphs, according to the new models and to the new aesthetic and technical principles.

Indeed, this widespread phenomenon may be compared to the standardization and diffusion of baroque monumental writing that had taken place two centuries earlier and that, as we have already pointed out, corresponded to the celebrative and aesthetic needs of privileged social categories that exercised public power in various ways and to various degrees. Likewise, the reasons for the success of neoclassical monumental script as the most prestigious and universal tool of graphic expression must be sought in the social

function that this form of lettering played in various social and historical contexts over a rather long period.

First, the new style corresponded to the canons of clarity and essentiality so highly esteemed by the aesthetics of the time and was also derived from the models that Morcelli had so authoritatively endorsed. In its formal characteristics and its general model of graphic construction, the neoclassical style also fulfilled the requirements of comprehensibility and visibility and yet at the same time conveyed a classical sense of solemnity that the bourgeois ruling class was eager to see expressed in graphic products, particularly in those that they created themselves or that were somehow directly associated with them.

In defining itself as a monumental script, Bodoni's capital of classical derivation gained a very high official and normative status. This, however, entailed certain limitations, which led in the end to an impoverishment of the aesthetic potential of letter forms, in comparison with the marked creative freedom that graphic culture had enjoyed during the baroque era. Indeed, this direct dependence on utilitarian requirements, and the consequent emphasis on the indicative and explicative function of the letter form manifested by the classical standard in all areas of usage, enormously reduced its expressive capacities. This stressing of the letter's indicative-explicative function, which was bound up with the technical evolution of printing equipment and with the specific characteristics of the new products (e.g., posters and daily newspapers), made it virtually impossible for monumental lettering to break out of the rigid square layout pattern and spill out into the margins. Moreover, the arrangement of texts in any pattern other than the rigid linear one was now something inconceivable. To this impoverishment of the graphic sign's expressive potential, we must add the divorce—not total, yet always present—of ornamental elements from illustrative accompaniment, which distinguishes a large part of the graphic production of the nineteenth century.

The bourgeois establishment's adoption of a classical, typographical style that was functional and uniform in its various standardized forms marks the height of the supremacy of this script in Western graphic culture and signals the greatest moment of separation between sign systems of phonetic value (i.e., writing) and sign systems of purely symbolic value (i.e., the figurative arts since ancient times).

By the mid-nineteenth century, the neoclassical graphic style had generally been adopted by government organs and by the public administration (for documentary and legal purposes), by the university (for the diffusion of official knowledge), and by commercial advertising, all of whom found this

new style particularly suited to their communicative, documentative, and celebrative needs. It is no mere chance that the revolutionary posters printed in 1848 are identical in layout, typeface, and style to the ones printed by the local governments and by the Austrian authorities, just as it is no mere chance that the editions of the very first translations into Romance languages of Marx and Engel's *Manifesto* or of *Das Capital* were clothed no differently from texts on economy or political theory published by bourgeois university professors.

In Italy, and in Europe in general, the popularity and success of the Bodoni style at the beginning of the 1800s was accompanied by two parallel and conflicting developments: the conquest of monumental writing by the urban bourgeoisie as a tool of social advancement and, somewhat later, the attempt by working-class political organizations to appropriate, in different ways but for the same ends, the spaces and channels of public writing. In three areas the bourgeoisie manipulated display writing as a symbol of personal social status. First was the signs advertising shops, commercial or financial enterprises, and factories, which not only advertised the services offered or the product manufactured (furniture factories, banks, hardware stores, etc.) but now began to display the name of the manager and owner outdoors in large letters. This not only indicates the shift from the use of pictures in shop signs and similar settings, characteristic of earlier eras, to the use of writing; it also underlines the celebrative function of these signs, which emphasized the major role played by the bourgeoisie within the fabric of urban society, where the consequences of this verbal use replaced those of the ancient tombstones of popes and kings.

The second area was the calling or visiting card, which between the eighteenth and nineteenth centuries evolved from a mere token of identification and recognition restricted to the noble classes into a genuine social passport for the career man, the financier, the professor, the merchant, and the high-ranking bureaucrat.

The third area was the written testimony in solemn letters immortalizing one's own death on tombstones or funerary monuments, which the lay bourgeois brought out of religious areas into public areas now transformed through this display of self-glorification, just as the baroque churches had been transformed by the aristocratic classes, a practice that successfully barred the presence of the lower classes through economic discrimination.

During the mid-1800s, however, the lower classes of Europe began to organize politically and to demand their right to a better life. Their leaders, some of whom came from educated backgrounds while others were simply self-taught, quickly recognized that display and other forms of writing were

indispensable tools of expression and of power. The workers movements produced and diffused a variety of graphic products such as manifestos, banners, and newspapers, but on the whole these tended to imitate the graphic products of the petit bourgeois, which were of the lowest artistic and technical quality, characterized by a miscellany of scripts, dense haphazard layouts, and inappropriate decoration, all of which derived from the chaotically diversified models of popular typography and of posters and placards displayed in the streets.

The break with the graphic-stylistic equilibrium of the Bodoni standard occurred not in the realm of the class struggle but rather in other areas, namely, the realm of literary publishing, which was less directly influenced by institutions of public power and therefore more open to the experiments in the form of the figurative arts, and the realm of commercial distribution, which was growing more and more preoccupied with the problem of achieving the widespread diffusion of its products and therefore was keenly interested in the role graphics could play in advertising. The breaking of the norm thus did not take place in Italy but elsewhere and was but dimly reflected in Italian graphic culture.

Chapter Nine

DEVIANT PHENOMENA

I n this chapter we attempt to identify and analyze a rather complex, diversified, and therefore elusive phenomenon that is present to some extent in every phase of Italian (and European) graphic history: the use of nonstandard graphic norms in display writing that diverge from the prevailing aesthetic-graphic norm in use in any given period or environment and yet that are intended to express formal elegance.

When this divergence is repeated often enough in time and space with greater or lesser regularity, it may become a genuine deviation from the norm. Deviance may involve the letter forms, format, layout, setting, or technical means used in creating a text; it may also involve linguistic features of the text (nearly always written in the vernacular and not in Latin), its formulary, or its ornamental and decorative accompaniment. Any of these deviations may significantly alter the use and function of monumental writing within very specific, and at times very limited, social environments.

In many cases of deviance, we are dealing with an insignificant and isolated phenomenon in which the reigning graphic norm is generally and consciously respected. These isolated anomalies are usually the product of the writer's inability to reproduce the norm or (though this is somewhat rarer) an intentional deviation from it. Though examples of this kind are common and are often meant to be displayed publicly, they cannot be considered of any historical value. In order for them to be considered so, the following factors must be present:

1. The deviation from the norm must be respected in similar circumstances and within the same environment by several writers over a sufficiently long period of time.

2. It must not be an isolated episode (e.g., limited to a diversity in some aspect of only one letter) but must be expressed more generally in divergences that involve not only the graphic-aesthetic aspects of a text but

also the technique used, the process through which it was produced, and so on.

3. It must be present in graphic products explicitly intended for public display and accepted as public by the community in which they are displayed.

As we have already pointed out, these deviances are nonetheless always the result of the writer's wish to use some form of monumental script that expresses a certain degree of ceremonial formality in the creating of a text for public display.

There are two main reasons why writers may choose a graphic-aesthetic norm other than the one adopted for standard use. They may be unaware of the norm or are unable to reproduce it and therefore must substitute it with something else. Alternatively, they may wish to deviate intentionally from this norm.

Those cases of deviance conforming to the circumstances defined above may be the result of the following causes:

1. Ignorance of the norm and inability to reproduce it, not only of individual writers themselves (in which case we would be dealing with an isolated phenomenon of negligible importance), but also of other writers in the same environment and, more generally, of the entire community of which they are part.

2. Passive acceptance of models that in themselves deviate from the norm and that have been elaborated outside the environment and introduced through authoritative channels (e.g., schools, printed matter, images). This is eloquently illustrated by the title pages of printed books produced by the lower classes between the sixteenth and nineteenth centuries. These were often based on antiquated models and were quite different from the prevailing aesthetic graphic norm and yet were so common as to create a separate norm within the environment in which they circulated.

3. Influence of graphic traditions concerning specific socio-geographic areas or specific types of art, craft, or graphic products that deviate from the norm but that through time have come to be accepted as standard within the context of that particular area.

4. Intentional divergence (and this is a modern rather than a historical phenomenon) in the search for new monumental letter forms that vary from the norm, often used for the writing of political-ideological display texts. In this particular case, the subversive nature or protest of the message is visibly manifest in the new language of signs used. Also in this category we may consider other intentionally deviant graphic phenomena that are

the fruit of cultural-aesthetic choices (i.e., the graphics of avant-garde movements) or of economic concerns (advertising).

The list of examples that follows is limited to a few episodes selected from across the span of three centuries and is not meant to furnish complete documentation of all the various circumstances described above. This does not suggest, however, that there is any lack of evidence to substantiate the other cases, some of which will be discussed in the concluding chapters of this book, of which this chapter, deviant itself in both subject matter and length, is only a part.

I n Florence and in Tuscany in general, there was no sudden break with Gothic models, no immediate return to the classical capital of ancient Roman epigraphy. Rather, there was an intermediary phase lasting until the mid-fifteenth century, during which a style that may be defined as Romanesque, created by Poggio Bracciolini and his followers, came to dominate bookwork and epigraphy. According to E. Casamassima,

> The Florentine stone-carved letters, which blend so admirably with the sculpture and architecture of the period, do not faithfully reproduce the classical alphabet, either in proportion or in the plasticity of the signs. These differences do not consist merely in a different sense of form [see FIG. 13]: a few letters, such as the *G* and the *M*, would seem to be modeled on epigraphs of the Romanesque age. In their tall, slim, compact proportions, we may recognize the traces of the Gothic graphic tradition.

This fact is worthy of note because it was during the latter half of the Quattrocento in Florence and Siena (and more sporadically in other areas of Tuscany) that the first deviations in monumental lettering began to appear. These deviations are to be found in a vast range of figurative products, all intended for public display and commercial distribution, designed for personal use and purchased by private individuals, including paintings on wooden panels, prints, and ceramics decorated with profane and religious scenes. In its higher forms of expression this phenomenon did not remain anonymous: in Siena its aesthetic norms were canonized in the paintings of Sano di Pietro (1406–81) and his pupils.

The script that Sano di Pietro used for the captions (mostly in the vernacular) to the paintings and panels produced by his prolific workshop during over fifty years of activity had few things in common with the monumental

scripts used by other Tuscan artists, or more generally by other Italian artists at that time (see FIG. 95). It was indeed a rather mixed script in which the Romanesque capital of the local tradition appeared together with minuscule letters such as *b, d, e, h,* and *q,* as well as the round *G* (at times consisting of two interlocking semicircles), the rounded *X,* the *Z* as a tailed *c,* and the squared *C.* These features, however, cannot be accounted for by the artist's lack of skill, given the extreme elegance of the end product, nor can it be considered an isolated personal episode. Similar features with some variations, including the typical addition of the backward *N,* may be found in the captions to paintings by Domenico de Bartolo and by Vecchietta dating from the same period and produced in the same city.

An even more remarkable example of the standardizing of deviant graphic forms may be found in the illustrated *Cronaca fiorentina* in the British Museum and in a series of well-known Florentine engravings dating from the same period that are accompanied by lengthy captions in the vernacular. For our concerns here, the most interesting of these engravings is *Pianeti* (c. 1460, redone 1464–65), a series devoted to the seven planets (see FIG. 96), which bears close stylistic resemblances to the *Sibille* and *Profeti* series dating from 1470 (see FIG. 97). In the lower margin of each engraving a long text appears, densely written in mixed script using minuscule forms for *b, q,* and *z.* The backward *s* appears consistently throughout the text and therefore cannot be accounted for by an oversight on the part of the engraver. Similar graphic features may be found in other Florentine engravings of this same period such as *Sant'Antonio da Padova* (H. 65), *Martirio di san Simone di Trento* (H. 74), *Teseo e il labirinto* (H. 101), and *Allegoria* (H. 106). The scripts appearing in these inscriptions all show strong resemblance to the script used by Sano di Pietro's Sienese workshop.

In Florence this episode soon drew to a close even before the end of the century. When new editions of the *Profeti* and *Sibille* series were reprinted in 1490, the lettering of the captions was redone in the Tuscan-style capital, eliminating all irregularities, with the exception of some slight flaws due to the engravers' imperfect technique.

The connection between Italian Renaissance printing and ceramic production is quite well known. Indeed if we examine the inscriptions on a few Florentine dishes dating from the latter half of the fifteenth century (see FIG. 98), we will note several graphic peculiarities (i.e., minuscule letters, the *G* consisting of two interlocking semicircles, and the use of curious structural ligatures in capital inscriptions), which are very similar to the unusual scripts used in Florentine engravings during this same period (or slightly earlier) and in the paintings produced by Sano's workshop.

It is somewhat more difficult to retrace the origin of those scripts that combine minuscule letter forms such as *b, d, g,* and *h* with irregular capitals. This was very common in the ex-votos produced in northern Italy at the end of the fifteenth century. Further research over a vaster territory and time span would undoubtedly lead to the discovery of many more such examples. Moreover, it is worth mentioning that in popular ceramics produced in rural areas such as Ariano, the mixing of minuscule and majuscule scripts in dedications or signatures continued up until the eighteenth and nineteenth centuries. In these same areas we also find a few genuine graphic archetypes that elsewhere had long vanished from use and from the memory of educated society such as the *A* with angular cross-stroke (A), the raised minuscule *q* with serif (q), and the *T* with embellished horizontal (T).

As a whole, this phenomenon could be interpreted as an attempt— though pursued in different ways in various environments that were not in contact with each other but that were similar in their level of cultural development and graphic education—to create monumental scripts by combining nonstandard capital alphabets with the basic minuscule alphabet that was taught at the very first level of scholastic instruction. To this were added a few curious adaptations such as the *S* and *N* nearly always written backward. These features, along with the nature of these inscriptions (which were devotional, practical, or amorous), suggest that they were for the most part produced, diffused, and used within the ranks of the lower classes.

In short (returning to our earlier general analysis), here we are dealing with an attempt to substitute the graphic norm that the writers were unable to reproduce or one whose authority was not sufficiently felt. This substitution was restricted in space and time to a particular artistic environment (the workshops of Sano di Pietro, of the master who had created the *Pianeti* series, and of a few ceramic craftsmen) where through a process of standardization, repetition, and modification the nonstandard norm became a genuine stylistic feature.

From the Middle Ages until the seventeenth century the use of Latin in epigraphy was a fixed and absolute rule. Yet there were exceptions that may offer us today precious testimony of those areas in which the use of monumental scripts did not develop in accordance with the usual textual norms or, as a consequence, with the usual graphic ones.

During the late Middle Ages, literacy gradually became more widespread throughout the varied levels of Italian society, including craftsmen, merchants, bankers, and women as well as members of the lower classes. Latin, if not the only written language, was the language of higher culture, the language of learning, of the varied professions, and of the church. The social

categories that were excluded from the use of this particular tool of expression, yet who were able to write, were not always willing to turn to others, to the learned experts of Latin for the monumental inscriptions so necessary for the affirmation of their social status (as individuals, families, or groups), such as funerary monuments or dedications, and so they demanded that these be written in the vernacular. In other cases, the use of vernacular in ceremonial or public display texts was indispensable in order to ensure that the message would be understood by the readers it was intended for, especially when readers' understanding of the text was vital to the interests of the authorities, as in the case of epigraphs in convents or public ordinances and edicts addressed to the entire population. This factor explains the abundance of vernacular inscriptions dating from the fifteenth to the eighteenth centuries—carved, penciled, painted, and displayed in the most varied ways, where the intentional (or unavoidable) linguistic deviance of the text is accompanied by graphic deviance in layout and arrangement of the text and by the use of novel formats and decorative elements.

Many examples of this kind are to be found in women's religious communities in Italy, which were traditionally condemned to cultural inferiority, often bordering on illiteracy. The level of literacy of these nuns rarely went beyond the vernacular, despite the fact that they played a direct role in the spread of written culture, creating and collecting codices written in the vernacular in medieval times and teaching the young children and young women living within their communities how to read and write in modern times. The written testimony of these environments is at times quite unique, bearing signs of a notable cultural and graphic ignorance, as for example the vernacular manuscripts produced between the fifteenth and nineteenth centuries by the Monteluce Convent in Perugia, which are written in an antiquated and shaky Gothic hand characterized by rather uncertain letter forms and by the surprising presence of the backward *g*.

The monumental inscriptions created for the churches and convents of these communities were also quite unique in their use of the vernacular, their unusual layouts, their use of abbreviations, and also the presence of various peculiarities in the graphic systems used, all of which distinguish these epigraphs from the standard epigraphy of the period. Examples of this phenomenon, far too numerous and widespread to be listed here individually, may also be found in the major cities where the official graphic language was created, such as in Rome during the late fifteenth century. For example, in the Roman monastery of the Sisters of Santa Francesca Romana in Tor de' Specchi, there are two series of frescoes dedicated to the life of the saint, the work of Antoniazzo and his pupils, which are accompanied

by long captions in the vernacular full of colorful expressions in dialect. The text is written in Gothic rotunda on a white background where a line has been provided as a guide and the beginning initials are done in red, similar to red letters of bookwork. Both graphically and linguistically these are very unusual details for an epigraph. Equally unusual is the frequent use of abbreviations in the later series of frescoes located in the refectory. Copies of these frescoes dating from the eighteenth century have been preserved in the atrium. Here too the captions feature unusual abbreviations and the anomalous use of the minuscule *z* and the dotted *i* used within a context of irregular capitals.

M ost of the monumental inscriptions pertaining to the artisans' guilds produced between the late 1400s and early 1800s have many things in common with the inscriptions found in women's religious communities. They are written in the vernacular; they are located in religious buildings, in churches or chapels associated with the guilds; and they display unusual text layouts and other graphic peculiarities.

We can cite a few examples from the area of Rome. In San Bartolomeo on Tiber Island, there is a slab mounted by the millers guild in celebration of restoration work financed by the guild in 1626 that includes a vernacular inscription and a drawing of a mill (see FIG. 99). Other examples include two commemorative floor stones dedicated by different Roman "universities" which are located in Santa Maria dell'Orto in Trastevere. In this particular case, the solemnity of the location and of the occasion (commemoration of works done) led the craftsmen to choose standard formats (e.g., scrolls, curling plaques, and ribbons) and capital letters corresponding to the official norm. However, several epigraphs celebrating important moments in the history of the lay fraternity, which are located in the portico adjoining the church, display deviant features such as a full page layout (very common) and the use of Arabic numerals and monetary symbols.

Venice offers us many vivid examples of monumental inscriptions pertaining to the guilds, for example, the *tolete* of the various Venetian craft and trade guilds that have been passed down to us today through eighteenth-century remakes. These are wooden panels depicting the various artisans and tradesmen at work, which are very similar in typology to sixteenth century ex-votos (see FIGS. 100–101). Antiquated and other anomalous graphic elements appear in many *tolete* dating from the Cinquecento, while in those dating from the 1700s we often find the graphic archetypes mentioned earlier, namely the A and the dotted capital *I*.

However, either because of the patrons' eagerness to advance their social and cultural status, or perhaps because of the charisma and conditioning power of monumental writing itself, very often the monumental inscriptions created for the guilds do indeed respect the official graphic norm, though they may use the vernacular and even imitate the layout and presentation typically found in learned epigraphy. Similarly, the inscriptions found in the Venetian tolete of the 1700s and in many ex-votos are often written on curving scrolls or on elaborately framed plaques. Thus the graphic works of the guilds display antiquated and irregular letter forms deriving from popular monumental scripts along with a tendency to follow official graphic norms. However, they were also heavily influenced by another type of vernacular inscription, namely, epigraphic posters and notices created for public inscriptions of an administrative or documentative nature.

The publication in epigraphic form—that is, the setting down in stone of documents issued by the public authorities—is a practice that belonged to the classical world and that was repeated on various occasions during the Middle Ages. After the 1300s, it became more frequent throughout the cities of Europe. In Rome, papal briefs, letters, and charters were often carved in stone and mounted inside or outside the churches to which they pertained.

However, we are dealing with a completely different type of graphic product, namely, documentary texts drafted and issued in the vernacular, intended for the public reader, inscriptions that were genuinely epigraphic in origin and yet that have almost nothing epigraphic about them.

In Rome, in many parts of the old center, prohibitory notices dating from the seventeenth and eighteenth centuries may still be seen on the walls of the houses. These contain summaries of edicts issued by the "monsignor president of the streets," threatening to punish anyone who attempts to collect garbage or carry out other forbidden activities within the bounds of that particular district (see FIG. 102). These are very unique inscriptions, generally set within a simple frame, with very crowded lines arranged like a printed page. The frequent use of Arabic numerals, cursive elements, and the vernacular instead of Latin contributes to the shabby, rather than solemn, overall effect.

This type of epigraphic document seems to have provided the inspiration for various inscriptions containing vernacular summaries of notary documents, wills, and council resolutions, which were mounted on monuments or in areas associated with artisans' guilds or with cooperative institutions. It also provided inspiration for epigraphs created for private patrons for similar socio-cultural circumstances, such as the inscribed slab in the floor of San

Zaccaria commissioned by Francesco Cerchieri in 1676 (see FIG. 103). Here the verboseness of the text is quite characteristic.

Let us move from these examples of deviance determined by social-professional factors and examine those cases involving territorial areas and entire communities. As far as concerns the monumental inscriptions produced in Italy during the ancien régime, we may identify a few limited geographic areas of graphic deviance, characterized by particular stylistic features that are significantly different from those found in neighboring areas during the same period.

Let us begin with Ascoli Piceno. When this town was rebuilt between the fifteenth and sixteenth centuries, many of the new houses were decorated with mottoes and proverbs in Latin and in the vernacular inscribed on the architraves above the door. The lettering used for these inscriptions was the Renaissance capital, which showed no significant variation from the standard norm. But the situation was quite different in the rural areas, where during the Cinquecento it became the custom to decorate the doors and houses of the humble dwellings of mountain villages with mottoes in both Latin and vernacular, carved by wandering masters who used rather inconsistent letter forms of an uncertain style. In the village of Forca di Montegallo there are two houses, dating from 1561 and 1562, which are decorated with mottoes carved in relief. One of these inscriptions consists entirely of basic minuscule letter forms that have been enormously magnified for display purposes.

F ar more numerous examples may be found in the area of the Bolognese Apennines, in the Val di Limenta and the Val di Reno. Here in the various villages, the architraves of the doors and windows of the rustic buildings display inscriptions in vernacular or in Latin cut in capital letter forms mixed with minuscules, or in pure basic minuscule. These date back to a period ranging from the early 1500s to the late 1600s and were the handiwork of Lombard artisans who possessed a sufficiently homogeneous artistic and graphic style, a fact significant in itself. The script they adopted contained elements deriving from the commercial hand such as the alembic-shaped G and various vestiges of the Gothic style (D, M), as well as the dotted capital I, which seems to be characteristic of popular inscription everywhere, perhaps because this detail somehow enhances the reader's immediate comprehension of the text.

Other examples from the area of the Lessini Mountains north of Verona are more confused and sporadic. Here we find a vast production of religious sculpture in the simple, flat relief style characteristic of the early Middle Ages

but that in reality was the work of anonymous and, in all likelihood, local artisans between the sixteenth and nineteenth centuries. Some of these sculptures that are displayed outdoors in public areas are accompanied by crudely carved inscriptions in simplified capital letters that cannot be traced back to a common standard and style.

We must also mention the graphic deviance found in genuine epigraphy, mostly funerary inscriptions, written in Latin and located in churches and other religious areas in smaller towns that were cut off from the direct influence of the major cultural centers and thus were ignorant of stylistic and scriptorial norms. However, even in a city as important as Naples, characters deriving from the popular epigraphic tradition such as the Λ, the ꝺ, and the dotted capital *I* may be found in the poorer Latin and vernacular funerary inscriptions. A few examples should suffice to illustrate the significance of the episodes we have just mentioned. It must be remembered that the examples given below all belong to an era in which the graphic standard, despite the more extravagant expressions of the baroque, was universally diffused and respected.

In Veroli there is a shrine in Via Garibaldi that is decorated with an inscription dating from 1730 where majuscules and minuscules alternate in a most disorderly manner. The *A* appears in both minuscule form and in the archaic Λ form, and the text, in Latin, also contains several abbreviations. In the Church of Gesù and Maria in Foggia, on a tombstone dated 1707, the inscription surprisingly displays a very delicately drawn pre-Quattrocento *M,* structural ligatures, and the Λ. In Teggiano, Polla, and Padula, all in the area of Salerno, we may find numerous eighteenth-century tombstones exhibiting thin, capital letters of uncertain style, characterized by archaic features. Finally, in Erice (Monte San Giuliano) in the far eastern corner of Sicily, a similar deviant epigraphic tradition characterized by traces of Spanish influence and by graphic fossiles (such as the ꝺ and the Λ) survived until the beginning of the 1800s (see FIG. 104). Here as elsewhere, these examples could easily be multiplied, and the phenomenon studied more thoroughly through appropriate comparison across a wider territorial area.

The products of what we call popular art are usually rich in alphabetic signs. Domestic items and devotional objects are often decorated with inscriptions, which may range from brief invocations to God to rather long captions that have already been mentioned in our discussion of graphic deviance in monumental or display contexts.

The ex-votos that cover the walls of many Italian and European churches and sanctuaries are very typical of this phenomenon. These are still pro-

duced and displayed today following stylistic modes and typologies that have remained unchanged throughout the centuries. Ex-votos generally include one or more inscriptions that nearly always refer to the miraculous event they commemorate or more simply to the patron's offering. In the former, there is usually a long and complex text or texts; in the latter, a brief formula is given in Latin or Italian, usually reduced to an abbreviation. In both cases the inscriptions were written by the artisan, not by the patron, although sometimes next to the artisan's inscription other texts may appear, written by the hand of the pious patron on pieces of paper glued to the panel, thereby offering an even more complex graphic testimony.

The arrangement of text and image of the ex-voto generally follows rudimentary layout criteria (see FIGS. 105–6). A large space is left blank for the painted scene, and the inscription is inserted either in the lower margin or directly in areas of the scene itself that have been left empty, such as the sky, the corners, or objects with empty surfaces. The script used by the artist (nearly always anonymous) is usually a nonstandard capital, often characterized by structural ligatures, by the incorporating of smaller letters in larger ones, and by graphic idioms such as the use of 3 for the final M (e.g., MANU3 for MANUM in Latin passages or texts), the combining of varied letter forms, as well as the presence of graphic archetypes such as the A, which persisted until the mid-eighteenth century. A striking illustration of graphic adaptation is offered by an ex-voto dating from 1884 that shows an inscription carved in relief in a mixed majuscule-minuscule alphabet, with dotted I's and simplified letter forms. In this ex-voto, which shows a strong sense of composition, we also find an extremely balanced treatment of the figurative and written sections, which follow the same inspiration and which have been rendered with the same technique.

Yet even in this type of art or craft product, which was generally the work of guild members, the direct and exclusive influence of cultured models is at times clearly evident. Indeed the inscriptions appearing on ex-votos produced between the late seventeenth century and the early nineteenth century (and on the other popular art or craft products we have already mentioned) are presented in formats such as scrolls, molded plaques, and drapery, which most certainly derived from official epigraphy. Likewise in the early nineteenth century the formats and layouts of ex-voto inscriptions reflected neoclassical tastes, and the majuscule alphabet used begins to show traces of the Bodoni capital.

In the production of this type of article, the artisan's function as intermediary with the sacred was of major importance (even though it may not have been explicitly felt), especially as far as concerns the iconography adopted,

the organization of available space, and the ratio of figurative to graphic elements. It is undeniable, however, that the role of patrons in this process, and especially their influence on the inscriptions that accompanied the ex-voto (which were sometimes written by their own hand), notably increased over the course of time. This trend is confirmed by the fact that between the 1600s and 1800s, parallel to the spreading of literacy, the number of ex-votos without inscriptions diminished significantly everywhere.

The funerary epigraphy of the lower classes dating from the 1800s to the beginning of our century represents yet another area in which we may detect the use of deviant graphic elements that developed in various though substantially consistent ways over a period of time and eventually became standardized into genuine deviant norms. This phenomenon, which has been virtually ignored in Italy by all types of criticism, first began at the end of the last century (in Rome around 1890), when the petit bourgeoisie gained entrance to the urban cemeteries. In obvious opposition to the norms of official epigraphy, which was written in Latin and in Bodoni letters, the petit bourgeoisie wanted their inscriptions written in Italian. They also reintroduced the practice of including a portrait of the deceased on funerary monuments, for which varied techniques were used. Portraits were painted on lava or glass, or photos were printed on porcelain, creating new models for the layout of epigraphic texts and new patterns of text and figure, supplanting the neoclassical tradition.

Further steps toward modernization and toward the separate specificity of funerary epigraphy occurred with the large-scale commemoration of the great massacre of the First World War, celebrated in all Italian cemeteries in accordance with the new fashion, Art Nouveau, which was rich in fanciful scripts. The elaborate floral designs of the new style provided lavish borders for the portraits of bewildered and unwitting martyrs and for accompanying inscriptions, which echoed with the inflated tones of high rhetoric. Through this phenomenon, which was commissioned and promoted by patriotic committees, local fascist governments, and military associations, the proletariat finally won the right to see the names of their own dead glorified in writing. For the first time they obtained tombstones of their own with inscriptions that, although written by bourgeois intellectuals, bore the indelible sign of their own proletarian faces and of their unknown names. Thus it was that from the twenties to the thirties of our century, first in the urban areas and later in the provinces, the lower classes won the right to their own writing and memorial display space inside the cemetery. To funerary epigraphy they brought their semiliterate graphic culture and tastes, includ-

ing their preference for irregular layouts and textual dislocation, their insistence on combining text and image, and their love of religious symbols, bright colors, and a variety of scripts.

Of particular interest in the cemetery of Verano in Rome is the displacement of texts from a flat surface to the uneven surface of a scroll or an open book carved in marble, both of which appear on many monuments dating from the thirties up until today, or the use of italic for varied texts alongside majuscule generally used for the basic information of name and vital data of the deceased. In some provincial areas, such as Cosentino, not only were these models common as late as the 1960s, but other striking scriptorial idioms are also frequent, such as backward letters, graphic fossils, (i.e., the *i* in majuscule contexts), and other graphic vestiges of the past century.

The scriptorial deviances that may still be found today in Italian memorial monuments derive from the socio-cultural correspondences between lower-class or petit bourgeois patrons and specialized categories of artists who constitute a closed and separate artistic tradition and who jealously cling to their particular stylizations and archaic diversities.

A quick examination of the vast category of domestic items produced in the rural areas of Italy will yield analogous results. In fact, as we already have mentioned, many of these objects, such as pottery, olive presses, canes, flasks, wooden cups, cattle yokes, chests, and cupboards, were often decorated with inscriptions, either painted or carved, that show signs of graphic deviance, such as inverted initials and Arabic numerals deformed into arabesques or minuscule and cursive lettering. At times, when the text is very brief, these divergences are insignificant, yet at other times they may be of major importance, since they are the product of a separate and inferior cultural context where the function of monumental writing, often endowed with magical-ritual meaning, continued to thrive.

Let us shift our attention from graphic products to models. If we wish to discover the itineraries traveled by particular graphic styles and scriptorial deviances across the unfamiliar territory of lower-class Italian culture, we must ask ourselves new and complex questions and trace these various phenomena back to the circumstances in which written culture developed in Italy both in terms of chronology and in terms of socio-geographic areas.

Indeed, there is no doubt that if monumental writing is to be assimilated and adopted by separate sectors or separate geographic areas of a society, then literacy must be relatively widespread in the lower-middle level, if not in the very lowest levels, of that society. This would seem to be a sine qua non for the development of phenomena such as the ones we are examining here, and it is significant that they all date back to a period ranging from the

late fifteenth century to the early nineteenth century, one that witnessed the diffusion of the printing press along with the gradual spreading of literacy, especially in the urban areas, which were culturally and socially more compact.

The acquisition of literacy was thus vital, but it is not sufficient in itself to explain the arising of a general need for monumental writing, partly because literacy was rather restricted socially and was at times limited to the knowledge of how to read and write a few letters. The production of monumental writing in lower-class environments and typologies, however, requires the participation not only of very specific and diversified categories of skilled craftsmen and of course patrons but also of a public that we may consider only partially passive. The complex nature of this sort of productive process contributed to the creation of one of the basic characteristics shared by most graphic products that exhibit forms of graphic deviance: the use of inappropriate or crude techniques and of substitute materials. This process also affected the monumental scripts used, the choice and elaboration of which were hampered by the patrons' and craftsmen's limited graphic knowledge, which corresponded directly to the low cultural level of the potential audience for whom these products were made.

In areas where literacy was limited or in which semiliteracy was restricted to certain sectors of society, the low cultural level of patrons and craftsmen explains the use of mixed scripts combining capital and minuscule forms. It also explains the presence of cursive elements and of other elements properly belonging to the commercial hand (until the end of the Cinquecento). Finally, it explains the surprising use of the basic minuscule alphabet and the absolute dependence on layout patterns and formats copied, however unskillfully, from the epigraphy of the educated classes.

However, it does not explain the use of what I have called graphic archetypes, or more generally the presence of antiquated or archaic features, which are very common. For those we must seek other reasons, retrace other routes of diffusion, and identify those areas which offered the greatest resistance to change.

No monumental script comes into being without a series of models behind it that developed in alien cultural contexts. This is also true for the monumental scripts that in separate areas or lower levels of society replaced the norm used by the educated classes when this was absent or unrepeatable. Yet in modern Italy between the sixteenth and seventeenth centuries, the graphic models most readily available to the creators and consumers of these deviant products were furnished by woodcut illustrations of religious or fantastic scenes; by printed books, including collections of devotional writings,

prayers, narrative poetry, technical treatises; and by public playbills and posters, which inundated Italy before and after the Council of Trent.

This is not the place to examine this phenomenon in depth, but it certainly represents a deviation from the prevailing aesthetic and printing standards of educated society at that time. Furthermore, it furnished the culturally inferior sectors of society not only with models of social behavior, practical-technical knowledge, religious ideology, and fantastic entertainment but also with examples of elegant writing and of monumental scripts that often contained the archaic elements and graphic archetypes described above, which elsewhere had vanished from use. These archaic features had persisted in the graphic production of the lower classes because of the naturally conservative tendencies of this type of production, the work of craftsmen who were condemned to the use of techniques that had been superseded (woodcut), and the use of models that were determined by economic factors and by the demands of a market difficult to change.

It is significant, for example, that the dense Gothic script used in the long captions on several ex-votos dating from the end of the fifteenth century found in the sanctuary of the Madonna del Monte in Cesena is very similar to the heavy Gothic script common in printing during this era, a font that frequently appeared in popular typography and in the title pages of devotional works and books of poetry, which were widely circulated. In this same period, the Florentine engravings with captions displaying mixed alphabets mentioned at the beginning of this chapter also served as a vehicle for deviant models and archaic graphic elements. Similar examples may be identified in the standardized and stylistically inferior production of sacred images in woodcut, such as a Saint Anthony dating from the end of the fifteenth century that exhibits a curious ligature of US in the form of an 8, and another image of Saint Vitus of Polignano (Bari), dating from the 1700s, in which the text is carved on wood in an alphabet of mixed majuscule and minuscule forms. These are cited here as examples of an extremely vast phenomenon that is still to be explored.

The city of the late Renaissance and of the baroque era became once again a center of writing. This has already been discussed in reference to the monumental writing created by "high," or official, culture. In the urban areas, however, the spreading of literacy and the development of intense commercial activity soon contributed to the creation of other types of display texts, such as shop signs, notices, playbills advertising shows and fairs, and satyrical posters created for carnival time. These were produced by the lower social-cultural strata and were therefore destined to contain some form of graphic deviance. Made of wood, cardboard, or cloth, they were

indeed fragile and ephemeral. Unlike the official form of ephemeral inscription created for funeral ceremonies or public celebrations, descriptions of which have been left by scholars and engravers, hardly any testimony to these cruder forms has survived. Enough traces have remained, however, to allow us to identify those traits that deviate from the prevailing graphic norm. For example, a poster advertising "La Nave" coffee in Venice is based on a baroque design. It has an inscription in capital letters mixed with minuscule and other letter forms, engraved on drapery, and is very similar to the inscriptions of playbills advertising Sicilian puppet shows or to those on the street signs advertising the wares of Florentine watermelon vendors. The text is in Italian, of course.

Finally, we should mention a phenomenon that was to become more and more frequent in Italy: the appearance of all kinds of spontaneous, handwritten inscriptions on the city walls. These represented the free if somewhat crude expression of semiliterate children and adults who used writing as a game, as a means of unleashing anger, and as a form of entertainment and creative self-expression. Very few of these inscriptions have survived outdoors, but inside on the plastered walls, architraves, and pilasters of old buildings, a few traces sketched or scrawled in charcoal are still to be found. In the legal archives of Rome, we may find many eye-opening examples of defamatory posters that were pasted in the dead of night on the doors of houses, taverns, churches, or other buildings, or on street corners and piazzas in order to deride, insult, or threaten a rival in love, a dishonest shopkeeper, an arrogant nobleman, a corrupt priest, a whore, and so forth. Usually written in uncertain majuscules or in an assorted mix of majuscules and minuscules, they are frequently accompanied by obscene or bizarre drawings (see FIGS. 107–8). Most important, these signs represent a form of intentional manipulation of display writing that is considered as a crime by society. Indeed, examples of these posters have survived today because they have been kept as criminal evidence in connection with various proceedings against persons unknown conducted by the diligent governor of Rome.

There is also an abundance of indirect evidence testifying to this practice, including the story of one Constantino Saccardino, charlatan and joker, who hung blasphemous posters throughout the city of Bologna and was finally hanged together with his accomplices in November 1622. Further evidence was offered by Marc-Antoine Muret, who complained that the walls of the university were so covered with "abominable sayings and drawings" that one had the impression of being in a public toilet rather than in an institution of learning. In 1683 (there is nothing new under the sun) the rector of the university of Rome issued an edict threatening to punish any-

one "who dares paint or write with charcoal, pencil, chalk, or any other instrument dishonest sayings or drawings, or any letters, signs, characters, verses, mottoes, lines, arms, or notices upon the walls, doors, columns, capitals, windows, or cornices or in any other way deface them, even if he paints or writes nice things."

This type of inscription, created for the purposes of public display (which is evident when we examine them), tends toward the monumental and the ceremonial, therefore the use of capital letters generally prevails, though with various modifications and adaptations, which for the most part are the result of the writer's lack of skill, the general circumstances, and other technical difficulties.

It is difficult to believe that in the cities of Europe of the ancien régime, the act of writing freely on the walls could have been considered as a gesture of self-expression, testifying to the universal appropriation of writing, and that it could have contributed toward the modification of the structure and form of alphabetic system. This will happen, as we will see, but only much later. It is indeed significant that during the Counter-Reformation, however, when literacy was generally widespread, the graphic impulse was felt by a great many individuals, both literate and semiliterate, who were moved to cover the walls of their cities, churches, and homes with signs and drawings, in very much the same way as their Latin-speaking ancestors had done centuries before, though in very different circumstances.

Much later in the 1960s their successors would repeat this very process within the sacred grounds of the university, which had once been so innocently despoiled by students of the late seventeenth century.

Chapter Ten

THE BREAKING OF THE NORM

Before the close of the last century, when William Morris harshly condemned Bodoni models as stifling and hateful, the classical graphic norm was already in the midst of a crisis and had been the subject of contestation for some time. The reaction against the use of these characters in writing and printing was manifest in very different ways and to varying degrees and was especially strong in the more technically advanced (and therefore more typographically advanced) countries of Europe such as Victorian England and imperial Germany. One of the underlying causes of this reaction was the influence of Gothic script, which dominated a vast quantity of printed matter, including novels, periodicals, and sheet music, even in the Latin countries. Gothic lettering had become popular again because of the neo-Gothic revival in England and also because of the reawakening of the nationalist movement in Germany, which had endorsed the Gothic alphabet as the most appropriate sign system for the German race. Another cause was the growing preference shown by advertising graphics and daily newspapers for more varied layouts and for typefaces that were somewhat less elaborate than the classical style. Finally, with the discovery of the intriguing artifice of Oriental calligraphy, which was based on the free use of the line as pure aesthetic expression unfettered by geometric constriction, tastes in art now began to shift toward the anti-classical, at first in France and in the German-speaking countries and then throughout the rest of Europe.

In Great Britain, the search for a new graphic style began with William Morris. Active from 1856 to 1875 as calligrapher and illuminator, Morris created new scripts and new forms of ornamentation by imitating medieval, Gothic, and Renaissance manuscripts. He revived the art of handwriting, the use of naturally drawn decorative motifs, and the use of bright colors and borders, all of which offer striking contrast to the black uniformity of the printed page. Later as founder and typographer of the Kelmscott Press after 1891, he designed many new fonts, including the Gothic Troy and

Chaucer, the semi-Gothic Subiaco, and the Roman Golden, which was modeled on Jenson's type. In the field of book design, Morris created a new equilibrium of text and woodcut decoration by treating the double page as a formal unit.

The basic tenets of Morris's revolution in typography and book design—a new relationship between script and ornament, a reaffirmation of the aesthetic value of "written" type, and the drawing of inspiration from a variety of antique models—were soon adopted throughout Europe and America, freeing monumental scripts from their dependence on the geometric and typographical standard that had been previously unquestioned as an absolute model. Monumental scripts became more and more widely used by designers and artists in the field of advertising, and there was a move away from engraving and the use of hard-surface materials (stone in epigraphy, metal matrices in typography) toward suppler and freer techniques such as the pen, brush, and soft lead pencil. The classical tradition with its geometric laws of proportion gave way to the total freedom of the line as design, which was now able to re-create alphabetic signs and their formal aspects anew within a framework that was no longer necessarily linear.

But these were only general trends that were developed by Morris and his followers in the most varied ways in Great Britain, where a revival of the Italian humanistic scripts of the Quattrocento and Cinquecento took place. These letter forms, re-created with great skill by Edward Johnson, were even used as a model for the teaching of handwriting in schools.

In the German-speaking countries, the breaking of the classical norm was manifested in other ways and was influenced by the rediscovery of the woodcut as an art form. This medium tended to produce squarish letter forms and a rather rigid and heavy effect on the printed page. Moreover, it created a closer relationship between blocks of writing and the figurative motifs, which were cut with the same technique; most important, it furnished a direct link between the new experiments in graphics, artbook design, and the avant-garde movements and their magazines. The woodcut, from Munch to Nolde, not only revolutionized the use of writing for aesthetic purposes in the German-speaking countries but also represented a recurring motif present throughout all the major episodes of aesthetic experimentation and renovation from Jugendstil to expressionism to the Bauhaus.

The breaking of the norm thus took widely diverse forms and expressed itself through the interweaving of various trends and currents. In the liquid misshapen letters penned by Toulouse-Lautrec and Bonnard for their lithographic posters, we may recognize a tendency toward bloated letter forms and sinuous strokes, which may also be found in the posters created by the

artists of the Viennese secession during this same period. At the turn of the century the advertising posters of the more advanced European countries were characterized by a hybrid mixture of graphic types, from cursive to majuscule, and by the combining of writing and figure. The bourgeoisie now recognized itself as public and as patron in the new graphic languages and began to demand that these new languages appear in the products promoted by advertising. The quick spread of literacy through the urban population had created a vast number of potential consumers capable of reading short, simple sentences that were enhanced by the accompaniment of colorful and attractive pictures. According to Walter Benjamin: "Imaginative creation was preparing to become practical through the medium of advertising graphics."

This was achieved by combining lettering and images in a context that left little room for interpretation on the part of the public. The reader was excluded from any dialogue with the text or from any direct relationship with the image and was transformed into a passive receiver of influences that were rapidly transmitted by the spasmodic circulation of city traffic.

The field of advertising design thus became the chosen realm for the creation of new graphic models for monumental scripts. In the industrialized world it was not to lose its cultural and formal ascendancy, which would soon be transformed into a genuine form of linguistic domination.

From the very beginning, the breaking of the graphic norm developed in close connection with the rise of modern capitalist industry. Thus it arrived in Italy rather late, at a time when it had already reached a high level of development and diffusion in other European countries. When the new trend found its way to Italy, it brought the servile imitation of graphic styles that had been elaborated elsewhere and had been judged the most appropriate for the purposes of commercial advertising that the new graphic products, especially placards, were to serve.

During the last decade of the nineteenth century, the classical norm was rejected by the graphic culture of Italy and was replaced in books, advertising posters, and other printed matter by hybrid stylizations inspired by both the English Pre-Raphaelite movement and by the rather heavy, overly decorative tendencies prevalent in the German-speaking countries. The editions published by the Roman publisher Sommaruga during the early 1880s offer a fascinating and exaggerated illustration of the new vogue: ornate floral decorations and borders, richly colored illustrated plates, with an emphasis on red and black, and a new expressive language defined by Scipio Slataper in 1911 as: "a multicolored arabesque, initials tailed in Leonardo

fashion, filigree settings, framed sonnets, slender vignettes . . . lovely paper for soft cheeks, typographical characters exciting to the touch."

In 1887 Carlo Dossi designed the cover for his *Amori,* inspired by Japanese models reelaborated with an accent on floral motifs and printed on paper with special care. This event had no immediate impact on the graphic tastes of the time, however, and remained a unique episode in the career of this rather unusual and isolated literary figure. A more substantial and general change in graphic tastes would occur only a few years later with the advent of the new century and the introduction of new models and techniques.

In 1902 an international exposition of modern decorative art was held in Turin at the headquarters of the newly born Fiat. This exposition, brainchild of Thovez, sanctioned Art Nouveau in Italian territory, not only in the field of architecture and interior decoration, but in the vaster field of "graphics," to which two entire sections (XX and XXI) were dedicated. The rich poster designed by Leonardo Bistolfi gives a vivid illustration of the new style. In Florence that same year Adolfo De Karolis (later De Carolis), decorator and illustrator, designed the woodcut illustrations for Gabriele D'Annunzio's *Francesca da Rimini* and over the next few years produced a large number of title pages and woodcut illustrations for works by D'Annunzio and Pascoli and also for a few avant-garde magazines such as *Leonardo* (1903) and *Hermes* (1904). This very gifted illustrator was not only one of the first to launch the woodcut as an art form, but was also the creator of an original, if somewhat artificial and manneristic, majuscule alphabet. In designing these letter forms to be used in his woodcuts, De Carolis followed the example of the Pre-Raphaelites, drawing from Florentine models of the Quattrocento—and more specifically from Della Robbia's ceramic inscriptions, which he had carefully studied (see FIG. 109). De Carolis's alphabet, qutie distinct from the typographical norms of the classical tradition, was characterized by varied letter shapes, the inclusion of smaller letters in larger ones, the use of ligatures, bifurcation at the end of the strokes, the round G, the tailed Z, and other archaic features.

The new, more pliable woodcut technique—used not as a means of mere reproduction but rather as a form of artistic expression, found not only in books but also in newspapers, periodicals, and posters—soon spread through Europe and directly contributed to the breaking of the classical norm and to the general renewal of monumental graphics that occurred at the turn of the century. There were several reasons for this. First, the new art form had developed in strict connection with book design and offered

an element of sharp contrast to the stylized typographical layout of the printed page, which did not adapt easily to use of the woodcut. Second, the woodcut often included lines of writing, thus creating new layout patterns and new equilibrium of text and figure. Finally, the woodcut proved to be an excellent means for creating large, eye-catching monumental scripts whose morphology and style were modified by the cutting technique itself. All this was to have wide repercussions in the overall field of graphic design.

The use of photo-mechanically reproduced handwriting in book design, attempted by various Italian artists and illustrators, deserves separate mention. The experiments in this direction were greatly influenced by the manuscript books of William Morris and by the graphic tastes of the Pre-Raphaelites in general. In 1913 Giulio Aristide Sartorio designed an alphabet of powerful visual impact, composed of heavy, contorted strokes that vaguely suggested both semi-Gothic and the *antiqua* of Italian codices of the Quattrocento. (See FIG. 110.) In this same year, Charles Doudelet, member of the group Eroica, clumsily imitated the *antiqua* script in two volumes published by Argentieri in Spoleto.

De Carolis headed a school that produced many direct and indirect disciples among the illustrators of the first two decades of our century. Many of these were associated with the literary review *L'Eroica* published by the young Ettore Cozzani, the paladin of the new graphics. But the capital letter forms created by De Carolis for his woodcuts on the basis of models that had been designed for other techniques, such as the pen and the brush, did not seem suited to the new style of artistic expression and thus were rejected by the artist himself in later works and also by his more illustrious disciples who had broken with their master in the meantime. A new style emerged featuring rigid letters with bold, angular irregularities inserted in severe and square writing space. This new style reached the height of its dramatic expression in the work of Lorenzo Viani (see FIG. 111), and its greatest calm in the elegant pages of Armando Cermignani (see FIG. 112).

In 1911 Ettore Cozzani praised the fruits of what he so emphatically described as "the beautiful school" in the pages of his newborn *L'Eroica*. In 1915 he celebrated the secession of large group of De Carolis's disciples "in the name of an art that is not artificial, and in the name of wood that speaks with the voice of wood." In 1922 he lucidly listed the functional merits of Cermignani's monumental script in woodcut: "Personal, clear, solid, airy, which blends very well with typeface and with the lyrical movement of figurative illustration—creates stunning title pages and cover designs, with no harsh impact of lines, no abstruse tangle of letters—serene, vast, attractive." This praise was most definitely anticalligraphic.

However, the calligraphic tendencies of De Carolis's early work continued to be imitated with brush, pen, and engraving techniques by artists such as Gino Barbieri (d. 1917), Emilio Mantelli, Bruno da Osimo, and the talented poster-designer Guido Marussig, appearing in books, posters, and other minor graphic products. But the influence of the great decorator, who was keenly aware of what he called "the lapidary layout" of the woodcut, was felt even in monumental epigraphy, which continued to imitate De Carolis's models during the early decades of the century, adapting his capricious letter forms to new materials such as bronze, copper, and brass for outdoor display alongside marble and stone. (See FIG. 113.)

Meanwhile, in the graphic design of periodicals and books intended for popular consumption, rather moderate experiments were taking place that were careful not to frighten the petit bourgeois reader, such as the use of cursive minuscule in titles, the creation of new majuscule types, and the combining of writing and figure. The more artistic magazines with their colorful covers such as *Emporium,* published by the Institute of Graphic Art in Bergamo, became the heralds of the new trend, which consisted in an indistinct blending of styles that was more or less the direct consequence of the variety of models and designs proffered by the advertising graphics of the period.

Sometime before De Carolis's Art Nouveau style deteriorated into the precious calligraphs of Art Deco popular in advertising and printed matter aimed at the masses during the 1920s (the magazines published by Mondadori in those years are a case in point, with their illustrated title pages by Bruno Angoletta; see also the work of Sergio Tofano), Marinetti's futurist movement rebelled against one aspect of the Bodoni heritage that Art Nouveau had failed to take into account—the traditional typographical scheme and layout design of the printed page.

To have an idea of how long it took the futurist typographical revolution to make itself felt, we need only compare Alberto Martini's title design for Marinetti's *Poesia*—which appeared in 1908 and which displays strong Art Nouveau, or rather De Carolis, influence in its layout, type, and ornamentation—with any of the futurist *tavole parolibere* (texts whose chaotic layout defied the straight line: bits and phrases scattered here and there across the page) that appeared just five or six years later. Many things have happened in the meantime. First, the futurist movement has formulated its theoretical basis, which is set forth in the famous manifesto of 1909. It has also elucidated its choice of techniques in the later manifesto *Téchnique de la litterature futuriste* of May 11, 1912. Last and most important, it has borrowed the graphic and typographical models created by the new French poetry that

followed in the wake of Mallarmé's typographical experiments in 1897, which attempted to give figurative expression to the meaning of the text through experimental layouts, typeface, and text arrangements, thereby breaking with the canons and conventions of traditional and commercial printing. Among the exponents of visual poetry was Apollinaire (who was also a friend of Marinetti's), whose work deeply influenced the Italian futurists.

In the manifesto *L'immaginazione senza fili e le parole in libertà,* published in Milan on May 11, 1915, Marinetti made the first complete statement of the principles of what he defined as "a typographical revolution," which in reality, given the modesty of what he was proposing, was yet to come. "Thus on the same page we will use three or four inks of different colors or twenty different typographical characters if necessary. For example: italic for a series of similar, quick sensations, bold for violent onomatopoeia, etc." It was also affirmed that "the book must be the futurist expression of our futurist thought," and that the revolution was against the so-called "typographical harmony of the page, which is contrary to the ebb and flow, the fits and starts, the bursts of style." To this were added the more general rhetorical dictates already mentioned: the abolition of punctuation and the use of onomatopoeia and numerical symbols. However, the fact remained that for the moment this was primarily a controverisal campaign "against the brutish and nauseating conception à la D'Annunzio of the book of verse, with handmade seventeenth-century paper, adorned with Roman helmets, Minervas and Apollos, red initials, doodles, mythological vegetables, missal ribbons, epigraphs, and Roman numerals." In other words, Marinetti stood against the style that dominated Italian book design at that time, the style of D'Annunzio, Pascoli, De Carolis, and *L'Eroica,* and also that of the major publishers of books for mass distribution, from Treves to Zanichelli.

Slight knowledge of the history and of the techniques of printing, along with an extreme provincial attitude toward the modest products of Italian typography, kept the theorist of the futurist movement from venturing further than a biting, if rather general, atttack. Less than a year later, however, the *parole in libertà* (the free words), the creation of the first *tavole parolibere,* and the direct contact with what was happening in France led to the frank and specific statements expressed in the manifesto *Lo splendore geometrico e meccanico e la sensibilità numerica* of March 18, 1914. There it is stated that: "free words, in a continued search for the greatest power and depth of expression, are naturally transformed into auto-illustrations through the use of free and expressive spelling and typography, synoptic tables of lyric values, and figurative analogies."

In 1913 Francesco Cangiullo composed his *tavole parolibere,* which were later published under the title *Piedigrotta* in 1916. In 1914 Marinetti's poem "Zang tumb tumb" appeared, followed by "Alfabeto a sorpresa" by Cangiullo and by other works in a similar vein by Soffici, Paolo Buzzi, Carrà, Govoni, and many others of greater and lesser renown. Indeed, in a letter to Marinetti dated January 1915, Corrado Govoni cursed the disgusting form of ordinary book design. In their experimental works, the futurists rejected and attacked the traditional organization, layout, and linear arrangement of the text and challenged the expressive unity of typographical characters. Type was violently mixed with handwriting and figurative elements. The traditional design and format of books and fliers was also modified. All this had a strong visual impact on the public but at the same time compromised the public's ability to understand, participate, and criticize. The message of the text was difficult to grasp, and the distracted and aggressive forms of expression of the *tavole parolibere* showed little respect for the reader and also revealed a general inability to fulfill any positive task whatsoever in terms of educating and informing the public or in making these works known and understood by Italian society as a whole at that time.

And yet, these new works and their new textual-graphic language represent the greatest achievement of the futurist movement, the very reason for its success in France, and its point of contact with the Russian avant-garde movement. Finally, they are an indication of a sincere attempt to reach a new mass literary public. Although Boccioni complained in 1914 that the masses were quite alien to the movement, in 1922 Gramsci gave credit to Marinetti and his followers for the success of their efforts in this direction.

In the best examples of the *tavole parolibere,* which were also the work of figurative artists such as Soffici, the appearance of mathematical symbols ($+$, $=$, etc.) and the frequent use of typographical elements to create geometric designs such as circles, triangles, frames, underlining, or interruptions helped create a new formal equilirium within the disarranged space of the single or double page, where static and dynamic elements are divided into clearly delineated sections and placed in harmonious juxtapositon. Such principles of layout at times resulted in the dry, schematic, and sober mode of expression found in the posters of artists such as Depero (see FIG. 114), which was to become popular in the commercial graphics of the period, though under different stylistic influences.

Somewhat later, when the aggressive impact of the futurist movement on Italian culture had begun to fade, experiments in form by various members of the movement (the neofuturists) opened the way to new ideas. In 1927 the famous Tumminelli and Treves book pavilion was created, designed by

Depero. The entire construction was composed of squared letter forms resembling typeface, gigantic majuscules that were placed across an underlying structure. In 1932 Tullio D'Albisola created a book of tin consisting of a series of texts by Marinetti printed in color on sheets of metal and supposedly expressing the "futuristic valuation of the materials of mechanical modernity, mobility, and lyricization." A year later, in an article significantly entitled "Immensificare la poesia," Michele Leskovich, under the pseudonym Escodame, predicted the futurists' grapic conquest of open urban space (this was an elaboration on a theme already explored by Mayakovsky), of "the facades of our homes, " and of "the new architecture, replacing typeface with letters made of lightbulbs and neon tubes." In 1943, when Marinetti was nearing the end of his life, the last manifesto of the movement appeared. It not only summed up the graphic achievements of futurism but also reiterated the unlimited possibilities for the expansion of writing in urban space, foreseeing "futuristic cities where moving luminous signs compel the reader toward the page/piazza."

At the end of its journey, futurist graphics broke with the limitations of the book and of the page and sought its far horizon in the equation "writing = architecture." But someone had already preceded the futurists in this direction; the open spaces of Italian cities in this period had already been discovered and occupied by a specific celebrative ideology (with which Marinetti fully agreed) and by a very different expressive language—the language of the new purist rationalism with its more or less lucid followers. The avant-garde pseudo-revolution had ended. The war was almost over.

Chapter Eleven

THE NEW ORDER AND THE

SIGNS OF THE REGIME

"What is most striking is the tendency in typography toward a rather common typeface, more elegant, refined, and commercial, without clear distinctions or severity, the same characters, the same ornamentation, the same appeal of illustration and facsimile." With these words Renato Serra in 1914 presented the books produced by Italian publishers during the previous year, judging that progress had been made and underlining the tendency toward typographical uniformity displayed in the outward appearance of these books, a development that would seem to contrast sharply with the breaking of the classical and traditional norm that we have already discussed.

From his standpoint Serra was right, for he had a global view of the situation and also because, being a literary man of keen perceptiveness, he obviously sensed the resistance mounting on the part of both the more sophisticated and the ordinary reading public against the excesses of the innovators. This resistance, which would soon be expressed by the bare and simple graphic style of De Robertis's magazine *Voce,* was especially evident in book and periodical publishing, an area directly related to (or at least influenced by) official culture, which clung to its time-honored traditions and which catered to the cultural and aesthetic tastes of the average petit bourgeois reading public.

This fact, along with the intermingling of diverse factors and foreign influences, contributed to the arising of a very strong and widespread tendency toward extreme simplicity, clarity of presentation, and symmetry of all elements, which dominated the field of graphic design during the years 1915–30, a time of great social upheaval in Italy marked by the Great War and the rise of Fascism. The new trend found inspiration and support in the realm of art, and more specifically in the neoclassical (and anti-Art Nouveau and antifuturist) movement that revolved around artists such as Carrà, Savinio, De Chirico, and the magazine *Valori Plastici,* which first appeared in

1918. It also found response in the literary movement associated with the magazine *Ronda,* which was first published in 1919. The rather severe brick-red cover of this magazine, with its classical Bodoni lettering and its nineteenth-century-inspired drawing of a drummer boy, represented a return to older models and to rigorous, "normal" layouts, which had never been completely abandoned by some of the more sophisticated publishers, such as Laterza, a disciple of Benedetto Croce.

At the beginning of our century, Italian graphic culture began to participate much more actively (though in a somewhat secondary role) in the vaster and tormented area of European graphics. In this phase of reaction against the avant-garde and of rehabilitation of "normal" values and absolute rules, Italy followed suit, importing the new developments from France and especially from Germany, which were characterized by the same tendencies toward normalization and rationalization, and imitating these new models in varied and often contradictory ways. In this regard we may trace the development of a markedly traditional trend represented by Bertieri and by the significantly named review *Il Risorgimento grafico,* published in Milan in 1902 and edited by Bertieri after 1906. To this man, a typographer and the owner of the Bertieri graphic institute from 1927, we owe the new focus on the book as the sole model for graphic design, the creation of the myth of "the beautiful book," and the most narrow-minded and vigorous reaction against all tendencies toward innovation. As director of the Scuola del Libro dell'Umanitaria in Milan, affiliated with the Fascist regime after 1926, we must credit him with the design of a few characters directly based on models from the Quattrocento and Cinquecento. During this same period, Francesco Pastonchi had a new font designed, based on Renaissance models, that was to bear his name.

In our discussion of the revival of formal values in typography and the return to the book as a model, we must also mention the complex figure of Giovanni Mardersteig, the great Italo-German master of typograpy, heir to a refined Eastern European cultural heritage, who was heavily influenced by Morris. (See FIG. 116.) Mardersteig restored the use of the Bodoni style and of Italian Renaissance models for graphic and book design, first in Switzerland and later in Verona.

Thus this was not an Italian but a European phenomenon, and in Europe skirmishes and battles between classicists and innovators had already occurred. Both camps had their prophets and their renegades, and both had experienced victory, defeat, and historical partings of the ways. This phenomenon partly involved the Dadaist movement in France and Switzerland, which had further elaborated a few ideas borrowed from the surrealist and

futurist typographical revolutions. It also partly involved Russia, from whence the new futuristic book had arrived at the beginning of the 1920s, in which the order of graphic composition was radically disrupted. These developments found a new terrain for fervid comparison and mediation in Germany after the First World War and in the Bauhaus movement.

The new tendencies were enthusiastically proclaimed in 1928 by Jan Tschichold (then twenty-six years old) in his treatise *Die neue Typographie,* in which he called for the abolition of the symmetrical layout and the adoption of a single type font, bare of ornament and uniform in stroke. In the name of a new typographical clarity and simplicity, he advocated the sans serif character.

Sans serif type already had a long history behind it and was based on an ancient model. It had first emerged in neoclassical England in imitation of the Greek epigraphic capital and was used for the relief inscription of the London Pantecnichon in 1830. It was revised by Edward Johnston (on the basis of the skeleton of roman capitals) in 1916, with strikingly slender and modern forms for the signs of the London Transport underground. Adopted by the Bauhaus in Weimar for their publications, the sans serif corresponded to the new demands for stark clarity and rationality and brought a much-desired burst of innovation, given that both the futurists and the Dadaists had failed in creating their own original codes of graphic signs.

Tschichold himself, the self-chosen champion of the sans serif, later abandoned it as he abandoned all the other revolutionary proposals of his youth and turned to the arduous pursuit of an ascetic classicism.

Then, shortly before the Bauhaus was dispersed by the tides of Nazism, Paul Renner redesigned the sans serif character with vigor and imagination, creating the font Futura in 1927–30 (see FIG. 117), which made its debut at the Triennale of Milan in 1933, at a moment when the drive toward rationalism in art and architecture in Italy was becoming more and more marked.

In the Fascist-ruled Italy of 1927, political posters such as one by Luigi Spazzapan advertising a meeting of the Blackshirts not only represented the new style for the new regime but, more important, expressed an outright rejection of the calligraphic tendencies that had been manifest in Art Nouveau and Art Deco, in "the tombstones of mountain village cemeteries," in those "ugly calendars," and in those "horrible covers" which that same year were branded as "trinkets and trumpery" by the newspaper *Critica fascista.* In this same line, the following year in the eleventh issue of the new magazine *Casabella,* Gio Ponti praised the sporty style of the advertising placards that had appeared on gas station pumps, and later in 1931 the editors of *Il Selvaggio* described the recent signs defending Italian products as "effective, con-

temporary, serious, and vigorous" and applauded "the eviction of de Carolism . . . with its oblique *S's.*"

In reality, the controversy went much further than the realm of graphics and involved contemporary Italian architecture, which perhaps for the first time became associated with a particular graphic style and which stressed the aesthetic and ideological values inherent in a code of signs. The innovative architects who had first banded together to form the Group of 7 (1926–27) and later the Miar (1928–31) proclaimed a genuine manifesto of rational architecture according to which graphic design was to respect the general canons of essentiality, functionality, and simplicity. The famous "table of horrors" with its Art Nouveau and Art Deco graphic inserts exhibited in the second Exhibition of Rational Architecture in 1931 made it very clear what the chief targets of the new movement were. However, the geometric majuscule alphabets designed by Giuseppe Terragni (one of the more authoritative members of the group) and extensively displayed in the Exhibition of the Fascist Revolution in 1932 revealed how deeply the graphic and architectural language of the new political regime had in reality been influenced by Soviet and Weimar models.

Two years after the Miar dissolved in 1931, the "bearers of the New Word" began to congregate around another magnetic center: the *Campo Grafico,* a journal of aesthetics and graphic techniques founded by Attilio Rossi, Carolo Dardi, and Luigi Minadi. (See FIG. 115.) This new magazine was characterized by an extremely modern cover design, daring text arrangements, lavish use of photography, and a new printing technique, all of which were based on the new English journals *Design in Industry* (1932) and *Design for To-day (1933). Campo Grafico* soon became the forum for attacks on Bertier's classicism, on the concept of typography as "a beautiful art," and on the supremacy of the book as the sole model for graphic design. It also served as a showcase for new fonts, new layouts, and neofuturist experiments (to which issues 3–5 in 1939 were dedicated).

These were decisive years for Italian graphics. Milan witnessed a burst of activity, including *Campo Grafico,* the Boggeri design studio, and the work of Luigi Veronesi and Edoardo Persico, the latter the director of *Casabella.* These were the years of Paul Renner's participation in the fifth Triennale, of the Bauhaus, and of new influences from Eastern Europe, England, France, Switzerland, and Soviet Russia. It was also in this period that the forces tending toward rationalism and renewal, which had been nourished on all these influences (with the exception of the early *Campo Grafico*), began to recognize in Fascism, or rather in the Fascist state, the natural client and receiver of the new architectural graphic language then in elaboration.

From the absolutism, functionality, and formal rigor of the rationalist outlook to the ceremonial solemnity of a square and uniform style as the ideal medium of a message of subjection and consensus, the distance was not so great as one might have thought. It was quickly traversed by many, if not all.

In 1933, much of the vast display space inside and outside the fifth Triennale of Milan was occupied by inscriptions. These were painted, sculpted, and cut in monumental majuscule letters employed for titles, captions, celebrative mottoes, and lengthy quotations from Mussolini. The layout of these inscriptions was nearly always classical, the arrangement of the text and framing only slightly less traditional, and the lettering very modern indeed, using the austere and simple sans serif font. Thus the monumental script of the Fascist regime was officially inaugurated. This was substantially the same script used by rationalist architecture, by the Bauhaus, and (with the exception of the alphabetic system) by Soviet graphics, according to a form of logic that was only apparently contradictory. Although the function of the new graphic code as a means of mass communication had been completely turned around, as it were (compared to its function, for example, in Soviet Russia), the fonts themselves were left intact and were reused in contexts far removed from their original ones, to which, however, they did bear a certain resemblance.

Earlier, in 1925, addressing the city from the Campidoglio, Mussolini announced a new plan soon to become a constant element of the regime's urban policy dictated by ceremonial-monumental concerns, namely, creation of vast open spaces in the historical center of Rome, to be accomplished through his famous "disemboweling" of the old neighborhoods. Likewise, in the new urban areas and the new neighborhoods created in the old cities, vast open spaces were to be laid out around new monumental structures. The aim was to open up new vistas and extensive surface space to the gaze of the city's inhabitants. What could have been more natural than to fill these empty spaces with writing, with ceremonial and celebrative inscriptions visible at a great distance and durable in time thanks to the use of monumental writing? Thus the epigraphic majuscule of the Fascist era was created for and in those open spaces. It lasted only a decade, but those years were rich in technical experimentation and in the elaborate adaptation of ancient models to a formally modern graphic language.

There was basically only one graphic typology, as we have already mentioned—the sans serif typographical font, simple, square, and bare of ornament, epigraphic in origin. However, the techniques were many. The most common was relief carving. When this technique was used, the letters seemed to jut out from the plain background and were very legible, espe-

cially when viewed in perspective and accompanied by oblique lighting. The traditional system of V-cut carving was seldom used, primarily because the sans serif, which has no finishing details at the end of the strokes, did not give good visibility when cut with this technique. The practice of inserting metal letters on a stone background was occasionally resumed, similar to the inscription of Augustus inserted in the base of the Ara Pacis in Rome. Mosaic was frequently revived as a form of ritual homage to ancient Rome, but its graphic application often betrayed a certain tendency toward interpretation. Another technique widely adopted, even for rather ordinary daily propaganda, was the wall mural, either painted with a brush or printed on rolls of paper and pasted inside and outside monuments. These were often displayed on the available wall space of public housing projects. The inscriptions of these murals were rendered in carefully studied and rigorously proportioned letter forms that reveal artifice and imposition and have an air of officiality that is the exact opposite of what mural writing is (or should be) in terms of free expression.

Rome was of course the privileged site of the regime, the place chosen for its graphic experiments, which represented an essential element of comment and accompaniment to its monumental policy. Between 1930 and 1942, hundreds of declamatory and celebrative writings in Latin and in Italian, in prose and in verse, appeared in the piazzas and on the plain surfaces of the monuments built by Mussolini's architects in Rome. Many of these inscriptions are still there today. Conceived and planned together with the building projects of these monuments, these inscriptions were designed to be an essential part of the overall architectural-spatial display, as we can see from Marcello Piancentini's sketches for the rectorate of the University City in Rome.

Today in those places where they are still visible in their entirety, the vast surfaces inscribed with relief epigraphs furnish an irreplaceable element of aesthetic equilibrium and of completion to the overall architectural structure, as for example in the buildings of Piazza Augusto Imperatore built by Vittorio Ballio Morpurgo and completed in 1940 (see FIG. 119), and also in the University City in Rome (see FIG. 118). The building complex with the richest display of celebrative inscriptions is the Foro Italico (see FIG. 134), designed by Enrico Del Debbio, where the grand avenue of the Foro leading from the monolith to the globe fountain has been treated as a true graphic display. The designs of the vast mosaic pavement are accompanied by captions, while similar inscriptions run along the sides. Still other inscriptions are engraved on large blocks of travertine set along the sides, each one commemorating an important date or event in the history of regime. Fi-

nally, outside the ornately illustrated ring encircling the fountain, a large inscription in big square letters appears, divided into equal sections of three lines each.

Similar examples were to be found throughout Italy and the colonies and were even made obligatory. Thus the regime ordered all municipalities of Italy to mount a slab commemorating the "sanctions" of November 18, 1935, on public buildings. (See FIG. 121.) Inscriptions of this kind may be found on the monument to Victory in Bolzano, in Piazza della Vittoria in Genoa, on the new Palace of Justice in Milan (see FIG. 120), all designed by Piancentini, as well as on the Palace of the Fascist Unions of Industry in Milan, on the large complex of Piazza della Vittoria in Brescia, on the monument to Armando Diaz in Naples, on the Casa Littoria in Ravenna, and in many other places. The monumental script adopted by the Fascist regime for these epigraphs also appeared in other contexts, variously painted, drawn, or photographed, and was always present on special occasions and during those brief and periodic celebrations that the regime organized so generously in Rome, in the provinces, and in the colonies, such as exhibitions, inauguration ceremonies, fairs, commemorations of historical events, military parades, gymnastic recitals, and so on. All this activity brought about a new phase of ephemeral display writing that seemed to revive, though on a much lower plane, the ephemeral display writing of the baroque era two centuries earlier. Commercial advertising quickly adapted itself to the new style dominating public display writing, and soon Mussolini's monumental script could be seen multiplied across all the walls of Italy— painted and photographed, reproduced in all possible ways and forms, including sculpted minuscules. Thus during the years 1930–43, the square sans serif capital letter became one of the characteristic features of the regime's theatrical liturgy and of its physical presence, a symbol of its supremacy. In the end, it became the graphic style of an entire epoch of Italian history.

Thus for the last time, in the closed and provincial world of the Duce's Italy, epigraphic monumental script came to enjoy graphic supremacy and to function as the matrix for all models of writing. Thus for the last time, the manifold models elaborated by avant-garde artists and designers and promoted by commercial advertising were substituted on the official plane by the indisputable uniformity of the regime's monolithic script.

The formal supremacy of the epigraphic norm brought about the rapid deterioration of Fascist poster and placard design during the thirties and the war years. The crudely realistic vulgarity typical of the drawings (see the work of Boccasile) in these posters was accompanied by banal graphic choices, according to Albe Steiner: "The placard/poster designers had very

few clients—for the most part their clientele consisted of the government or Fascist organizations and a handful of private firms. . . . That was all. The market was closed, and the professional skill of these artists was limited to the knowledge of painting, which they tried to apply to drawing or illustration."

In this period in which the official epigraphic norm enjoyed absolute dominion, a period so exaggeratedly and at times sullenly Fascist—one, however, distinguished by its very modern graphic aesthetic tastes—a new monumental script came into being, quite different from the prevailing one. The new script made its appearance in Mino Maccari's *Il Selvaggio* (1924–43) and more particularly in the sophisticated edition published in Rome from 1932 until the end. (See FIG. 122.) It was characterized by large irregular letters, contorted majuscules, and italic letters with improbable embellishments curling across the pages of linoleum block and woodcut illustrations in perfect harmony with the bold, grotesque scribbles and the dense nineteenth-century-inspired text arrangements.

In reality, behind Maccari's and Longanesi's *selvaggismo* (wildness), as behind Bontempelli's *novecentismo* (modernism), there was a notable element of cultural poverty and provincialism, along with a total approval of Fascism in its most radically reactionary and obtusely fierce form—the deeply buried fascism of a certain strata of the Italian lower and middle class, uneducated, racist, and brutal in its elementary class-consciousness. But there was also an awareness of some of the major developments in European graphics (the work of Grosz, for example) and an adventurous inclination toward graphic experimentation, the combining of drawing, photograph, and script, and a provocative reelaboration of popular models from the nineteenth century, rendered through poor techniques. This style survived Fascism and, through imitation and reelaboration, became an independent line of graphic research in postwar Italy, chiefly because of Leo Longanesi's varied efforts as publisher, journalist, and artist. Its influence would be felt far beyond the narrow field of periodicals and elite publishing.

Chapter Twelve

THE RED SIGN

I n the beginning there was Russia. What better words could be found to begin our discussion of the present subject: the efforts of the workers movement and its official publications in our century to master its own autonomous code of signs and to develop its own monumental lettering to serve as a tool and as a weapon of political and social propaganda.

Speaking of Italian newspapers, Albe Steiner once remarked, "I can't understand why the working classes haven't yet managed to express their own progressive ideas with visual forms that correspond to those ideas." Indeed, from a purely scriptorial point of view, there is no doubt that before 1945, socialist (and Communist) graphics consisted of a mere adaptation of current stylistic (and therefore conformist) models to political concepts that represented, at least potentially, an alternative.

But in places where the social context was quite different, such as Soviet Russia, this was not the case. For the Russian ruling classes (and especially for the bourgeoisie), monumental lettering had functioned mainly as the graphic representation and manifestation of power, as a tool for the one-way transmission of a message of domination addressed to the masses, whose consensus or submission was the prime object. This was not true of the revolutionary avant-garde, who were concerned rather with the problem of how to involve the masses as the true masters of a new language, not merely as passive receivers of the message, and with the problem of how to renew and disseminate the use of public display writing for revolutionary political purposes with tools and forms that were not only easily understood by the proletariat but that also corresponded to their needs. Thus the forms and typologies of the new language were necessarily very different from those of bourgeois graphics.

From 1917 until the end of the 1920s, artists such as Mayakovsky, Kruchenich, and El Lissitzky took up this challenge, promoting the literacy of the masses while striving to create an essential, political, graphic language

that was inseparable from its revolutionary message and that was legible to all, literate and illiterate alike.

This aim, which was pervaded by a strongly pedagogical and propagandist element, was pursued through varied means, including the skillful combining of letters and pictures, the use of square and essential letter forms (the Cyrillic alphabet with its long history of majuscules was indeed an asset in this sense), and the adaptation of graphic products (such as the placard) previously used for other purposes to new ends. In the space of a few years, thousands of prototypes were created and millions of copies were printed; new types of products were invented such as the illustrated mural newspaper, and various forms of ephemeral monumental lettering were created for special occasions and celebrations, to be displayed on buildings, in the squares, and on special propaganda trains.

At the very beginning of this process we find in Russia a handful of artists and intellectuals, genuine creators of new models, turning the graphic language of the European avant-garde inside out for very new ends, working within a context in which the relationship between writing and power had undergone deep modification. However, this did not last long, ending when Josef Stalin, the great "normalizer," came to power. Shortly thereafter, the graphic messages and models elaborated in revolutionary Russia found their way (or in some cases returned home) to Western Europe, thanks to El Lissitzky's journeys to Germany and Switzerland, where they were to have a profound impact on the graphic experiments of the Continental avant-garde. Filtered through the asceptic outlook of the Bauhaus and of rationalism, these models were soon adapted to the needs of the social-democratic, bourgeois, and openly Fascist societies of Western Europe.

In Italy the new search began in 1945 at the end of the war, with the fall of Fascism and the triumph of the Resistance. The new configuration of political and social forces enabled the workers movement to pose the problem (with clarity, though without much success) of the need for a new, revolutionary graphic style. In reality, during the Resistance (1943–45) the anti-Fascist groups and leftist parties and organizations had demonstrated that they did not possess a graphic language of their own and that they did not know how to create or propose one to the masses, with the exception of a few artists such as Albe Steiner and Luigi Veronesi, who were working in isolation. Yet the struggle now under way in Italy required such a language. Newspapers were being printed and posters pasted up, commemorative stones carved, and monuments inaugurated. The sans serif letters endorsed by the graphic display of the enemy regime had been rejected, and a

rather disorderly, free-for-all search for appropriate letter forms had ensued, guided by the inspiration of amateur or semieducated craftsmen (stonecutters, graphic designers, typographers) who jumbled characters together and created absurd layouts, crude illustrations, texts so dense so as to be illegible, and so on.

In the realm of commemorative epigraphy, which flourished in the period immediately following the end of the war, only a few memorial inscriptions escaped this fate, namely, those few texts whose significant literary content or illustrious authorship demanded a dignified style. This is the case for what I am convinced is the first inscription of the Italian Resistance, which was composed by Benedetto Croce to honor victims massacred by the Nazis at Caiazzo on October 13, 1943. (See FIG. 123.) It is also true of several inscriptions by Piero Calamandrei that are clothed in the high rhetoric of the Risorgimento and engraved in elegant capitals accompanied by a severe layout. However, it is not true of many others (including some by Calamandrei), for the most part rather humble, simple funerary inscriptions that are to be found scattered throughout the regions of north-central Italy, commemorating the fallen, the tortured, and the executed and fashioned by local craftsmen according to the poor but lively traditions of lower-class and petit bourgeois funerary epigraphy that we have already discussed. Even the memorial to the victims of the Nazi concentration camps designed by G. L. Banfi, L. B. Belgioioso, E. Peressutti, and E. N. Rogers, erected in 1946 in the monumental cemetery of Milan and rebuilt in 1952, displays an unattractive, narrow, and densely written capital and a rather chaotic layout.

On September 29, 1945, the first issue of a new weekly appeared—the *Politecnico,* published by Einaudi and edited by Elio Vittorini. At this time Italy was flooded with new periodicals. Yet this one, despite its old-fashioned name, was something quite new. (See FIG. 124.) The first page had an asymmetrical layout, and the title appeared in white letters printed on a red band across the top of the page. Sans serif characters were used systematically throughout, accompanied by the lively addition of drawings and photographs and a violent contrast of red and black ink. Here the signs and the more daring stylistic features were charged with powerful political meaning. The conquests of the great Soviet graphic designers and of rationalist Europe had just made their first clamorous appearance on the Italian scene.

Franco Fortini commented:

> I had no doubt about the meaning of the graphic design or
> of the political content it conveyed. It expressed, to sum it

up in a word, the very same content that Vittorini wanted to find in the articles he published: a fondness for a positive didacticism, with nothing left obscure, a sort of psychological gaiety of the straight and narrow, of intellectual purity in contrast to the repugnant chaos of fragmentation, waste, and refuse, real and symbolic, which had been the legacy of the war.

Vittorini was the author of the *Politecnico*'s verbal message. Its powerful graphic message—whose strength, simplicity, and modernity may still be felt today—was the creation of Albe Steiner, an Italo Czech of Eastern European background who had been in Milan since 1930, absorbing the influences of futurism, architectural rationalism, the Bauhaus, and the Soviets. In 1939 he became a member of the Communist party, and in 1945, as a teacher in a technical school, he began to teach a new way of interpreting the professional role of the graphic designer.

In his creative and political works, Steiner's use of monumental writing followed a few basic principles: maximum simplicity and legibility of the sign, consisting of sans serif characters; minimum use of handwritten or painted letters to the advantage of typography; the prevalence of images (generally photographs) over script, which was reduced to its most essential; and finally, the drawing of a direct analogy between the balance of architectural forms and typographical composition, namely, "the balance of the page, the balance of the form, the search for special effects which are not merely static but also dynamic, letters which may become marvelous signs and which have a life of their own." A more general principle was the expressive autonomy of script from the graphic point of view. As Steiner defined it, it was:

> the discovery of the relationship between literature and typography, between poetry and typography, between aesthetics and typography. The discovery and the careful search for an effect that may be obtained through the spoken word, and thus through meter, rhyme, typography, color, the relationship between color and graphics, pure graphics, the graphics of composition . . . not graphics intended as a sign borrowed from a painter and copied from a painter.

All this contributed to Steiner's greatness as a graphic designer and as an artist to whom we owe not only many outstanding examples in the design of books and periodicals (e.g., his work for Feltrinelli and Zanichelli) but also a very new and modern interpretation of the role of display writing in

advertising and politics. However, still other principles and values shaped his work as militant graphic artist and are manifested in his graphic designs for the journals *Milano Sera, Politecnico, Contemporaneo,* and *Rinascita;* in his campaign posters for the Communist party and his work for *Unità* (see FIG. 125); and in his design for the memorial inscriptions honoring the deported political and racial victims of Carpi (1964; see FIG. 128), as well as in many other works distinguished by his easily recognizable "red sign." These principles all express an "underlying respect for the receiver of the message"— that is, the masses, to whom the display message is always addressed in our contemporary society—and reveal a pedagogical and instructive attitude toward the masses, who must be stimulated and elevated and whose aspirations must be appropriately guided by experts with whom they share a deep bond. They also suggest total approval of industrial society. "I am not speaking to an elite. I must speak to a great number of consumers. I live in an industrial society, and I am quite happy with this society."

Although they were placed at the service of progressive political ideas, these principles substantially confirmed the role of graphics as a "hidden persuader" and implicitly denied the masses their right to seize direct possession of writing or of the places in which it was displayed. Furthermore, in emphasizing the professional figure of the graphic artist, modes of expression, and the mechanisms of production, they blurred the distinctions between commercial graphic design and political graphic design. Though for Steiner this should have led the latter to perform a public service and to provide tools of culture, in reality it inevitably brought about the transformation of political graphic design into a genre of commercial advertising.

However we wish to view Steiner's influence, it remained minor and was finally defeated not by direct attack or by the *Politecnico*'s violent death but rather by a general state of cultural backwardness that embraced vast categories of intellectuals from both the petit bourgeoisie and the proletariat. Testifying to this backwardness on the part of the historical left was the widespread adoption of a certain type of placard design that was influenced by the figurative language of social realism and that, on the graphic plane, was characterized by the use of mixed characters, formal archaisms, casual layouts, and poor legibility, following rather uncultured and provincial traditions that, as we have seen, originated during the years of the Resistance. This style was countered by a type of placard design used by the Christian Democrats that reproduced the lettering, verbal messages, and modes found in Fascist propaganda a few years earlier, addressed to the same public and designed by artists such as Boccasile and Molino.

The years of the *Politecnico,* which were sad and trying years for the workers movement, corresponding to the Christian Democrat regime, witnessed the success of a unique new type of printed product on the Italian market: the weekly news magazine printed on the rotary offset press, promoted by private publishers, widely distributed, and generally based on a moderately conservative or openly reactionary ideology. The layout, use of photos and pictures, and headines of this type of graphic product conveyed a message of conformism and cultural ignorance. The most popular of these was *Oggi,* the first issue of which was published in Milan on January 1, 1946. From a graphic point of view, it may be considered a truly alternative (and triumphant) model compared with Vittorini and Steiner's *Politecnico.*

From this point on, the battle for the renewal of Italian graphic culture ceased to be conducted by the Left. Rather, between the end of the fifties and the early sixties, the years of the economic and consumer boom of Italian and international capitalism, this battle was conducted by the huge Italian and American advertising agencies, which reaffirmed their supremacy in Italy in the realm of display messages and monumental writing, a privilege they had already exercised in the United States and in the more advanced European countires.

Through the use of modern graphics in advertising design, the average Italian citizen became accustomed to the mixing of photos and writing, the use of asymmetrical layouts, the aggressive presence of alphabetic signs and of objects, new characters and letter bodies, a new and plainer formal equilibrium, and new aesthetically appealing modes of presentation based on abstract geometric design, such as the billboard created for Campari by Bruno Munari in 1965, which was ingeniously based on graphic overlay. In the sixties and seventies, these same characteristics made their appearance in public graphics for social or functional uses, as for example the signs directing pedestrians in the Milan subway system, prepared in 1962–63 by Franco Albini. Finally they came to penetrate the field of political graphic design, transforming the language and symbols of all the parties, even those on the left, diluting their original characteristics with easily understandable images and words in a process that, as far as the Communist party is concerned, attempted (and is still trying) to eliminate all trace of red.

Chapter Thirteen

THE SIGNS OF NO

After May 1968, the graphic culture of capitalist European countries—and most particularly of Italy—was influenced and partially altered by the emergence on a vast scale of spontaneous display mural writing in the larger metropolitan areas (incorrectly known as graffiti). In the brief sampling of so-called graffiti given below, we may identify three different attitudes, which represent the basic views shared by the majority of graffiti writers concerning the meaning of their work and more generally of this graphic-literary genre, which has been in existence for over a decade.

1. Je cris, j'écris. [Paris, 1968]
2. Behind writing there is life. [Rome, 1977]
3. Wall, you are all mine. [Rome, 1977]
4. Let's write here. [Rome, 1977]
5. Ici on spontane. [Paris]
6. Writing is beautiful. [Rome, 1978]
7. Write all over the place. [Paris, 1968]
8. It's time to beautify this city—Do it with graffiti. [New York]
9. White walls are sad, but not ex-white walls. [Rome, 1977]

According to the first attitude (seen in nos. 1–4), mural writing is above all a private form of expression. The second attitude (nos. 5–6) stresses the creative and aesthetic aspect of this genre. The third (nos. 7–9) deals with its spatial, and therefore explicitly political, aspect—namely, its occupation and transformation of urban spaces.

From what we have said thus far in this book, the reader could easily conclude that the ceremonial and official display of writing in open urban areas is the exclusive privilege of the public authorities and of the ruling classes who have manipulated display writing for centuries as political propaganda or as a means of self-celebration. Furthermore, the reader might think that all the major modifications that this genre has undergone and its potential for acquiring new aesthetic meanings are all related to this fact.

But it is also true that in the past, and especially (but not exclusively) in periods of widespread literacy, the practice of writing on the walls of buildings was quite common in the city, although it was for the most part a private gesture, often limited to the writer's name or to a few words concerning the particular circumstances of his or her individual graphic act and equally limited in letter size, collocation, and technique of execution. This private and occasional production of writing (e.g., the graffiti of Pompei in ancient Roman times, the writing on the walls of churches and sanctuaries in the Middle Ages, or the graffiti on prison walls in modern times) never developed its own autonomous or homogeneous formal stylization, nor did it in any way influence the aesthetic evolution of public monumental writing, with which any direct comparison was impossible, given the essentially clandestine nature of graffiti.

The individual, personal mural inscription was nearly always the work of individual writers, who considered (or consider) their message as something private (as in the case of devotional writings in churches and sanctuaries) or as something transgressive (as in the case of obscene writings) or as addressed to a particular person (in the case of erotic messages). Or it may have been the handiwork of those who felt (or feel) excluded from participation in the channels of "public" writing and therefore sought (or seek) to express themselves by writing on the walls, but who also felt (or feel) that in doing so, they had gone against the rules.

In the display mural writing of the last decade, the authors' awareness of their own exclusion (becauses of class-based and therefore violent discrimination) from the production mechanisms of lettering is accompanied by their understanding that through the "graphic occupation" of city wallspace they are breaking a rule. However, what most distinguishes the value of these writings from that of purely private and occasional ones is the obvious point of contact between these two considerations. This very feeling of being excluded moves the graffitist to action, a fact that stresses the strong exhibitionist tendencies underlying the whole operation and yet at the same time renders it an external and public act. This in turn has an influence on the morphology and appearance of the individual inscriptions and invites a comparison with the public inscriptions triumphantly displayed on the walls of the city by the economic and political authorities, whose messages are challenged, replaced, and obliterated by the invasaion of graffiti into their own space.

These mural writings are all substantially political, even though their messages may not be explicitly so. For this reason they are usually not the work of individuals but of relatively large and organized groups who use them as

propaganda and also as a means of asserting their power on a local level and of communicating with the inhabitants of the areas in which they operate. Indeed, it is the complexity of the functions performed by this type of graphic manifestation that has often led its authors to accompany their mural inscriptions with other analogous forms of public display writing such as posters and signs, the former being of a fixed nature, and the latter movable. This has given rise to a proliferation of spontaneous and predominantly handwritten inscriptions, posters, signs, and so forth, which are often quite complex and may require elaborate and at times even sophisticated techniques of writing and reproduction.

The May 1968 student revolution in Paris witnessed the first large-scale manifestation in Europe of this type of graphic production. It was indeed a real explosion of spontaneous writing, which began by covering the interior and exterior of the university and student-occupied buildings and later spilled out to the Latin Quarter and to the rest of the city. One of the principal vehicles for this graphic invasion were the eight hundred or so political silk-screen posters fashioned according to the instructions of Vasco Gasquet, reproduced in approximately 600,000 copies and pasted on the walls all over Paris. Compared with the traditional graphics of advertisements, these hand-painted student creations (many of the "artists" were enrolled at the Ecole des Beaux-Arts) were almost totally devoid of figurative symbols and consisted entirely of words—that is to say, of pure writing. Moreover, they paid no heed whatsoever to the rules of layout (some writings seemed to be slowly sliding to the ground) or to aesthetic concerns. As Eco remarks, these student graphics "reintroduce into the universe of the glossy and polished ad brutal and unpleasant configurations and a rough drawing technique in red and black which offends at first glance." These posters functioned as a centrally controlled tool of political communication and counterinformation transmitted through a circuit that "horizontally" connected senders and receivers.

According to Tiberi,

> The entire city became a huge mural newspaper. The walls of the university, of the houses, of public buildings—which had always been accustomed to listening—now began to speak. . . . The elevators spoke, and the paving stones in the street, the walls of the churches, and of course the signs carried by the demonstrators. One huge newspaper, printed in a limited edition of one. A newspaper whose layout had been designed by dilettantes. . . . No general editing, no censorship, no official responsibility.

In that same year this "ugly" spontaneous graphic phenomenon made its way to Italy, and as Bruno Zevi recounts, that summer outside the entrance to the Biennale, Carlo Scarpa, master of Italian contemporary design and architecture, tore up a poster carried by a cortege of demonstrators because, or so he shouted, its layout "offended his aesthetic sense." The symbolic value of this episode cannot be overlooked.

The fact that the spontaneous writing of 1968 was "ugly" certainly does not mean that it was something alien to (although it originated "outside") the official culture of the establishment or that it had its roots in the excluded lower classes of the social system. On the contrary, in Italy these writings were the creation of university students who, although they may have professed radical and revolutionary ideologies, were socially and culturally members of the bourgeoisie. Given the position they occupied in society, since they belonged to those levels that traditionally were the producers of writing, there was no reason why they should have felt excluded—in the sense we have described here—from the forum of public writing, unless this feeling of exclusion was the fruit of their own political-ideological rejection of the relationship that existed between writing and power in the society they were challenging.

Therefore the nontraditional appearance, the antiaesthetic forms, the blatant ignoring of layout rules, the messy technique, the general illegibility and crudeness of the end result were due not to a lack of technical skill but rather to a conscious rejection of commercial-political graphics and to a repudiation of what it represented, given its dependency on the establishment. It is this rejection, the anarchy of form that it entailed, the poverty and roughness of technique, and the improvising of solutions depending on the individual circumstances re-creating anew the relationship between writing and space with every effort that formed the basis of the new aesthetic of display writing and of its ideological value. These new values, which the writers were fully conscious of, had their own evolution and came to play a significant role in the successive development of official political and commercial graphics.

In Italy as in Paris, the most important aspect of this whole phenomenon was the conquest of urban spaces, the occupation of these spaces by lettering and their subsequent visual transformation, a conquest undertaken by all the various radical groups and movements in recent years—including students, squatters, factory workers, feminists, and the unemployed—who have covered the walls of the major Italian cities with extensive documentation.

As we have already suggested, at the basis of this operation lies the writers' awareness of their own alienation from the urban environment and from

the monumental writing that dominates there—along with their determination to assert themselves (as a group) and to publicize the reasons for their struggle by writing on the walls. Indeed, they feel that through this gesture their aspirations may somehow be realized, just as the attractive lies of advertising are made real through public display. The choice of place is never fortuitous because it is determined by the political nature of the spot or by its intrinsic suitability as a writing surface (plaques, monuments, epigraphs), so that new inscriptions are often written over ancient ones, not necessarily as a gesture of protest, thereby creating "natural palimpsests." Claudio Mutini, commenting on the graffiti painted in red down the facade of the University of Rome Letters Faculty in 1977 (see FIG. 126) remarked, "The inscription *Creativity kills power* obstructs the prophets' path to immortality, humiliating the authority of the letters in relief, while the redness of the paint defaces the sparkling white marble of the halls of learning."

The techniques employed are varied: silk screen, magic markers (very common indoors and in enclosed spaces), whitewash or tar applied with paintbrush (neither of which is very practical), and finally spray paint held at a close distance from the surface. Practical, quick, and durable, this last medium has become the most popular.

The formal typology of these inscriptions depends more on the choice of technique and location and on the nature of the writing surface than on the content of the message itself. Choice of color is an exception here. Black or blue is usually found in right-wing inscriptions, red or red and black for left wing, but this rule is not always respected. The paintbrush, a rather slow technique, produces wide strokes and enables the writer to create large inscriptions whose format and lettering are similar to those used in traditional monumental lettering, that is, large geometric majuscules drawn with broad uniform strokes. Magic markers and especially spray paint are unsuited to the wide stroke and large format and tend to encourage the use of cursive strokes and of pronounced ligatures, often resulting in a profound deformation of the morphology of the sign (the lettering and figurative design), yet at the same time creating disturbing new and dynamic formal equilibriums. The writing surface provides the frame and background, influences the structure and appearance of the signs, and contributes with its own visual peculiarities, sections, and background color to the overall effect of the inscription.

Two basic consequences of mural writing in turn have a profound impact on the process as a whole. First is the contesting, transforming, or blotting out of the inscription by the writers' political adversaries, often through the use of the same or similar graphic techniques, thereby creating illegible

palimpsests, tangled signs void of meaning, smears of paint across the walls, and, in the words of Crispolti, "pure parageometric structuralism, an incomprehensible chaotic tangle" or simply "mindless decoration."

The second consequence is the efforts of the university administration and the municipal authorities to curb this phenomenon by calling in the police or passing ordinances against it, or to destroy it outright by painting over it or erasing it with solvents. The graffiti-guerrilla warfare of New York, where an antigraffiti law was passed in 1972, and the erasing of the student inscriptions from the facades of the Italian universities in 1977–78 (see FIG. 126) have come to assume a symbolic meaning. The measures taken by the public to banish this (typologically and politically) "different" writing from the urban universe (already thoroughly corrupted by the display writing of the economic and political establishment) violently modified the complex and stratified graphic-visual configuration of those urban areas occupied by spontaneous mural writings. In the very act of eradicating these inscriptions, the authorities unwittingly brought them to the attention of the public and rendered their underlying message of social dissent even more evident. The cry of protest uttered by those who had felt excluded from public writing lived on in the collective memory and in the visual traces left behind, in the faded letters and in the conspicuous blankness of those walls suddenly emptied of meaning.

Thus the desire to vindicate spontaneous writing as a meaningful and creative product of the urban space is countered in our cities by the equally strong desire to distort and eliminate it from the walls through destructive rather than creative means. Aside from its specific social-political connotations, this tragic game of creating and destroying signs quite resembles (or perhaps inspired) the distorting of writing used as figurative element in the work of a few Italian and European artists who, during this same period, were exploring the aesthetic value of the letter as design in the most diverse ways. The history of this hybrid expressive genre, which stands on the dividing line between two worlds—the world of the verbal sign and that of the figurative sign—has a very long history whose roots may be traced back to the avant-garde movements of the early twentieth century (in this context mention must be made of the futurist movement in Italy) or even back to the baroque calligrams of eighteenth-century writing manuals. More recently, we find the work of artists such as Paul Klee, whose experiments and theoretical studies regarding the expressive potential of the letter sign as figurative structure and as pure line have been extremely influential.

It is not easy today—and most especially it is not easy for the author of this book—to indicate itineraries or comment on the positions of individual

artists or groups in a constantly changing situation like the one in which the Italian artists of this genre are working at the present time. But we may recognize at least three different trends that refer to and use writing as the key element of their repertory.

The first trend involves what is known as concrete poetry, created by practitioners of the word working in the wake of a tradition still very much alive today that juxtaposes alphabetic and figurative elements without destroying the verbal meaning of graphic signs. (See FIG. 127.) In these works verbal meaning is still the predominant element. This trend embraces experiments both in typographical and handwritten techniques and may be placed in the same category as the experiments by underground presses that challenged the traditional limits and structures of the graphic context but nonetheless respected its basic values.

Moving from "ut pictura poesis" to "ut scriptura pictura," the second tendency involves the use of graphic signs and letter forms as pure figurative designs, stripped of any apparent or predominant verbal meaning, to provide the main visual element of an artwork's composition. The experiments in this field are associated with what is sometimes known as abstract calligrapy.

The third trend concerns the exploitation of the graphic product or element (something handwritten or typewritten, a sheet of paper, a book, etc.) for the purposes of sheer experimentation, freed from all reference to the limitations, interpretations, or structures traditionally associated with graphic products. In this type of artwork the letter sign is used only so that it may be dissimulated, nullified, and negated, and the graphic product vanishes in contexts that are neither typographical nor handwritten and that have only the faintest connection with writing or that allude to it only in the most intentionally vague way. The evolution of this genre began with the contesting of the typographical permanence and repetitiveness of the letter sign, went on to negate verbal meaning and to focus on the letter form as design, and finally led to the disappearance of both the verbal meaning and the design, to the negation of writing itself and to a renunciation of any form of authority whatsoever in the elaboration of aesthetic-visual models of writing.

During this period in Italy, as in other advanced capitalist countries, it was the graphic production of the advertising world that enjoyed this authority, as the main disseminator of linguistic-graphic models in the contemporary city. Indeed, the true dominators of urban space, printed matter, and the mass media were the commercial illustrators. In the 1970s advertising graphics demonstrated an enormous capacity for assimilating and reutilizing every

new style or technique introduced into the limited sectors of urban graphic culture by the artists of the neo-avant-garde and by the various radical movements. There is not a single graphic style, medium, or mode of expression that was not reelaborated, reproduced, and re-presented to the public in contexts far removed from their original ones, forced to serve aims that were quite the opposite of their creators' intentions. Mural writing, collages, giant posters, visual poetry, handwriting, distorted characters, brightly colored letters, and partial or total annihilation of the verbal message was all absorbed and fused into a smooth, elegant, and polished language, uniform and homogeneous, alien to the public and in the end completely useless, since all analogous messages have a tendency to cancel each other out.

Blanket uniformity in apparent diversity is only one of the basic characteristics of this new graphic language, which has its origin in the internationalization of the advertising business, now a multinational operation like the industrial economic complex upon which it depends. The other basic characteristic of the language of commercial graphics is its tendency to furnish the public not with a verbal-visual message but with a shock or a provocation, opting for irrationality, for a primitive and brutal aggressiveness. At the economic and political level, this choice mirrors the analogous (and inevitable?) process occurring at the other end of the social hierarchy, where the graphic language of social dissent has been reduced to a crude and schematic slogan.

W hat is the relationship between the new graphics of the radical or avant-garde movements and the graphics of the traditional Left? What parallels may be drawn between the "red sign" and the tradition of artists such as Steiner on one hand and "The Signs of No" on the other? Not many, as far as the category of spontaneous mural writing, signs, or handwritten posters is concerned, but quite a few in the category of daily newspapers and magazines voicing the opinions of the New Left, on whose pages the work of many of the old Left's artists or at least many of its models may be found. For example, the austere new layout of the newspaper *Il manifesto* was created by Giuseppe Trevisani, one of Steiner's collaborators, while the red and black headlines of *Lotta continua* are clearly in the tradition of the *Politecnico*.

Steiner himself, in the final phase of his career, designed several explosive posters for the student movement of Milan and was also responsible for the complex decoration of the museum in Carpi dedicated to the memory of the political and racial victims deported to Nazi concentration camps. (See FIG. 128.) In this monument Steiner's mural graffiti engraved on a blood-

red background strongly evoke the powerful tones of accusation often manifest in spontaneous writing, while the fifteen steles in the courtyard bearing the names of the concentration camps where the victims died re-create the solemn resonance of epigraphic rhetoric. In the grim Hall of Names, Steiner's inscriptions convey to us a feeling of the permanence of writing as memento. In 1974, the year of his death, he designed a memorial stone for the station of Turin, honoring deported victims, which represents an innovation in lapidary forms. It is modeled on the poster, and its austere typographical lettering is accompanied by a dynamic sketch by Cagli (already used at the Carpi memorial; see FIG. 129).

In general the linguistic-figurative developments in the graphics of the New Left resemble those of the traditional Left only in those shared contexts of political and trade union struggles, namely, in the designs of posters, banners, streamers, and placards for factory demonstrations and corteges; in the production of printed matter by young people's cultural organizations using very simple means; and perhaps in the use of a few letter symbols such as the politicized *k* (Amerika), the swastika used as a substitute for the *x* in Nixon, the use of the double *S* to allude to the SS, and so on. Here we should mention the caustic graphic-figurative works of politically committed artists such as Bruno Caruso (see FIG. 130), who uses a heavy writing technique in his drawings (the letters almost seem to be engraved on the paper) to underline the aggressive protest expressed in both text and image. We might also mention artists such as Massimo Dolcini (see FIG. 131), whose posters, though possessing their own stylistic originality, follow in the graphic-political tradition of Albe Steiner.

Another tradition of the old Left (which in turn was connected to an even older tradition dating from the Risorgimento and post-Risorgimento) continued by the New Left was the use of memorial epigraphy. The workers movement hastened to honor its dead and its martyrs in the same way that the ruling classes had always done: by celebrating them with epigraphs on the walls of the city, and several of the New Left radical movements have done just that. Many cities in Italy—Rome in particular—are covered with epigraphs honoring the memory of partisans fallen in the struggle against Fascism. Generally these plaques are rather small, plain, unframed, and engraved in red with traditional layout and lettering.

During the 1970s similar inscriptions celebrating the heroes of the new political movements began to appear. These epigraphs, quite varied in setting and typology, are generally characterized by long and complex texts variously arranged on a large background surface of stone (see FIG. 132), though sometimes metal is used (see FIG. 133). The intention is not neces-

sarily to evoke the bronze inscriptions of the Soviet Union but rather to provide a form of protection (stone slabs may be broken by Fascists, but metal resists) in the desperate search for permanence. In this context we must mention the plaque commemorating Giorgiana Masi, who was shot by police on May 12, 1977, during a demonstration. With its bold yet highly legible layout, its molded construction, and the elegant rhetoric of its long poetic text (by Gloria Guasti), this plaque is perhaps the most innovative and most aesthetically accomplished of these inscriptions. But who among those protesters excluded from the forum of public writing may recognize himself or herself here? How many can identify a sign of their own making here on the alien and hostile stones of the city?

Chapter Fourteen

WRITING AGAINST

T he walls of our cities have still to be wiped clean. The simple, reassuring messages of billboards and political posters are not the only occupants of empty urban spaces. Here and there spontaneous inscriptions of symbols, slogans, and names appear in aggressive disarray. The war continues, assaulting monuments and buildings, embankments along waterways and railway tracks, fences around factories. It explodes near the stadiums and in the poorer suburban areas, in the schools and in universities, seeking refuge in the outskirts, dirtying shop shutters, street signs, and statues.

Over the last few years, several new types of spontaneous display writing have sprung into being in all the major Italian cities, writings that are all quite different in their nature, style, and purpose, their models and setting, and yet all related to the world of youth, to its varied forms of culture, and to its violent need for communication and self-expression. Some of these forms, of purely erotic or interpersonal motivation, are based on models drawn from the rock subculture and may be found anywhere, while others, of a political nature, either on the far right or far left, are related to the earlier traditions of various movements that we have discussed at length. Still others belong to specific categories of young people such as soldiers and students, who have been forced by institutions to share the same living space. Finally, at the lowest level of linguistic-graphic creation, we find the inscriptions produced by gangs of sports fans. These are characterized by the writers' cruel and hostile attitude and are often macabre and repugnant, genuine expressions of hatred.

As far as concerns this last category, which is widely represented in specific areas of the city, it must be said that the graphic products of the new urban guerrilla warfare are quite different from those of the 1968 or 1977 student movements in that they consist solely of inscriptions that are extremely simple in content and formulation, and rather approximative and crude in the writing of the alphabetic signs and figurative symbols. Further-

127

more, they tend to respect traditional stereotypes of layout and arrangement and on the whole appear to be the slavish expression of a very elementary, repetitive, and substantially lower-class graphic culture, the product of a futile semiliteracy exercised within the closed and separate circuit of alienation, violence, and ignorance. It is no mere chance that the graphic products of the so-called armed parties of terrorist groups belong to this rather poor and simplified typology. And it is significant that the carefully handwritten posters and signs of the Red Brigades were in general characterized by a geometric graphic design devoid of any creative imaginativeness typical of the petit bourgeoisie.

Like many other highly developed industrial, capitalist countries, Italy is full of young people and adults who can hardly read—nonconstitutional citizens, as Tullio de Mauro has described them. They have "mutilated hands" practically unable to write, are ignorant of "graphic culture," though they learned to read at elementary school, and have been relegated to the outer limits of the metropolis, of the productive process, and of political life and union activity.

Most of the spontaneous writings that have recently been scrawled across the walls of our cities in chaotic patches are the work of a new semiliterate subproletariat, namely, the young and very young inhabitants of the poor-income suburbs who have learned at school that words like *cazzo* (cock), *culo* (asshole), and *Forza Roma* (Go Rome) can be not only shouted but also written on the walls. This phenomenon has a few points in common with the graffiti of the New York ghettos written by young blacks and Puerto Ricans that consist of obsessive repetitions of their nicknames in fantastically elaborate and colorful letter forms.

But a quick visit to the area behind the Olympic Stadium in Rome (or any other stadium in a major Italian city) will show us how profoundly different New York graffiti are from the inscriptions of the Italian subproletariat. The New York variety is substantially an aesthetic-figurative creation with hardly any verbal message, whereas the Italian variety is devoid of conscious aesthetic concerns, the message consisting of slogans, threats, and brutal insults. The former is rigorously individual and signed, the latter produced anonymously by groups, or rather gangs. The former derives from the models provided by advertising graphics and cartoons, the latter from political inscriptions—specifically Fascist ones—and is characterized by extreme simplicity and brutality of expression. It is significant that this new form of spontaneous graphics is not a dominant model; it is not imitated by commercial advertising, does not offend the bourgeoisie, and does not outrage public opinion or provoke the authorities. Limited to a few preferred

areas—the stadium, the subway, the periphery—it is left to proliferate in the midst of silence and indifference. At the Foro Italico in Rome, in what appears to be an obscure historical nemesis, bizarre inscriptions written by sports fans such as the "red yellow brigades" and the "blue white commandos" together with inscriptions by Fascist gangs and a few isolated "red symbols" create a chaotic graphic universe, indecipherable in its aggressive spontaneity, scrawled across the smooth surface of the Fascist epigraphs, thus defacing the statues, engraved slabs, and mosaics created by Mussolini's artists, poets, and orators. (See FIG. 134). Thus two separate routes of display writing have come to overlap—one the creation of an obtuse, ridiculous class-conscious regime, the other the product of young, ignorant, and desperate "second-class" citizens. Two routes, two opposite poles between which lies the vast tragedy of Italian democracy, never fully realized, and therefore cruelly imperfect.

Bibliographic Essay

1. WRITING AND THE CITY

For problems concerning space in the Italian cities of the early and late Middle Ages, I found useful references in L. Mumford, *The City in History*, vol. 2, *From the Cloister to the Baroque* (New York, 1961), and in D. Herlihy, "Società e spazio nella città italiana del Medioevo," in *La storiografia urbanistica*, Acts of the First International Congress on Urbanistic History (Lucca, 1976), pp. 174–94. On the subject of Pisan epigraphy, see G. Scalia, "Epigraphica pisana. Testi latini sulla spedizione contro le Baleari del 1113–5 e su altre imprese antisaracene del secolo XI," *Miscellanea di studi ispanici* 6 (1963): 234–86. See also by the same author "Ancora intorno all'epigrafe sulla fondazione del Duomo pisano," *Studi medievali*, 3d ser., 10 (1969): 483–519, and *"Romanitas* pisana tra XI e XII secolo. Le iscrizioni romane del Duomo e la statua del console Rodolfo," ibid. 13, no. 2 (1972): 791–843. Photos and dates concerning inscriptions found on medieval monuments in southern Italy are provided in M. D'Onofrio and V. Pace, *La Campania* (Milan 1981). On this topic see also P. Delogu, *Mito di una città meridionale* (Naples, 1977), pp. 144–46 and pls. 15–16; for specific reference to Salerno, see pp. 152–90. A study of Sant'Angelo in Formis appears in A. Moppert-Schmitt, *Die Fresken von S. Angelo* (Zurich,1967), in particular, see p. 21. Concerning Pomposa, see M. Salmi, *L'abbazia di Pomposa* (Forli, 1966).

For Modena, aside form G. Bertoni's rather old *Atlante storico-paleografico del Duomo di Modena* (Modena 1909), see W. Montorsi, "Iscrizioni modenesi romaniche e gotiche. Duomo e palazzo del Comune," in *Biblioteca della deputazione di Storia Patria per le antiche province modensi*, no. 35 (1977); G. Trovabene, *Il Museo lapidario del Duomo (Modena)* (Modena, 1984); and especially A. Campana, "La testimonianza delle iscrizioni," in *Lanfranco e Wiligelmo. Il Duomo di Modena,* vol. 1 (Modena, 1984), pp. 363–403 (which is followed by S. Lomartire's article "I segni dei lapicidi," pp. 405–13.). On the subject of Gothic epigraphy, see B. Breveglieri, *Scritture lapidarie romaniche e gotiche a Bo-*

logna. Osservazioni paleografiche . . . (Imola, 1986). For a discussion of the epigraphy of the communes, see P. Sella, "Decreti lapidari dei secoli XII–XIII," *Studi medievali* 1 (1928): 406–21, and more generally G. M Tabarelli, *Palazzi pubblici d'Italia. Nascita e trasformazione del palazzo pubblico in Italia fino al XVI secolo* (Busto Arsizio, 1978). Concerning the Valcamonica inscription, see A. Frugoni, "Fantasia su una iscrizione rupestre del sec. XII a Cemmo in Valcamonica," in *Studi di storia dell'arte, bibliologia ed erudizione in onore di Alfredo Petrucci* (Rome, 1969), pp. 115–18. For the Milanese inscriptions, see E. Arslan in *Storia di Milano*, vol. 3 (Milan, 1954), pp. 590–91, and G. L. Barni, ibid. 4:81, 84–85, 93–95.

Concerning the reutilization of ancient inscriptions, see A. Esch, "Spolien, Zur Wiederverwendung antiker Baustücke und Skulpturen im mittelalterlichen Italien," *Archiv für Kulturgeschichte* 51 (1969): 1–64, and M. Greenhalgh, "*Ipsa ruina docet:* L'uso dell'antico nel Medioevo," in *Memoria dell'antico nell'arte italiana*, ed. S. Settis, vol. 1, *L'uso dei classici* (Turin, 1984), pp. 115–67. Photos and transcriptions of the Ferrara statutes may be found in A. Franceschini, *I frammenti epigrafici degli statuti di Ferrara del 1173 venuti in luce nella Cattedrale* (Ferrara, 1969). Concerning the signatures of artists, R. H. Bautier makes a useful contribution to methodology in "Un essai d'identification et de datation d'œuvres de Benedetto Antelami à Parme et à Fidenza, d'après l'étude paléographique de leurs inscriptions," *Bulletin de la Société nationale des Antiquaires de France,* 1968, pp. 96–115; the reader will also find very helpful the observations of S. Morison in *Politics and Script* (Oxford, 1972), pp. 248–52. For a study of the Byzantine inscriptions that appear on bronze doors and mosaics, see O. Demus, *The Mosaics of Norman Sicily* (London, 1949), and by the same author, *The Mosaics of San Marco in Venice*, vol. 1, pt. 1, *The Eleventh and Twelfth Centuries;* pt. 2, *The Thirteenth Century* (Chicago and London), 1984. See also M. English Frazer, "Church Doors and the Gates of Paradise: Byzantine Bronze Doors in Italy," *Dumbarton Oaks Papers* 27 (1973): 146–62.

On the subject of Roman epigraphy, aside from A. Silvagni, "Monumenta epigraphica christiana, I: Roma," in *Civitate Vaticana* (1943), and C. Cecchelli, *La vita di Roma nel Medioevo*, vol. 1, *Le arti minori e il costume* (Rome, 1951–52), see Cecchelli's "Continuità storica di Roma antica nell'alto Medioevo, in *La città nell'alto Medioevo* (Spoleto, 1959), pp. 89–149. On this subject, see also E. Hutton, *The Cosmati: The Roman Marble Workers of the Twelfth and Thirteenth Centuries* (London, 1950), and F. Gandolfo, "Assisi e il Laterano," *Archivio della Società romana di storia patria,* no. 106 (1983): 63–113. A more detailed study of the Augustals in use during Emperor Frederick's reign may be found in S. Ricci, "Gli *augustali* di Federico II," *Studi medievali* 1 (1928): 57–73, and E. Kantorowicz, *Federico II imperatore* (Milan, 1976), pp. 705–11. For the Gate of Capua, see C. A. Willemsen, "Die Bauten Kaiser Friedrichs II. In Süditalien," in *Die Zeit der Staufer Geschichte. Kunst. Kultur. Katalog der Ausstellung,* vol. 3 (Stuttgart, 1977). The emperor's portrait is dis-

cussed in A. Prandi, "Un documento d'arte federiciana. *Divi Friderici Caesaris imago,*" *Rivista dell'Istituto Nazionale di Architettura e Storia dell'Arte,* n.s., 2 (1953): 263–302.

For a more general discussion concerning the epigraphy of southern Italy during the Norman-Swabian era, see H. W. Schultz, *Denkmaler der Kunst des Mittelalters in Unteritalien,* 4 vols. (Dresden, 1860). The quotation from G. B. Rossi appears in his *Inscriptiones christianae Urbis Romae septimo saeculo antiquiores,* vol. 2 (Rome, 1888), p. 300. See also I. Calabi Limentani, "Sul non saper leggere le epigrafi classiche nei secoli XII e XIII; sulla scoperta graduale delle abbreviazioni," *Acme* 23 (1970): 253–82. For a study of Cimabue's frescoes in Assisi, see M. Andaloro, "Ancora una volta sull'Italia di Cimabue," *Arte medievale* 2 (1985): 143–81. A different approach may be found in E. Battisti, *Cimabue* (Milan, 1963), p. 86, n. 62. For further reference on the subject of Florentine inscriptions, see R. Moghen, "Vita religiosa e vita cittadina nella Firenze del Duecento," in *La coscienza cittadina dei Comuni italiani del Duecento* (Todi, 1972), pp. 195–228. References to Durand are drawn from the Venetian edition of *Rationale* (1509), fols. 4r and v, and also 5r. See also G. Azzaro, *Durando di Mende* (Catania, 1968), pp. 138ff.

A major study of the funerary epigraphy of the Gothic era may be found in I. Herklotz, "*Sepulcra*" e "*monumenta*" del Medioevo. Studi sull'arte sepolcrale in Italia (Rome, 1985). In reference to Padua, see Guido Billanovich, "Il preumanesimo padovano," in *Storia della cultura veneta. Il Trecento,* vol. 2 (Vicenza, 1976), pp. 92–110, and also Giuseppe Billanovich, "Tradizione classica e cristiana e scienza antiquaria," in ibid. 1:124–34. The Scaligeri epigraphs are discussed in C. Cipolla and F. Pellegrini, "Poesie minori riguardanti gli Scaligeri," *Bollettino dell'Istituto storico italiano* 24 (1902): 7–206. In reference to Cola di Rienzo, see F. Saxl, "The Classical Inscription in Renaissance Art and Politics," *Journal of the Warburg and Courtauld Institutes,* 4 (1940–41): 19–46, where the passage I have quoted appears. For a study of Petrarch's inscriptions, see A. Petrucci, *La scrittura di Francesco Petrarca* (Vatican City, 1967), pp. 68–69. A study of the epitaphs composed by Coluccio Salutati for the Corsini family may be found in L. Miglio, "Un nome per tre epitaffi: Coluccio Salutati e gli elogi funebri dei Corsini," *Italia medioevale e umanistica* 26 (1983): 361–74.

2. IMITATION, EMULATION, CIPHER

A detailed study regarding the graphic culture of humanism and the rebirth of the classical epigraphic capital appears in Casamassima, *Trattati di scrittura del Cinquecento italiano* (Milan, 1966), in particular pp. 9–36. (The passage I have quoted from Casamassima is taken from "Lettere antiche. Note per la storia della riforma grafica umanistica," *Gutenberg Jahrbuch,* 1964, pp. 24–25.) See also M. Meiss, *Andrea Mantegna as Illuminator: An Episode in Renaissance Art, Humanism, and Diplomacy* (New York, 1957), and "Towards a More Compre-

hensive Renaissance Palaeography," *Art Bulletin* 42 (1960): 97–112. See also L. A. Ciapponi, "A Fragmentary Treatise on Epigraphic Alphabets by Fra Giocondo da Verona," *Renaissance Quarterly* 32 (1979): 18–40.

For a discussion of Renaissance epigraphy, see Sparrow, *Visible Words* (with bibliography), and I. Kajanto, *Classical and Christian: Studies in the Latin Epitaphs of Medieval and Renaissance Rome* (Helsinki, 1980). On this same subject, see G. Romano, "Verso la maniera moderna: Da Mantegna a Raffaello," in *Storia dell'arte italiana,* vol. 6 (Turin, 1981), pp. 5–85, specifically pp. 10–11, and C. R. Chiarlo, "Gli fragmenti della sancta antiquitate: Studi antiquari e produzione delle immagini da Ciriaco d'Ancona a Francesco Colonna," in *Memoria dell'antico nell'arte italiana,* vol. 1, *L'uso dei classici,* ed. S. Settis (Turin, 1984), pp. 269–97. See also A. Petrucci, "L'antiche e le moderne carte, *imitatio* e *renovatio* nella riforma grafica umanistica," in *Renaissance und Humanistischenhandschriften,* ed. J. Autenrieth (Munich, 1988), pp. 1–12. For Bellini's signatures, see A. Campana, "Notizie sulla *Pietà* riminese di Giovanni Bellini," in *Scritti di storia dell'arte in onore di Mario Salmi* (Rome, 1962), pp. 405–27. Bellini's interest in epigraphy is discussed in F. Saxl, "Jacopo Bellini and Mantegna as Antiquarians," in *Lectures* (London, 1957), pp. 157–60.

On the Chapel of the Cardinal of Portugal, see F. Hartt, G. Corti, and C. Kennedy, *The Chapel of the Cardinal of Portugal (1434–1459) at San Miniato in Florence* (Philadelphia, 1964). In reference to the Tempio Malatestiano, see Petrucci, "Potere, spazi urbani. Scritture esposte: Proposte ed esempi," in *Culture et idéologie dans la genèse de l'état moderne* (Rome, 1985), pp. 85–97. For detailed studies of Sistine epigraphy in Rome during the late Quattrocento, see the following: V. Golzio and G. Zander, *L'arte in Roma nel secolo XV* (Bologna, 1968); G. Mariacher, "Bregno," in *Dizionario biografico degli italiani,* vol. 14 (Rome, 1972), pp. 111–13; P. L. Williams, "Two Roman Reliefs in Renaissance Disguise," Journal of the Warburg and Courtauld Institutes 4 (1941): 47–66; A. Campana, "Antonio Blado e Bartolomeo Platina," in *Miscellanea bibliografica in memoria di d. Tommaso Accurti* (Rome, 1947), pp. 39–50; R. Weiss, *The Medals of Pope Sixtus IV* (Rome, 1961); *Ponte Sisto (1475–1975). Ricerche e proposte, Catalogo* (Rome, 1977); J. B. Horrigan, "Imperial and Urban Ideology in a Renaissance Inscription," *Comitatus: A Journal of Medieval and Renaissance Studies* 9 (1978): 73–86; S. Danesi Squarzina, "La qualità antiquaria degli interventi quattrocenteschi in Ostia tiberina," in *Il Borgo di Ostia da Sisto IV a Giulio II* (Rome, 1980), pp. 13–53; M. Miglio, "Roma dopo Avignone. La politica dell'antico," in *Memoria dell'antico nell'arte italiana* 1:75–111; D. Porro, "La restituzione delle capitali epigrafiche . . . ," in *Un pontificato e una città, Sisto IV, 1471–1484* (Rome, 1986), pp. 409–27, in which Bartolomeo Sanvito is identified as the creator of the Sistine epigraphic style. For a critical edition of the *Hypnerotomachia Poliphili,* see Francesco Colonna, *Hypnerotomachia Poliphili,* ed. G. Pozzi and L. A. A Ciapponi, vol. 1 (Padua, 1964). For a discussion of Poliphilus, see C. Mutini, *L'autore e l'opera. Saggi*

sulla letteratura del Cinquecento (Rome), p. 88, and Sparrow, *Visible Words,* p. 38. Concerning the Roman origins of this work, see M. Calvesi, *Il sogno di Polifilo prenestino* (Rome, 1980). A study of title pages and Italian Renaissance typography appears in F. Barberi, *Il frontespizio nel libro italiano del Quattrocento,* vol. 1 (Milan, 1969).

The tastes of the period are discussed in A. Blunt, *Artistic Theory in Italy* (Oxford, 1962). On the subject of emblems, see M. Praz, *Studies in Seventeenth-Century Imagery,* 2d ed. (Rome, 1964), and also C. Ginzburg, "La simbologia delle immagini e le raccolte di emblemi," in *Terzo Programma,* no. 4 (1970): 176–88. See also E. H. Gombrich, *The Sala dei Venti in the Palazzo del Tè,"* in *Symbolic Images: Studies in the Art of the Renaissance* (London, 1972), pp. 109–18. A study of the Archiginnasio of Bologna is given in A. Sorbelli, *Le iscrizioni e gli stemmi dell'Archiginnasio,* vol. 1 (Bologna, 1916). For a general discussion of Roman pictorial arts during the early and late Cinquecento, and a more specific study of Caprarola and Santo Stefano Rotondo, see F. Zeri, *Pittura e Controriforma. L'arte senza tempo di Scipione da Gaeta* (Turin). The quotation from Sinisgalli appears in L. Jannattoni, *Una certa Roma. Stemmi, insegne, tavolette, emblemi* (Rome, 1971), pp. 39ff.

3. Search for a Standard and the Negation of Writing

Concerning Michelangelo's relationship to writing, see E. N. Girardi, "Le lettere e le Rime," in *Michelangelo artista, pensatore, scrittore* (Novara, 1965), pp. 543–68. A letter written by Michelangelo in the commercial hand *mercantesca* is reproduced in *Scriptorium florentinum. Autografi dell'Archivio Mediceo avanti il Principato,* ed. A. M. Fortuna and C. Lunghetti (Florence, 1977), pl. 103. In general I found very useful the essays in *Michelangelo architetto,* ed. P. Portoghesi and B. Zevi (Rome, 1964), in particular the essay by D. Gioseffi on Porta Pia, pp. 725–60, from which the quotation is taken (p. 735). See also C. De Tolnay, *Michelangelo,* vol. 2, *The Sistine Ceiling;* vol. 3, *The Medici Chapel;* vol. 4, *The Tomb of Julius II* (Princeton, 1945–54), and E. Panofsky, *Studies in Iconology* (New York, 1939). The quotation from Butor is taken from *Les mots dans la peinture* (Geneva, 1969), p. 65. For further reference concerning G. B. Palatino, see the following: J. Wardrop, "*Civis romanus sum:* Giovanbattista Palatino and His Circle," in *Signature,* n.s., no. 14 (1952): 3–39; Casamassima, *Trattati,* pp. 50–53; and V. Romani, "Tessere bibliologiche," *Accademie e Biblioteche d'Italia* 50 (1982): 76–77. For Ruano, see ibid., pp. 63–64.

On the Sala Paolina in Castel Sant'Angelo, see R. Harprath, *Papst Paul III. als Alexander der Grosse. Das Fresken Programm der Sala Paolina in der Engelsburg* (Berlin and New York, 1978); see also E. Gaudioso, "I lavori farnesiani a Castel S. Angelo," *Bollettino d'Arte* 61 (1976): 228–62, and *Gli affreschi di Paolo III a Castel Sant'Angelo. Progetto ed esecuzione. 1543–1548,* vol. 2

(Rome, 1981), pp. 104–17. For Palazzo Spada, see C. L. Frommel, *Der römische Palastbau der Hochrenaissance* (Tübingen, 1973), pp. 169–70 n. 26. On the Casino of Pius IV, besides W. Friedlander's *Das Kasino Pius des Vierten* (Leipzig, 1912), see M. Fagiolo and M. L. Madonna, "La Casino di Pio IV in Vaticano," *Storia dell'Arte* 15–16 (1972): 237–81, and G. Smith, *The Casino of Pius IV* (Princeton, 1977), which makes no mention of the problem posed by the inscriptions.

4. URBAN EPIGRAPHY IN THE MONUMENTAL CITY

For a study of Cresci and his school, see J. Wardrop, "The Vatican Scriptors: Documents for Ruano and Cresci," *Signature*, N.S., 5 (1948): 3–28; Cresci is described as "the first baroque calligrapher" on p. 26. See also Casamassima, *Trattati*, pp. 61–74 (the quotation is taken from p. 73). Further information may be found in the biographical sketch by F. Petrucci Nardelli that appears in *Dizionario Biografico degli italiani*, vol. 30 (Rome, 1984), pp. 668–70. The slab commemorating Francesco Maria in Santa Chiara in Urbino is mentioned in Vasari's *Vite*, ed. G. Milanesi, vol. 6 (Florence, 1881), in which Vasari states that this slab was designed by Girolamo Genga and carved by Ammannati, "who was very young at the time," and goes on to describe it as a "simple and economical," yet "very beautiful" work. Studies of Sixtus V's urban reform project may be found in J. A. F. Orbaan, *Sixtine Rome* (London, 1911); P. Portoghesi, *Roma barocca* (Rome, 1966), pp. 27–29; C. D'Onofrio, *Gli obelischi di Roma*, 2d ed. (Rome, 1967); and more particularly in L. Spezzaferro, "La Roma di Sisto V," in *Storia dell'arte italiana*, vol. 12, *Momenti di architettura* (Turin, 1983), pp. 365–405. Concerning the career of Luca Horfei, see S. Morison, *Calligraphy, 1535–1885* (Milan, 1962), pp. 21–27; Casamassima, *Trattati*, p. 77; J. Mosley, "Trajan Revived," *Alphabet*, 1964, pp. 17–36, and A. Petrucci, "Potere, spazi urbani"; A. S. Osley, *Luminario* (Nieuwkoop, 1972). A study of the inscriptions of the Salone Sistino appears in P. J. J. Van Thiel, "Litterarum inventores. Een uniek thema in de Sala Sistina van het Vaticaan," *Nederlands Kunsthistorisch Jaarboek* 15 (1964): 105–32, in which Horfei is not identified as the author of these inscriptions.

5. PAPER, COPPER, BRONZE, AND MARBLE

A general background to the period is provided by Spezzaferro, "Il recupero del Rinascimento," in *Storia dell'Arte italiana*," vol. 6, pt. 1 (Turin, 1981), pp. 185–274. For a study of the Horfei school, see Mosley, "Trajan Revived." Further documentation may be found in A. M. Corbo, *Fonti per la storia artistica romana al tempo di Clemente VIII* (Rome, 1975), for Domenichi and Rossi. A list of inscriptions dating from the pontificate of Paul V may be found in the ms. Vat. Barb. lat. 2353. Concerning the inscriptions made for Cardinal Cesare Baronius, see M. Smith O'Neil, "The Patronage of Cardinal Cesare Baronio at San Gregorio Magno: Renovation and Innovation," in *Baronio e*

l'arte (Sora, 1985), pp. 145–71, in which Domenichi is not identified as the author of the epigraphs, as the artist himself stated in his second treatise on writing, *Ortografia delle lettere nominate maiuscole antiche romane* (Rome, 1603), which was dedicated to Baronio (p. 9). On Badessi, see C. Fea, *Miscellanea filosofica critica e antiquaria,* vol. 2 (Rome, 1836), p. 14, where Badessi is erroneously indicated as Baldelli. In reference to Sarafellini, see G. Santhá, *San Jose de Calasanz. Sa obra, escritos* (Madrid, 1956), p. 156; Mosley, "Trajan Revived," p. 156; and E. Francia, *1506–1600. Storia della costruzione del nuovo San Pietro* (Rome, 1977), p. 121, where Sarafellini is erroneously identified as Farfallini. On the monumental inscription of Villa Aldobrandidni in Frascati, see C. D'Onofrio, *La Villa Aldobrandini di Frascati* (Rome, 1963), in which Agucchi is quoted in p. 1321 n. 2.

6. Mourning, Dissimulation, Celebration

Further references of a general nature may be found in *Retorica e barocco,* Acts of the Third International Congress on Humanistic Studies (Rome, 1955), see especially A. Chastel's essay "Le baroque et la mort," pp. 33–46; E. Panofsky, *Tomb Sculpture: Its Changing Aspects from Ancient Egypt to Bernini* (London, 1964); G. C. Argan, *L'Europa delle capitali, 1600–1700* (1964); Portoghesi, *Roma barocca;* M. Praz, *Mnemosyne: The Parallel between Literature and the Visual Arts* (Princeton, 1970); W. Benjamin, *Ursprung des deutschen Trauerspiels* (Frankfurt am Main, 1963), and R. Wittkower, *Art and Architecture in Italy, 1600–1750* (New York, 1973). For further documentation, see J. A. F. Orbaan, *Documenti sul barocco a Roma* (Rome, 1920); A. Grisebach, *Römische Porträtbusten der Gegenreformation* (Leipzig, 1936); U. R. Montini, *Le tombe dei papi* (Rome, 1957); R. Enggas, *Early Eighteenth-Century Sculpture in Rome,* 2 vols. (1976). On the Mantuan labyrinth, see H. Kern, *Labyrinthe* (Munich, 1982), no. 356 and pp. 284–85, and P. Carpeggiani, "Zwischen Symbol und Mythos. Das Labyrinth und die Gonzaga," *Daidalos* 3 (1982): 25–37. See also Sparrow, *Visible Words,* where on p. 88 the hidden text is viewed as "a degree of sophistication in the artist." An interpretation of Poussin's *Et in Arcadia ego* is given on pp. 80–83. For a further discussin of Poussin, see E. Panofsky, "*Et in Arcadia ego,* Poussin and the Elegiac Tradition, in *Meaning in the Visual Arts.*

Reproductions of baroque epigraphs from Naples and Lecce appear in A. Blunt, *Neapolitan Baroque and Rococo Architecture* (London, 1975). See also M. Calvesi and M. Manieri Elia, *Architettura barocca a Lecce e in Terra di Puglia* (Milan and Rome, 1971), and T. Pellegrino, *Piazza Duomo a Lecce* (Bari, 1972). For a study of Palermo and the Piazza dei Quattro Canti, see M. Fagiolo and M. L. Madonna, *Il Teatro del Sole* (Rome, 1981). A brief mention of the portraits and inscriptions appearing on the facades of baroque Venetian churches may be found in E. Castelnuovo, "Il significato del ritratto pittorico nella societá," in *Storia d'Italia Einaudi,* vol. 5, pt. 2 (Turin, 1973), pp. 1073–74. For a study of Bernini's sketches, see R. Preimesberger, "Das dritte Papstgrabmal

Berninis," *Römisches Jahrbuch für Kunstgeschichte* 17 (1978): 157–88, which includes an updated bibliography. On Fontana's work, see A. Braham and H. Hager, *Carlo Fontana: The Drawings at Windsor Castle* (London, 1977). The epigraphic war between Rome and Venice is discussed in L. von Pastor, *Storia dei papi,* vol. 13 (Rome, 1943), pp. 730–32.

7. EPHEMERAL MONUMENTAL AND PAPER MONUMENTAL

The quotations from Tesauro, *Il cannocchiale,* are taken from pp. 13, 23, 94, 701, 704. Tesauro's inscriptions are collected in *Inscriptiones quotquot reperiri potuerunt,* ed. E. F. Panebianco (Frankfurt and Leipzig, 1698). Cartari's diary may be found in Rome in the Archivio di Stato, Cartari-Febei, envelope 105. On the subject of public ceremonies in Rome, see F. Cancellieri, *Storia de' solenni possessi de' sommi pontefici* . . . (Rome, 1802). On Venetian ceremonies, see F. Sansovino, *Venetia città nobilissima et singolare* (Venice, 1663), in particular books 8 and 10. For further discussion of these festivities, see H. Tintelmont, "Annotazioni sull'importanza della festa teatrale . . . ," in *Retorica e barocco,* pp. 233–41; and most especially M. Fagiolo Dell'Arco, "Le forme dell'effimero," in *Storia dell'arte italiana,* vol. 11 (Turin, 1982), pp. 203–35, and *Barocco romano e barocco italiano. Il teatro, l'effimero, l'allegoria,* ed. M. Fagiolo and M. L. Madonna (Rome, 1985).

Concerning luxury editions in Italy between the seventeenth and eighteenth centuries, see S. Samek Ludovici, *Arte del libro. Tre secoli di storia del libro illustrato dal Quattrocento al Seicento* (Milan, 1974), and E. Coen Pirani, *Il libro illustrato italiano. Secoli XVII–XVIII* (Rome, 1956). However, I also found the following texts quite useful: G. Boffito, *Frontespizi incisi nel libro italiano del Seicento* (Florence, 1922); A. F. Johnson, *One Hundred Title Pages, 1500–1800* (London, 1928); G. Morazzoni, *Il libro illustrato veneziano del Settecento* (Milan, 1943); P. Hofer, *Baroque Book Illustration* (Cambridge, Mass., 1970); F. Barberi, "Titoli di libri italiani nell'età barocca," in *Bibliothekswelt und Kulturgeschichte* . . . (Munich, 1977), pp. 171–86; also by the same author, "L'antiporta nei libri italiani del Seicento," *Accademie e Biblioteche d'Italia* 50 (1982): 347–54, and "Il frontespizio nel libro italiano del Seicento," *La bibliofilia* 85 (1983): 49–72. A vast and useful collection of reproductions may be found in S. Piantanida, L. Diotallevi, and G. Livraghi, vol. 1, *Autori italiani del Seicento;* vol. 2, *Le scienze;* vol. 3, *La letteratura;* vol. 4, *Il teatro, la musica, l'arte, e la religione* (Milan, 1948–51). Related indexes appear in R. L. Bruni and D. W. Evans, *Italian Seventeenth Century Books* (Exeter, 1984). For Walter Benjamin's study of German theatrical editions, see his *Ursprung des deutschen Trauerspiels,* cited above in chapter 6.

Concerning the patrons of illustrated luxury editions, see two contributions by F. Petrucci Nardelli, "Libri e legature fra Roma e Napoli alla metà del XVIII secolo," *Accademie e Biblioteche d'Italia* 54 (1986): 43–55, and "Il card. Francesco Barberini senior e la stampa a Roma," *Archivio della Società romana di*

storia patria 108 (1985): 133–98. On Juvarra as illustrator, see M. Viale Ferrero and O. Mischiati, "Disegni e incisioni di Filippo Juvarra per edizioni romane del primo Settecento," *Atti dell'Accademia delle scienze di Torino, classe di scienze morali* 110 (1976): 211–74. On Rubens as illustrator and a comparison with Italian illustration, see Corpus Rubenianum L. Burchard, vol. 21, *Book Illustration and Title Pages,* ed. J. R. Hudson and C. Van de Velde, 2 vols. (Brussels, 1977). On the subject of display scripts, the reader will find indispensable G. Pozzi's *La parola dipinta* (Milan, 1981). Studies of Kircher may be found in V. Rivosecchi, *Esotismo in Roma barocca. Studi sul padre Kircher* (Rome, 1982); *Enciclopedismo in Roma barocca. Athanasius Kircher e il Museo del Collegio Romano tra Wunderkammer e museo scientifico* (Venice, 1986), in particular see L. Tongiorgi Tomasi's essay "Il simbolismo delle immagini: I frontespizi delle opere di Kircher," pp. 165–75. On the use of texts in engraved prints, see L. Salerno, "Immobilismo politico e Accademia," in *Storia dell'arte italiana,* vol. 6, pt. 1 (Turin, 1981), p. 483. In reference to Mitelli, see A. Bertarelli, *Le incisioni di Giuseppe Maria Mitelli. Catalogo critico* (Milan, 1940).

8. THE RETURN TO ORDER

For a general discussion, see L. Hautecoeur, *Rome et la Renaissance de l' Antiquité à la fin du XIIIᵉ siècle* (Paris, 1912). Concerning the manufacture of false epigraphs at the turn of the eighteenth century, a phenomenon that accompanied the neoclassical taste in epigraphy during this period, see M. P. Billanovich, "Falsi epigrafici," *Italia medievale e umanistica* 10 (1967): 27–110, and S. Panciera, *Un falsario del primo Ottocento: Girolamo Asquini e l'epigrafia antica delle Venezie* (Rome, 1970). On Piranesi's career, see the following: Alfredo Petrucci, "G. B. Piranesi," in *Maestri incisori* (Novara, 1953), pp. 91–102; H. Focillon, *Giovanni Battista Piranesi,* ed. M. Calvesi and A. Monferini (Bologna, 1967); P. Murray, *Piranesi and the Grandeur of Ancient Rome* (London, 1971); Calcografia Nazionale, *Grafica grafica,* vol. 2, pt. 2 (Rome, 1976), in particular, see the article by C. Bertelli, pp. 90–115 and 117–23, and the "Notice historique" by J. G. Legrand, pp. 136–62. See also the exhibition catalog *Piranesi nei luoghi di Piranesi,* 5 vols. (Rome, 1979).

Concerning the antiquarian culture and general background of Piranesi's era, see the following: B. Reudenbach, *Architektur als Bild. Der Wandel in der Architekturauffassung des achtzehnten Jahrhunderts* (Munich, 1979); *Piranesi e la cultura antiquaria. Gli antecedenti e il contesto. Atti del Convegno* (Rome, 1983); *Piranesi tra Venezia e l'Europa,* ed. A. Bettagno (Florence, 1983). For a discussion of classical-style graphic models popular in Italy and England during the crucial years of Piranesi's career, see also M. Vickers, "Value and Simplicity: Eighteenth-Century Taste and the Study of Greek Vases," *Past and Present* 116 (August 1987): 98–137. For an illustration of the use of antique-style display writing in the portraiture of the period, see J. Reynolds's extraordinary portrait of Horace Walpole at home in his study. For a study of the return to

classical characters in typography, see Morison, *Politics and Script*, chap. 7. On the subject of Italian books, see F. Riva, *Il libro italiano, 1800–1965* (Milan, 1966). More details regarding Bodoni's life and career may be found in F. Barberi's biographical sketch in *Dizionario biografico degli italiani*, vol. 11 (Rome, 1969), pp. 107–15. See also H. C. Brooks, *Compendiosa bibliografia di edizioni bodoniane* (Florence, 1927); P. Trevisani, *Bodoni. Epoca vita arte* (Milan, 1940); A. Ciavarella, *Catalogo del Museo bodoniano di Parma* (Parma, 1968).

For a study of the graphic arts in Rome during the time of Pius IX, see *Luigi Rossini incisore. Vedute di Roma, 1817–1850* (Rome, 1982), and G. Spagnesi, *L'architettura a Roma al tempo di Pio IX. Catalogo della mostra* (Rome, 1978). Concerning the old-fashioned and backward tendencies expressed in the graphic works produced by the workers movement, see two recent exhibition catalogs: *Un'altra Italia nelle bandiere dei lavoratori. Simboli e cultura dalla unità d'Italia all'avvento del fascismo* (Turin, 1980), and *Caratteri ribelli. La stampa democratica e operaia nell'Europa dell'Ottocento,* ed. M. Pelaja and L. Zannino (Rome, 1985). The activities of one so-called people's socialist publishing house are described in G. Tortorelli, *Le edizioni Nerbini (1897–1921). Catalogo* (Florence, 1983).

9. DEVIANT PHENOMENA

The passage from Casamassima is quoted from "Lettere antiche," p. 25 n. 37. On the standardizing of majuscule scripts in Florence and Siena, see S. Colvin, *A Florentine Picture-Chronicle, being a series of ninety-nine drawings representing scenes and personages of ancient history sacred and profane by Maso Finiguerra . . .* (London, 1898); A. M. Hind, *Early Italian Engraving: A Critical Catalogue . . . ,* 7 vols. (London and New York, 1938–48); C. Brandi, *Giovanni di Paolo* (Florence, 1947); E. Carli, *Le tavolette di Biccherna e di altri uffici dello Stato di Siena* (Florence, 1950); and most especially *Le Biccherne. Tavole dipinte delle magistrature senesi (secoli XIII–XVIII),* by varied authors (Rome, 1984), which includes documentation of interesting modifications of layout and script typologies; B. Berenson, *Italian Pictures of the Renaissance: Central Italian and North Italian Schools,* vol. 1 (London, 1968); P. Torriti, *La Pinacoteca nazionale di Siena,* vol. 1, *Dipinti dal XII al XV secolo* (Genoa, 1977). In general, useful reproductions of inscribed objects may be found in the following: *Arte religiosa popolare in Italia. Catalogo generale,* ed. E. Bona (Rome, 1943), and P. Toschi, *Arte popolare italiana* (Rome, 1960).

On the subject of ceramics, see G. Liverani, *La maiolica italiana* (Milan, 1957); G. Donatone, *Maiolica popolare campana* (Naples and Cava, 1976); M. Bellini and G. Conti, *Maioliche italiane del Rinascimento* (Milan, 1964); *Le ceramiche da farmacia a Roma tra '400 e '600,* ed. O. Mazzucato (Viterbo, 1990). Concerning the frescoes of the monastery of Tor de' Specchi in Rome, see F. Zeri, *Italian Paintings in the Walters Art Gallery,* vol. 1 (Baltimore, 1976), pp. 154–58. For a discussion of Venetian *tolete,* see G. Fogolari, "Le tavolette

delle arti veneziane," *Dedalo* 9 (1928–29): 723–42. Roman street inscriptions are discussed by F. S. Palermo in *Monsignore illustrissimo. Antichi mondezzari nelle strade romane* (Rome, 1980). For a discussion of the local traditions mentioned in the text, see L. Leporino, *Ascoli Piceno. L'architettura dai maestri vaganti ai Giosafatti* (Ascoli Piceno, 1973); *Territorio e conservazione. Proposta di rilevamento dei beni culturali immobili nell'Appennino bolognese . . . ,* ed. L. Gambi (Bologna, 1972); L. Franzoni, "Sculture popolari veronesi," *Saggi e memorie di storia dell'arte* 1 (1957): 227–58. For Bergamo, see L. Angelini, *Arte minore bergamasca,* 3d ed. (Bergamo, 1974).

In my examination of ex-votos, I found the following extremely useful: L. Kriss-Rettembeck, *Das Votivbild* (Munich, 1958); A. Ciarrocchi and E. Mori, *Les petits tableaux votifs italiens* (Udine, 1960); L. Novelli and M. Massaccesi, *Ex-voto del Santuario della Madonna del Monte di Cesena* (Forli and Cesena, 1961); P. Toschi and R. Penna, *Le Tavolette votive della Madonna dell'Arco* (Cava de' Tirreni, 1971); *Puglia Ex-voto. Bari, Biblioteca provinciale De Gemmis,* ed. E. Angiuli (Galatina, 1977); *Religiosità popolare e vita quotidiana. Le tavolette votive del territorio jesino-senigalliese,* ed. S. Anselmi (Jesi, 1980); A. Turchini, *Lo straordinario e il quotidiano. Ex-voto, santuario, religione nel Bresciano* (Brescia, 1980); B. Cousin, *Les miracles et le quotidien. Les ex-voto provençaux. Images d'une société* (Aix-en-Provence, 1983); and finally, P. Clemente and L. Orrù, "Sondaggi sull'arte popolare," in *Storia dell'arte italiana,* vol. 11 (Turin, 1982), pp. 277–97. On popular prints, see L. Sorrento, *Stampe popolari e libri figurati del Rinascimento lombardo* (Milan, 1942), and P. Toschi, *Stampe popolari italiane dal XV al XX secolo* (Milan, 1964). For a study of shop signs, see D. Villani, *Storia del manifesto pubblicitario* (Milan, 1964), and Toschi, *Arte popolare.*

The story of Saccardino may be found in C. Ginzburg and M. Ferrari, "La Colombara ha aperto gli occhi," *Quaderni storici* 38 (1978): 631–39; see also the entire volume dedicated to *Alfabetismo e cultura scritta.* For a study of funerary epigraphy in the Cosentine area, see *Imago mortis. Simboli e rituali della morte nella cultura popolare dell'Italia meridionale,* ed. L. Carloni (Rome, 1980). Inscribed *instrumentum domesticum* are discussed in E. Silvestrini, "Pastori e scrittura," *La ricerca folklorica* 5 (1982): 103–18. See also the whole issue dedicated to *La scrittura: Funzioni e ideologie,* ed. G. R. Cardona. Reproductions of posters pasted in layers one on top of the other may be found in B. Bellotto, "Figure sotto un portico," reprinted in U. Ojetti, N. Tarchiani, and L. Dami, *La pittura italiana del '600 e del '700* (Milan and Rome, 1924), pl. 22, and in B. Pinelli, *Riflessioni sull'associazioni,* reprinted in *Storia dell'arte italiana,* vol. 9, pt. 2 (Turin, 1981), fig. 443. For a study of defamatory posters in Rome, see A. Petrucci, *Scrittura e popolo nella Roma barocca* (Rome, 1982). On the subject of ancient "spontaneous" mural inscriptions, see M. Dall'Acqua, *Voci segrete dai muri. Controstoria parmigiana* (Parma, 1976). Concerning the wall inscriptions left by prisoners in Castel Sant'Angelo in Rome, see the articles by M. Miglio and L. Miglio in *Quando gli Dei si spogliano. Il bagno di Clemente VII a*

Castel Sant'Angelo e le altre stufe romane del primo Cinquecento (Rome, 1984), pp. 101–19. A study of similar inscriptions in the prisons of Palermo may be found in L. Sciascia, *Graffiti e disegni dei prigionieri dell'Inquisizione* (Palermo, 1977); a study of those found in the prisons of Lucca appears in M. Miglio, "Palinsesti dal carcere di Palazzo," in *Il Palazzo pubblico di Lucca* (Lucca, 1980), pp. 89–90.

10. THE BREAKING OF THE NORM

Useful references of a general nature may be found in F. Bologna, *Dalle arti minori all'industrial design. Storia di una ideologia,* (Bari, 1972). On European graphics, see Gray, *Lettering as Drawing* (Oxford, 1970), and S. Morison, *Letter Forms Typographic and Scriptorial . . .* (London, 1968). Concerning William Morris's work in graphics, see Morison, ibid., where Morris's judgment of Bodoni is discussed on p. 92 (also mentioned in F. Barberi, *Il libro a stampa* [Rome, 1965]., p. 53), and *William Morris and the Art of the Book* (New York, 1976). Two very important reviews that influenced English graphic tastes during the twenties and thirties were *The Fleuron,* published by Oliver Simon and S. Morison from 1923 to 1954, and *Signature: A Quadrimestral of Typography and Graphic Arts.* The latter, distinguished for its elegant typography and aesthetic sobriety, was published from 1935 to 1940 by Oliver Simon with the collaboration of S. Morison, A. F. Johnson, James Wardrop, Paul Nash, and Enschedé.

On the evolution of European and Italian commercial poster design over the last century, see G. Bocca, *I manifesti italiani tra "belle époque" e fascismo* (Milan, 1971); L. Menegazzo, *Il manifesto italiano, 1882–1925* (Milan, n.d.), and M. Gallo, *L'affiche miroir de l'histoire miroir de la vie* (Paris, 1973), with a critical study by A. C. Quintavalle. The quotation from Walter Benjamin may be found in *Schriften* (Frankfurt am Main, 1955). On the development of Art Nouveau in Italy, see *Torino 1902. Polemiche in Italia sull'Arte Nuova,* ed. F. R. Fratini (Turin, 1970). For a more general discussion, see E. Bairaiti, R. Bossaglia, and M. Rosci, *L'Italia liberty. Arredamento e arti decorative* (Milan, 1973). For a study of De Carolis, see L. Danila and A. Valentini, *Adolfo De Carolis* (Fermo, 1975). For further reference concerning the school associated with the magazine *Eroica,* see *L'"Eroica" e la xilografia,* ed. R. Bossaglia (Milan, 1981); E. Cozzani, "La bella scuolo," *L'Eroica* 1 (1911–12): 227–56; 5 (1915): 107–11. The critique regarding Cermignani is taken from E. Cozzani, *Armando Cermignani* (Milan, 1922), p. 20. A more general study of the graphics of the period may be found in C. Ratta, *Gli adornatori del libro in Italia,* 9 vols. (Bologna, 1923–37). For a discussion of Sartorio's work with scripts, see V. Romani, "Sartorio e l'alfabeto," *Lazio ieri e oggi* 8 (1972), fasc. 1, pp. 19–22.

On the subject of Art Deco, see R. Bossagli, *Il "déco" italiano. Fisionomia dello stile 1925 in Italia* (Milan, 1975). Futurist graphics are discussed in L. Pig-

notti and S. Stefanelli, *La scrittura verbo-visiva. Le avanguardie del Novecento tra parola e immagine* (1980), pp. 19–90; F. Roche-Pézard, *L'aventure futuriste, 1909–1916,* Collection de L'Ecole Francaise de Rome, 68 (Rome, 1983), pp. 403–49; documentation and texts are given in L. Caruso and S. M. Martini, *Tavole parolibere futuriste, 1912–1944,* 2 vols. (Naples, 1974–77), and in *Tavole parolibere e tipografia futurista,* ed. L. Caruso (Venice, 1977). Concerning Gramsci's views on futurism, see *2000 pagine di Gramsci* (Milan, 1964), pp. 552–54 and 633–35; see also A. Asor Rosa, *La cultura,* in *Storia d'Italia Einaudi,* vol. 4, pt. 2 (Turin, 1975), pp. 1290–1301. For a study of F. Depero, see *Fortunato Depero, 1892–1960* (Bassano del Grappa, 1970). Late developments of futurism are discussed in L. Patetta, "Neofuturismo, novecento e razionalismo . . . , *Controspazio* 3, nos. 4–5 (1971): pp. 87–96. Extensive documentation is given in F. Caroli and L. Caramel, *Testuale. Le parole e le immagini* (Milan, 1979).

11. THE NEW ORDER AND THE SIGNS OF THE REGIME

The opening quotation appears in R. Serra, *Le lettere* (Rome 1914), p. 15. On the interrelationship of rationalism, *novecentismo,* and fascism, see Asor Rosa, *La cultura,* pp. 1500–1513. For a general background to the period, I consulted the following: C. De Seta, *La cultura architettonica in Italia tra le due guerre* (Bari, 1972); U. Silva, *Ideologia e arte del Fascismo* (Milan, 1973); and P. Fossati, *L'immagine sospesa. Pittura e scultura astratte in Italia, 1934–40* (Turin, 1971). Important studies of several major graphic artists of the period may be found in *Heritage of the Graphic Arts: A Selection of Letters,* ed. C. B. Grannis (New York and London, 1972), which includes profiles of E. Johnston, E. Gill, G. Mardersteig, and Jan Tschichold. See also S. Danesi Squarzina, "Veronesi: Tipografia e réclame," *Grafica, grafica* 2 (1976): 6–14; G. Mardesteig, *The Officina Bodoni,* ed. H. Schmoller (London, 1981), and A. Steiner, *Il mestiere di grafico* (Turin, 1978), pp. 87–113. On the subject of Soviet graphics, see S. P. Compton, *The World Backwards: Russian Futurist Books, 1912–1916* (London, 1978). Further information on Bertieri may be found in F. Riva's article in the *Dizionario biografico degli italiani,* vol. 9 (Rome, 1967), pp. 58–29. References to the review *Campo grafico* may be found in C. Dradi and A. Rossi, *Millenovecentotrentatre, nasce a Milano la grafica moderna,"* in *Città di Milano,* September 1973.

City planning during the Fascist period is discussed in *Le città, il fascismo,* ed. M. Sanfilippo (Rome, 1978). For a study of the epigraphic and display writing of Fascism, see Bartram, *Lettering in Architecture* (London, 1975), pp. 144–57, and P. Ciani, *Graffiti del ventennio* (Milan, 1975). For a more specific focus on Rome, see G. Accasto, V. Fraticelli, and R. Nicolini, *L'architettura di Roma capitale; 1870—1970* (Rome, 1971); S. Kostof, *The Emperor and the Duce: The Planning of Piazzale Augusto Imperatore in Rome,* in *Art and Architecture in the Service of Politics,* ed. H. A. Millon and L. Nochlin (Cambridge,

Mass., 1978), pp. 270–325; S. Addamiano, "Le iscrizioni della città Universitaria," in *Università oggi. I cinquant'anni dell'Università di Roma, 1935–1985* (Rome, 1986), pp. 89–93. Regarding Turin, see *Torino 1920–1936. Società e cultura tra sviluppo industriale e capitalismo* (Turin, 1976). On Fascist poster design, see *Anni Trenta. Arte e cultura in Italia* (Milan, 1982), pp. 467–94; *Tempo di uomini tempo di vivere. I manifesti più belli dei magnifici anni Trenta,* ed. M. Veneziani (Rome, 1983).

12. THE RED SIGN

For a general discussion, see D. D. Egbert, *Social Radicalism and the Arts: Western Europe* (New York, 1970), which says little about Italy. On the subject of Soviet graphics, aside from Compton, *The World Backwards,* see *Majakovskij, Mejerchol'd Stanislavskij* (Venice, 1975). For more detailed studies of Steiner's life and work, see *Albe Steiner. Comunicazione visiva* (Florence, 1977), where the quotation from Fortini appears on p. 14. See also Steiner's own writings, *Il mestiere,* pp. 32–48, where the quotations I have reprinted appear, and *Il manifesto politico* (Rome, 1978), in which quoted passages appear on pp. 46, 60, 62, 92. For a study of Italian graphics during the postwar years, see P. Fossati, *Il design in Italia, 1945–1972* (Turin, 1972). A more specific study of political poster design appears in "Manifesti socialisti," in *Almanacco socialista 1977,* pp. 97–178. On this subject, see also *Via il regime della forchetta,* ed. G. Vittori (Rome, 1976), and the propaganda pamphlet *Modena 6 gennaio,* edited by the Italian Communist Party and reprinted in N. Misler, *La via italiana al realismo. La politica culturale artistica del Pci dal 1944 al 1956,* 2d ed. (Milan, 1976), pp. 351–76; see also *C'era una volta la Dc. Breve storia del periodo degasperiano attraverso i manifesti elettorali della Democrazia cristiana,* ed. L. Romano and P. Scabello (Rome, 1975), which includes an essay by L. M. Lombardi Satriani. Weekly magazines and periodicals are discussed by N. Ajello, "Il settimanale di attualità," in *La stampa italiana del neocapitalismo,* ed. V. Castronovo and N. Tranfaglia (Bari, 1976), pp. 173–249.

13. THE SIGNS OF NO

For a general background I found the following very helpful: *L'altra grafica,* ed. R. Cirio and P. Favari (Milan, 1972); *Almanacco letterario Bompiani, 1973;* R. Tiberi, *La contestazione murale. Una ricerca psico-sociale sul fenomeno contestatario attraverso lo studio de graffiti," e di mezzi di comunicazione di massa* (Bologna, 1972), from which the quotation is taken (p. 14); A. Bettanini, "Scritta murale," in *Comunicazioni di massa, lotta di classe. Contributi per un 'analisi,* ed. M. G. Lutzemberger and S. Bernardi (Rome, 1976); U. Eco and P. Violi, "La controinformazione," in *La stampa italiana del neocapitalismo,* pp. 97–172; and C. Garelli, *Il linguaggio murale* (Milan, 1978).

For a discussion of the posters in Paris in May 1968, see V. Gasquet, *Les 500 affiches de mai 68* (Paris, 1978). Reproductions and critical discussions of

graffiti appear in G. Cutilli, R. Filippi, and R. Petrucci, *Le scritte murali a Roma,* ed. E. Crispolti (Rome, 1974), from which I have taken the quotations concerning illegibility (no page numbers given). See also M. I. Macioti and M. D'Aurato, "I graffiti dell'Università," in *La critica sociologica,* no. 41 (1977): 122–51. The graffiti of Milan are discussed in A. Natali and A. Hammacher, "Scrittura e pittura politica urbana. Milan 1973–1976. I "murales" degli anni Settanta," in *Milan e il suo territorio,* vol. 2 (Milan, 1985), pp. 427–38. The quotation from Mutini is taken from C. Mutini, "Arte e letteratura," in *Storia dell' arte italiana,* vol. 10 (Turin, 1981), p. 374. See also G. Cianflone and D. Scafoglio, *Fascismo sui muri. Le scritte murali fasciste di Napoli* (Naples, 1977); P. Marchi, *Italia spray. Storia dell'ultima Italia scritta sui muri* (Florence, 1978). New York grafitti are discussed in J. Baudrillard, "I graffiti di New York ovvero l'insurrezione attraverso i segni," in *La critica sociologica,* no. 29 (1974): 148–50; no. 31 (1974): 6–10; A. Nelli, *Graffiti a New York, 1968–1986* (Cosenza, 1978); and N. Glazer, "On Subway Graffiti in New York," in *Face of Architecture: Civic Culture and Public Spaces,* ed. N. Glazer and M. Lilla (New York and London, 1987), pp. 371–80. An interesting study of organized urban graphic-guerrilla squads is given in D. Kunzle, "Art of the New Chile: Mural, Poster, and Comic Book in a 'Revolutionary Process,'" in *Art and Architecture in Service of Politics,* pp. 356–81.

On the subject of writing and contemporary art, I consulted the following: E. Miccini, *Poesia visiva* (Florence, 1970); *Scrittura visuale in Italia, 1912–1972,* ed. L. Ballerini (Turin, 1973); *La Scrittura,* ed. F. Menna and others (Rome, 1976); E. Crispolti, *Arte visive e partecipazione sociale,* vol. 1, *Da Volterra '73 alla Biennale 1976* (Bari, 1977); F. Caroli, *Parola-immagine. Per un'antropologia dell'immaginario: L'arte della cecità* (Milan, 1979); *Scrittura attiva. Processi artistici di scrittura,* ed. U. Carrega (Bologna, 1980); M. Bentivoglio, *Il non libro. Bibliofollia ieri e oggi in Italia* (Rome, 1985); and most especially Pignotti and Stefanelli, *La scrittura verbo-visiva.* See also l. Pignotti, *Sine aesthetica, sinestetica. Poesia visiva e arte plurisensoriale* (Rome, 1990). The text of the inscription commemorating Giorgiana Masi appears in *Dal fondo. La poesia dei marginali,* ed. C. Bordini and A. Veneziani (Rome, 1978), p. 79. On the political symbolism of graphic signs, see L. Petrucci, "Ancora qualche osservazione sull'uso del kappa 'politico' in Italia," *Lingua Nostra* 38 (1977): 114–17. Bruno Caruso's work is discussed in *Il fiore rosso. Venti anni di disegni politici,* ed. M. De Micheli (Padua, 1976). For further reference concerning Massimo Dolcini, see A. Allen, "Pesaro: A City Communicates through Posters," *Graphis* 37, no. 214 (1981–82): 174–80.

14. WRITING AGAINST

No critical or analytic bibliography may be provided for the spontaneous display writing discussed in this last chapter, although daily newspapers and magazines sometimes make reference to it as an oddity or a grotesque bit of local

news. Aside from the bibliography listed for New York graffiti, see also Cianflone and Scafoglio, *Fascismo sui muri,* which provides a useful general background to the subject. Photos (though obviously not recent ones) may be found in Marchi, *Italia spray.* To my knowledge, the only essay on this subject in existence is M. Onofri and A. Ricci, "I ragazzi della curva," *Il Mulino* 33 (1984): 813–35, which explores the subject of sports graffiti but includes no photos. In general, see also A. Abruzzese, "Antagonismo e subalternità nelle produzione di scrittura," in *Letteratura italiana,* ed. A. Asor Rosa, vol. 2, *Produzione e consumo,* (Turin, 1983), pp. 473–96, and A. Petrucci, *Scrivere e no. Analfabetismo e politiche della scrittura nel mondo d'oggi* (Rome, 1987), which includes an extensive critical bibliography, pp. 273–89.

Index